HIGH SCHOOL FOOTBALL
IN SOUTH CAROLINA

PALMETTO
-PIGSKIN-
HISTORY

JOHN BOYANOSKI

Charleston | London

THE
History
PRESS

Published by The History Press
Charleston, SC 29403
www.historypress.net

Front Cover image by Russell E Cooley IV.

First published 2010

Manufactured in the United States

ISBN 978.1.59629.979.5

Library of Congress Cataloging-in-Publication Data

Boyanoski, John.
High school football in South Carolina : palmetto pigskin history / John Boyanoski.
p. cm.
Includes bibliographical references and index.
ISBN 978-1-59629-979-5
1. Football--South Carolina--History. 2. High school football players--South Carolina--
History. 3. School sports--South Carolina--History. I. Title.
GV959.52.S6B69 2010
796.332'6209757--dc22
2010023668

For Shonda and Hannah

CONTENTS

PREFACE

I am not from South Carolina originally—I didn't move here until my early twenties, when I took a job at the *Spartanburg Herald-Journal*. That means I never heard of John McKissick, Pinky Babb, Willie Varner, Shell Dula, Bettis Herlong, Mooney Player or a host of other coaches who transformed high school football in this state before 1999. I had never of the rivalry between Parker High and Greenville and didn't know about Northwestern and Rock Hill, Myrtle Beach and Socastee, Spartanburg and Dorman, Lexington and Irmo, Mid-Carolina and Chapin and all of those rivalries that made Friday nights in the fall here so extraordinary. I had heard of some of the players, but I knew them for other reasons. William Perry? He was the Fridge, not a prep phenom from Aiken. Freddie Solomon? A wide receiver on the early 1980s Niners' teams that I hated because they were better than the Steelers—not possibly the greatest offensive player in state history. Harry Carson? The Giants' star linebacker who had turned dumping Gatorade on coaches into a national obsession, not the star defensive end from Wilson High who was caught up in a border dispute during the end of segregation in 1970.

These were nothing to me until August 1999, when Murray Glenn, the *Herald-Journal*'s cops reporter, told me in his classic southern drawl that I hadn't seen high school football until I had seen it on Friday nights in South Carolina. Murray was right. There is something about this sport in this state that transfixes people. Years later, Mike Fanning, the athletic director of the South Carolina Independent Schools Association,

explained it to me best when he said when you see stadium lights illuminating the darkened skies on Friday nights, it only means one thing. It's high school football.

I guess I had been silently collecting stories of South Carolina high school football for a decade before starting to write this book, and the credit for the actual writing goes to my good friend and fellow author, Robbie Goodall Boman. We were at a book signing together and discussing books we would like to write next. I mentioned I was thinking about writing a book on high school football (among other topics), and Robbie simply said, "You have to write that book." When I saw Robbie at a signing a month later, her first words were along the lines of, "Have you started that book?"

Here is that book.

ACKNOWLEDGEMENTS

Where to begin? I have worked with many great people during the course of this book as well as read the articles crafted by many outstanding sportswriters over the decades. The following is just a sampling—a minute of one game played—of the many writers and editors who began chronicling this great game in this great state long before I came on the scene:

Jim Anderson, Doc Baker, Ken Baldwin, Al Ballard, Bill Ballenger, Frank Ballenger, Paul Barrett, Alan Blondin, Frank Bolonkin, Tommy Braswell, Brent Breedin, Boyd Bridges, Barry Byers, Bob Castello (great writer, better friend), Richard Coco (still the funniest high school column pose in state history), Irvin Cribb, Bob Dalton, Mel Derrick, Doug Donahue, Mac Dover, Jim Fair, Dan Foster, Anthon Foy (we all owe him a lot), Bob Gillespie, Jason Gilmer (I doubt anyone loved covering high schools as much as he did), Fred Gonzalez, Chip Gray, Ron Green, Ray Guest, Abe Hardesty (Abe didn't write a lot about high schools, but I always stopped to read his columns while going through microfilm), Jeff Hartsell, Mark Hauser, Herman Helms, Mike Hembree (I didn't deserve to be in the same building with him), Buddy Hendrick, Charles Hill, Mac Howard, David Jones, Rudy Jones, H.E. Knight, Phil Kornblutt, Scoop Latimer, Tom Layton, Jim Maloney, Michael Mayo, Lonnie Morton, Ed McGranahan (he's forgotten more than I will ever know and still knows more than me), Bill Mitchell, John A. Montgomery, Ron Morris, Akilah Imani Nelson, Jim Noyes, Leslie Patterson, Gil Rowland, Charlie Sanders, Jerry Sanders, Steve "The Swami" Sanders, Bud Seifert, Don Smith, Sonny Smith, Willie

T. Smith, Charles Sowell (how a pulling guard from Strom Thurmond High could pick games so badly, yet write so brilliantly, is beyond me), Bob Spear, Leslie Timms, Ernie Trubiano (a gifted writer with a flair for humor), Woody White, Rip Wilder, Steve Wiseman, Jeff Worden and Bart Wright (a class act through and through).

CHAPTER 1

IN THE BEGINNING

The Origins and Early Years of High School Football

Football came roaring into the state when a team of Wofford collegians took on their already rivals from Furman on a fall day in 1889. The would-be Terriers beat the not-yet-named Paladins 5–1. Each touchdown was worth one point, so in modern parlance, Wofford would have won 35–7—a veritable rout. That inauspicious debut laid the groundwork for what is South Carolina's official sport. While the Wofford-Furman game is well documented, the first high school game is a little tougher to track down. Fritz P. Hamer, curator with the South Carolina State Museum, said high schools—mostly military and prep schools—likely began playing the sport sometime in the 1890s, but it was likely unorganized. High school games themselves started in the New England states in the mid-1870s. According to a November 28, 1940 article in the *Greenville News*, Clinton High School was playing Thornwell Orphanage as early as 1903, but records from that actual time do not list results, nor is there any other proof. But hometown pride wasn't the impetus for the sport's growth—it was the industrial revolution in the state, according to the *South Carolina Encyclopedia* (2006). The state economic recovery of the early twentieth century sent children from the fields and factories back into the classroom. Teen boys, especially, had free time. Add to that the sudden increase in public schools, and education officials looked for something for kids to do. The first effort at organization started in 1907, when a track and oratory commission was started in the Piedmont section of the state, according to the records of the South Carolina High School League (SCHSL). The SCHSL traces its

history to 1910, when F.E. Schofield, the director of physical education at the University of South Carolina, created a statewide track meet. That led to the formation of the Inter-High School Athletic and Oratorical Society in 1913 under the direction of R.C. Butts, and the group was basically an extension of the University of South Carolina.

At the same time, newspapers across the state started taking note of these high school games with rather short write-ups stashed away in the bottom of sport sections, which at the time rarely went beyond a full page in the fall and winter. Stories such as this one from the November 6, 1915 edition of *The State* were typical: "Rock Hill High School defeated Sumter High in a snappy game of football here 33–13. Both teams are strong and the game was closer than the score indicated." In a sign that things really haven't changed much in the past one hundred years, blowouts were common: Chester over Yorkville 46–0 in 1914, Heathwood beating Columbia 39–6 on the legs of a player named Toney, who scored four touchdowns, in 1915 and then there was Carlisle's November 26, 1915 whipping of Beaufort High at Rhoads Park in Bamberg. The final score was 144–0. It's doubtful that there has been a more lopsided score in state history. The account in *The State* gives few details other than it was 89–0 at the half and added that Beaufort was "outclassed from the start, the only point of interest was how high the score could get." In another sign of the organizational woes, Heathwood advertised in the October 7, 1916 *State* newspaper that any schools wishing to play it should contact school officials.

Through all of this, teams started to take delight in beating their opponents, and hometown pride soon came to the forefront. Ninety Six High School beat its rival, Abbeville, 24–0 in 1915, and *The State* noted that it now had the right to challenge any team in the state for the title. No mention of a follow-up game was made, but the November 27 edition of *The State* mentioned Porter Military Academy beating Bailey Military 32–13 for the state preparatory school title. It was obvious the seeds of something bigger were being sown. In stepped Dr. Reed Smith, who was described as a "close student of football" with a strong interest in the high school game. He pitched the idea to schools to hold a state title game in Columbia at the end of 1916, pitting the best squad from the Upper State and the best from the Lower State. The game was set up under the auspices of the University of South Carolina, and several hundred people—including ladies from the all-girls' Columbia College—were especially invited to see Florence High School beat Chester 33–14 at University Field. A short story in *The State* mentioned that Smith hoped to

make it an annual game. Almost one hundred years later, Smith's annual game has grown to six High School League title games and three South Carolina Independent Schools Association titles being awarded every year. Smith's idea of a title game wasn't revolutionary, and it is likely that it would have happened at some point without his intervention. But for all intents and purposes, Reed Smith invented modern high school football in the state.

THE FIRST DYNASTY

It is somewhat fitting that the first team to win the state's football title created a dynasty that set a standard that remains unbroken until this day. Florence High School—sometimes dubbed the Yellow Jackets or the Golden Tornado of the Pee Dee—won the first four titles. It is a record that has been tied several times but has yet to be surpassed over the generations. The team's name has been invariably dusted off over the years by high school scribes as teams have approached four straight titles and the lucky few who have vied for five and failed. The first Florence team was coached by a man named H.H. Painter and assisted by B.A. "Paw" Early, according to the *Florentine*, the school's leather-bound yearbook. Led by team captain Alston Wilcox Blount and with stars such as Herbert Timmons, Willie Holland and Charles Waters, the team rolled through its regular season schedule 9-0, outscoring its opponents 306–12. One of those victories was 88–0 over St. Matthew's. Others included 57–0 whippings of Charleston, 40–0 over Columbia and 36–0 over Bennettsville. The lone close games were a 12–6 victory over neighboring Darlington and 13–6 over the University of South Carolina freshman team. Yes, long before talk radio hosts filled the airwaves pondering if great high school teams could beat a college team and if a great college team could beat a pro team, Florence did just that. The season ended with the 33–14 victory over Chester, which according to *The State* had run undefeated across the Upstate. USC awarded Florence the Sylvan Cup, a jug-handled trophy that went to the winners during the first few years of title play. The 1917 team also would go undefeated in state play against public schools, including 85–0 over Bennettsville and 68–0 over Orangeburg, but it also dropped an 11–0 game to the USC "scrubs," or the freshman team, as well as a 27–0 game to Porter and,

The 1916 Florence team, shown here, won the state's first official state title, led by team captain Alston Wilcox Blount. *Courtesy of the Florence County Library South Carolina Room.*

Florence's trophy and game balls for winning the first two state titles. *Courtesy of the Florence County Library South Carolina Room.*

amazingly, a 48–0 match with Charlotte, North Carolina. Again, when people complain about high school teams playing out-of-state opponents nowadays, it shows this is nothing new.

Florence righted itself in time for the state title game with a 40–0 win over Winnsboro and a second Sylvan Cup. Florence—now coached by Hoyt Wilson—also won the Ragsdale Trophy as the champion of the Pee Dee due to its 7–0 victory over Darlington. A new coach, W.L. Booker, came on board for 1918, and an abbreviated schedule was played. Florence went 3-0, outscoring opponents 63–0. USC awarded the team the state title. The Yellow Jackets capped the dynasty in 1919 with yet another coach at the helm, R.E. Browne Jr., and an 8-0 record. The team gave up just 10 points, but the victories were not nearly as lopsided. The biggest were 25–0 over Mullins and, later, Orangeburg by the same score. Florence again won the state title without a playoff because USC officials found no clear Upstate winner. The new decade, though, brought changes. The team moved to a modern field on South Dargan Street in downtown Florence, but brought few experienced players. Many of the stars of the 1919 team graduated, including Waters, who had been captain of the 1918 and 1919 teams. The *Florentine* from 1921 summed up the 1920 season by saying, "The victories were not as evident."

THE ROARING TWENTIES

While Florence floundered, Charleston, Chester and Columbia rose up in 1920. A certain color was coming to the fall sport. Teams rode by train to away games, and it was common for fans to rent out special trains to go to big games. Newspapers such as *The State* began running almost daily columns from Sol Metzger, who answered questions about the game ranging from the rules on the forward pass to punting to defensive formations. The games were officiated by two men, sometimes chosen at random from the spectators or college football players called the day before because they knew the rules. Crowd levels began to grow. Some two thousand people watched Columbia beat Florence 26–0 in November 1920, signaling the rise of a new state power. Columbia's run was aided by a strange game on November 20 against visiting Camden. Leading 12–7 in the third, a commotion broke out at midfield between the Camden coach, the referee and the umpire. The referee—listed as Stubbs—ended the game like "a proverbial thunderclap"

and awarded a 1–0 forfeit to Columbia. It wasn't until two days later, though, that the cause of the commotion was made public when a letter from a Camden fan named John M. Villepique was printed in the November 21 *State*. Villepique admitted that Camden had not been playing well but said the trouble started with a Columbia fumble. The umpire, Jack Watkins, who had played quarterback at the University of Richmond, said the ball was recovered by Camden. Stubbs ruled it was Columbia, and Watkins left the field to find Camden's coach. Columbia then scored, and the Camden coach pulled his team in protest.

As good as Columbia was, though, Charleston was better. Then known as the Bantams and led by coach Carl Prause, Charleston was awarded the 1920 title and pounded Chester 34–0 in the 1921 title game and then Gaffney 48–0 in 1922—three days before Christmas, which makes it one of the latest dates the state title game has ever been held. They also beat a team from Peabody, Massachusetts, 13–6 in a 1921 exhibition in front of five thousand people. The Bantams' reign would come to an end in 1923, and they never would be able to replicate it.

SCANDALS AND MORE

High school football was growing. On November 1, 1923, *The State* ran an almost prophetic piece speculating how long it would take for football to overtake baseball as America's pastime. A pencil sketch showing a packed bowl stadium with screaming fans, pennants and balloons accompanied the article. High schools and stories began to grow in sports sections across the state by mid-decade. Papers carried play-by-play accounts of major games, and previews were printed throughout the week that included things such as players' ages and numbers. Actual statistics were rare, but many players were described by their athletic attributes. Linemen often received more credit than the players who scored. The preview of the 1923 state title game in *The State* gave the back stories of the players, the time they woke up each morning and the number of living parents for the players from the Thornwell Orphanage in Clinton. (And people say the Internet examines high school players too much now!) All-Star teams came into vogue, including an "All-Southern" team created by Red Davis of Florida starting in 1921.

All of this led the High School League to start examining where and how schools were getting players. In late November 1922, a committee made

up of Abbeville's J.D. Fulp, Honea Path's L.L. Wright and Anderson's T.L. Hanna met to discuss potential rule infractions. That list included a Rock Hill player believed to be more than twenty-one years old (his mother gave an affidavit saying he was twenty, which was apparently okay back then); another Rock Hill player who had received money to play baseball; and a third Rock Hill player who was enrolled in two schools. Rock Hill had to forfeit two games because of that. Chester also forfeited two games after it was discovered that a player was getting room and board from an unknown person to play for the school. Similar meetings and rulings would occur throughout the decade.

Things also were turning ugly at games. In the aftermath of a December 1922 game between Columbia and Charleston, the Bantams' Teddy Weeks said he heard Capital City fans chanting for the opposition to kill him. After Weeks was kicked in the head in the third quarter, fans stormed the field in anger. Order was restored, but after the game, Charleston players said Columbia fans jeered at them as they cleaned up at the local YMCA and then hurled eggs at their train as they left for home. And people say Internet forum posters are tough.

Finally, in November 1928, the state board of education made a somewhat curious announcement that while athletics were a good thing, it appeared the emphasis was going too much toward football. The game was starting to "obscure the fundamentals." There were no apparent moves to rein in the sport at the time, and the issue appears to have died rather quickly. Football was already out of its cage and unstoppable.

The Strange Road to the 1922 Title

Charleston whipped Gaffney in the title game 48–0 as they "outran, out passed and out kicked" their weary opposition. How weary? Gaffney had played the Upper State final on a mud-soaked field on a Friday against Thornwell, which ended in a 0–0 title. Gaffney's officials were given the options of letting Thornwell have the crown, playing another game against Thornwell on a Saturday and forfeiting the state title to Charleston or playing a Tuesday game at a field of Thornwell's choosing. They opted for the third and beat the "Orphans" 32–14 at Greenville's Manly Field. On a side note, this game was likely one that would have warmed the hearts of future proponents of passing, such as Sid Gillman, Dan Coryell and

Mike Martz, as Thornwell, which was unable to move the pigskin on the ground, threw thirteen straight passes at one point for 194 yards and two touchdowns. Gaffney, though, was unable to muster enough strength against Charleston three days later.

The "Tradition"

The 1920s brought about the state's first true heated intersectional rivalry. While Darlington and Florence, Columbia and Charleston, Greenville and Parker and Porter and Bailey were becoming major battles for bragging rights, none had the gravitas of Gaffney and Columbia. The two schools' fan bases built a heated dislike that could only be created through the intimacy of playing the state title game against each other six straight seasons. *The State* dubbed the annual battle "a habit, almost you might say, a tradition" just before the 1929 game. The first game came in 1924, when Gaffney came in 8-0 and outscoring opponents 279–14, but as hard as it is to believe, Columbia was better, with 256 points scored and not a single point allowed in eight games. Coached by Henry Lightsey, Columbia rolled over the Indians 37–0 in front of a then record four thousand people at University Field. Columbia outgained Gaffney 285 yards to 51 and first downs 18–2. It was more of the same in 1925, when Columbia routed Gaffney 24–0 at home in a game refereed by then Furman star (and future Greenville coach) Speedy Speer. It was a little closer the next year, 25–11, but Gaffney fans were getting angry.

On November 28—about a week before the title game—fans complained to their board of trustees that the game was unfair because it was always being played in Columbia, whose high school team was dubbed the Notre Dame of the southeastern high schools for its football prowess. Coincidentally or not, the 1927 game was played at Wingate College (the first time a state title game was not played in Columbia), and Gaffney broke through with an 8–0 victory thanks to a thirty-five-yard touchdown run by B. Clary and a safety. The 1928 game provided the first true nail-biter in championship history, or as *The State* put it, "excitement is no respecter of persons." Gaffney built a 20–0 lead heading into the fourth quarter, but Columbia rallied with two quick touchdowns and put on a long drive with the seconds winding down. Gaffney's defense stiffened and stopped a fourth-down plunge on the six-inch line. Gaffney coach L.F. "Scaley" Carson decided to punt the ball instead of

Columbia High dominated the game in the mid-1920s, winning three state titles, led by All-Southern end Louis Gilliam. *Courtesy of the Richland County Library.*

risking an offensive play from his own end zone, and the game ended. More than one thousand fans (many of whom had chanted "Beat Columbia" in Columbia during the week), including Limestone College coeds, greeted the Indians' train when it pulled back into Cherokee County. The celebration lasted until the early hours of the morning.

Gaffney returned to the title game in 1929 led by star Earl Clary in the midst of one of the greatest individual seasons in state history, following a 44–0 drubbing of Greenville in front of five thousand people the Upper State title game, while Columbia got in with a 37–7 victory over Charleston. The Indians, who by this time sported jerseys featuring the profile of a Native American in full feathered headdress, outslugged Columbia 20–14. Clary capped his season with an interception and two touchdowns, including one on an eighty-yard run.

THE GROWING GAME

There were 30 teams in the High School League in 1920. That number reached 121 by 1925. That kind of growth meant league officials had to get organized. It was decided to create a "district system," which was basically

the forerunner of the current region format. Teams from nine districts would play for their individual title in 1925 and then settle into a series of playoffs to get to the state title game. It was a perfect system—except for one problem. Leaders at the smaller schools complained that they were being left in the dust by the bigger schools such as Columbia, Charleston, Gaffney and Greenville. There was no way for them to win a title with those behemoths around. It was decided to split a select number of larger schools for the 1926 season to compete for an "A," title and the rest of the teams would continue in the district format for the "B" title. Because of the lower number of schools, the Class A squads played an ad hoc schedule based on winning percentage against at least four A schools. Mullins and Thornwell survived this new format to become the first B combatants at Melton Field in Columbia on December 9, 1926, and they came there in style. Mullins's eighteen players, two coaches, manager and Mayor Ransom Williams stayed overnight at the posh Jefferson Hotel downtown. Thornwell, coached by volunteer Lonnie McMillan, came down the day of the game on a special train so his players could sleep in their own beds. It is the first recorded hint of sports psychology in state high school athletics, and it worked for Thornwell. Senior All-Southern selection Earle Dunlap scored four touchdowns in the 34–18 victory.

Florence players in action in 1919. Note the lack of stands, which was common at the time. *Courtesy of the Florence County Library South Carolina Room.*

Meanwhile, in the Black Schools

It would be decades before the end of segregation, but black schools also started playing football in this era. Not to be outdone by their white counterparts, school officials began putting together title games. According to the December 7, 1928 *State*, Booker T. Washington of Columbia hosted a same-named high school from Atlanta for the southern title. The Georgians beat the Palmetto State squad 25–13. In 1929, Booker T. Washington beat Florence's Wilson High School 31–6 for the state black title. However, weekly scores and results were often hit and miss in most of the major papers, even as coverage of the white schools grew to include photos of players and coaches as well weekly columns (including the *State*'s "Hi-Lights") touting the growth of the sport.

Some Things Never Change

One of the beauties of high school football is the bonhomie that is built amongst teammates who spend those long, grueling practices in the sun, rain and cold, suffer agonizing defeats and share victories. Friendships and grudging respect is built, as well a certain sense of silliness. Nicknames and goofing on one another's strengths and weaknesses is part of the culture of the locker room. Apparently, it has been around for a long time. The 1916 Greenville High team (according to that year's annual) dubbed quarterback Luther Miller "Pretty Boy" (geez, even then quarterbacks got a bad rap), William Hammett was "Babe," tackle Arthur Gaines was "Grouchy" and Raymond Stansell was "Lady Killer" because of his "fame at calling girls and signals." Other great nicknames of the decade include Columbia captain "Stick" McCarley because of his hitting ability, while some of his teammates included running backs dubbed "Worm," "Speck" and "Bubber."

Columbia coach Henry Lightsey had one of the greatest starts to any career in state history. He took his aggregation to the 1923 finals and then won it all in the next two years. In the euphoria of the second title, he was asked his coaching philosophies and likely gave the first clichéd interview. He said he had his teams pray before games—not for victory, but for courage.

Greenville High's 1916 team returned football to the Upstate school for the first time in years. *Courtesy of Greenville High School.*

STATS, STORIES AND STARS

Columbia High School did not give up a point to an in-state school from the end of the 1923 championship game until the 1926 Lower State finals against Porter Military, when a cadet named Crill scored a two-yard touchdown in the third quarter.

Governor John Richards dropped by the Jefferson Hotel following the 1927 B title game to commiserate with the losers, Lancaster High, who had dropped a 2–0 game to Batesburg-Leesville. An early version of a pol trying to getting votes? Not likely. State law at the time limited governors to four years in office. The 2–0 Batesburg-Leesville victory is the lowest score for a title game in state history.

Gaffney's Earl Clary—later dubbed the Gaffney Ghost by Columbia wags during his time on the USC gridiron—scored twenty-four touchdowns in seven games in 1929. That included six at Lockhart and five at Greenville, as well as the two in the title game. Greenville's Charles Galloway must have

taken notice when they played Gaffney, because he scored five touchdowns against Anderson later in the season.

While Friday night is often associated with football now, that was not quite the case in the early days, as teams often took the field on Wednesdays, Thursdays, Fridays and Saturdays. And sometimes more. In 1929, Parker High in Greenville played a game on Friday at Laurens (a victory) and Saturday at Anderson (not surprisingly, a loss).

The 1926 Columbia team was apparently extremely respected throughout the Southeast following its 10-1 season. Teams from Tennessee and Georgia challenged it for a "Southern Championship" before a game was played against Richmond Academy in Augusta on December 12. The Columbia eleven (to steal a phrase from that era) lost 23–0.

Chester High had one of the decade's hipper emblems—a large block C with an isosceles triangle pointing upward over it. In addition, the people of Chester gave coach William K. Magill a new car for his work in leading the team in 1921.

Zemp Stadium opened in 1929 as the home field of the Camden football team. Named after Blake Zemp, one of the school's most famed supporters in the early years, the stadium is still being used by the Bulldogs as of 2010. That makes it the oldest in-use high school field in the state.

THE 1930s

*There's an Economic Depression,
but Not a Football One*

It's hard to fathom life in the 1930s through the prism of modern America. Never in the country's history was the jobless rate so high for so long, and the feeling that things were never going to get better was a way of life.

The Great Depression played out on the football field in ways that are easier to describe but much larger to comprehend. The disparity of the times led to one of the state's greatest dynasties at a school that swelled its numbers because of lost jobs and deaths. In the midst of the economic decay, the game's single most famous game was born as a fundraiser for sick children. The game itself also provided an outlet for young men. Heading into an uncertain future, they could put on primitive pads and seek glory on the playing field. For some it was the apex, while others used the sport to get athletic scholarships that, in theory, would lead to a better life. For one, the Depression meant a series of moves that landed him on a state championship team and later a destiny with the Nobel Prize.

The decade saw the game continue to grow but in somewhat odd ways. In 1930, the High School League stopped scheduling a Class A playoff system, instead awarding the crown to the team with the best record. It immediately led to confusion, as the league named Columbia the 1930 champion, while Spartanburg declared itself the best, according to *The State* of November 2, 1930. The two teams tried to play a charity game to settle the score, but Spartanburg coach Red Dobson declined, saying the season was over.

Two years later, though, the High School League added a third tier of the football system. Schools with more than 400 students would play in Class

A, teams between 101 and 399 were Class B and the rest were in Class C. The first Class C title game featured Ninety Six and Sardis but was hardly a success, as fewer than 200 people attended at Columbia's Melton Field. It was a strange game, as at least two players went without shoes, there were two Statue of Liberty plays and Ninety Six won 15–0 on the strength of a teen named Free, who received a cup for being player of the game, according to the December edition of *The State*. Surprisingly or not, there was no follow-up Class C championship in 1933, but the game was returned permanently in 1934.

THE ATTACK OF THE CYCLONES

"Each last game has a sad tinge even though it be a glorious victory."

This little line of doggerel was credited to Boyd Morrison, a member of the Chester High class of 1933, but the phrase appears unattributed several times in Great Depression–era Chester High yearbooks describing the final game of the season for the Red Cyclones. The idea was that the final game for seniors meant the last time pulling on their familiar red-and-white jerseys with the large C on the front, and that was a final moment in the sun regardless of the final score. Of course, few Chester seniors experienced a final loss—or any loss at all—during the school's historic run from 1930 through 1936. The Red Cyclones (the Red wouldn't be dropped until 1970) went 48-2-3 in that time, which included four state titles, two runner-up finishes and a 27-game winning streak. The dominance actually began in 1928, when Newberry native Lawrence Spearman arrived on campus in this tiny textile town seventeen miles southwest of Rock Hill to teach chemistry and coach football. The Red Cyclones lost the 1928 B title game but came back with a 12-0 record in 1929, including a 6–0 victory over a powerful Johnston High team where they "stashed, plowed, slipped and slid their way through the red mud" to victory.

After losing nine seniors from the 1929 team, Spearman's boys started the 1930 season with a 19–0 loss to Union, but any thoughts of a poor season were quelled the next week with a 60–0 victory over York High. This was the first of six straight shutouts before a wild 32–32 tie against Camden. The Camden game was a playoff game, and apparently the High School League didn't have a mechanism to handle ties at the time. So the playoffs

Chester players catch a breather in a 1936 game. *Courtesy of the Chester County Library.*

were redrawn, but more importantly, it woke up the rest of the state to the fact that Chester was a power. In the new playoffs, Chester beat Dreher and Rock Hill 13–6 each time and then 7–0 in a rematch against Camden, whose abilities on the field were aided by "the subtle tricks of experience," according to the Chester yearbook. Marion came out of the Lower State as champion, but should have stayed home rather than get whipped 47–0 by the Red Cyclones in the final.

After the season, William Martin, a team captain and starting halfback, willed continued gridiron success to his teammates in the future. Martin looked prophetic as the Cyclones went 6-0 in the regular season following a two-week preseason camp where donations from fans allowed Spearman to haul about twenty-five players into the North Carolina mountains for conditioning drills. They needed that extra training in the playoffs, when they played six games—or the same as the regular season schedule. The extra-long postseason came about because the High School League changed the playoff rules after the strange 1930 rescheduling. Tie games would be replayed within a few days. Chester tied Brookland-Cayce in the first round 6–6, but won the follow-up 7–0. The Upstate finals lasted

three games, as Thornwell tied the Red Cyclones 0–0 twice and then fell 13–0. By that time, Chester had played three Upstate title games in eight days and had gone past the official date for the state title. The High School League awarded Camden the title, but the Bulldogs refused and said they wanted to play Chester in a real game. Scheduled for Christmas Day 1931, Camden beat Chester 32–7 in what was dubbed a "memorable" game for years to come.

Success was catching up with the Red Cyclones, and the roster ballooned to thirty athletes in 1932. The result was the same as Spearman's squad and went 13-0, which included 2 forfeit victories

Lawrence Spearman coached Chester to five state championships in the 1930s. *Courtesy of the Chester County Library.*

and 7 other shutouts. While the title was a 12–7 victory over Camden, Spearman called the 13–7 victory over Thornwell in the Upstate finals "its best game of the season." More growth led the High School League to bump the Red Cyclones to the A division in 1933, but with two hundred boys, Chester was easily the smallest school in the classification. Chester rolled to a 9-0-1 record and did not allow an opponent to cross the goal line all season long. A 42–0 crushing of Rock Hill "bore with it the joy of kicking in an old foe," according to the Chester yearbook, which is known as the *Centrian*. The lone blemish was a 0–0 tie against Gaffney in which the Red Cyclones dominated defensively (they held Gaffney to two first downs and twelve yards from scrimmage) but failed on offense, including getting down to the Indians' one-yard line late. However, because Class A football did not have a playoff, the Red Cyclones took a championship backseat to an undefeated Columbia team. It should be noted that Chester officials did try to schedule a championship against Columbia but were denied. Chester fans, though, did not pout. They celebrated the team led by quarterback Harvey Castles, halfbacks Gene Robinson and S.W. Hopper and a line that included Bill Nunnery, Tom Gregory, John Holder, Charley Porter, "Fat" Ramsey, Tom McLure and Jimmy Weir.

The 1934 team went 7-2-1 but came back with another undefeated team in 1935 (9-0). The five-foot eleven-inch, 142-pound Robinson was named All-Southern for the second straight season. He scored forty-one touchdowns and connected on ten extra points for his career, according to that year's *Centrian*. The 1936 team again went to camp in North Carolina and started the season blasting Woodruff 45–0 and Union 44–0. The next two games were played under floodlights in Orangeburg (a victory) and Columbia (tie), and then a road trip to Florida to play the Miami High Stingarees. Chester won 2–0 and then rolled through the next six games, leaving goose eggs on the opponents' scoreboards. However, a state title was not clinched until Sumter upset an undefeated Charleston team. The dynasty's final gasp came in an 8–0 loss to Asheville High for a mythical four-state championship. Spearman left after the 1936 season, and the 1937 squad went 4-6. One note on the 1937 team—they were shut out in their six losses and blanked opponents in their four victories.

ON THE CUSP OF HISTORY

Six points were all that separated one special team from winning six straight state football titles—a feat that, if accomplished, would have forever ended any debates as to which was the greatest football dynasty in South Carolina history.

However, while fans of Chester, Summerville, Woodruff, Gaffney and others still puff out their chests and crow about hometown pride, this school's fan base is scattered and almost forgotten. The team was Epworth Orphanage, a Methodist-run facility for children that exists today as the Epworth Children's Home. Chris Wright, a school historian, said football started at the school in the 1920s, but it was more of a pickup game and was a distant second in popularity to baseball. However, the success at Thornwell Orphanage, coupled with a new superintendent named W.D. Roberts, changed the way the school looked at football, he said. Roberts stressed education and activities, and football became a top sport.

The State's Kent Babb discussed the team in a December 2, 2007 article:

> *They were picked up from the state's far reaches. They were dropped off at a sprawling campus in east Columbia, some against their wills and some with no idea where the road would end. Orphans, they were called. They attended Epworth Orphanage, a Methodist boarding school for hundreds of*

The 1930s

South Carolina children in the first half of the 20th century. Epworth was one of four church-supported orphanages in South Carolina. Epworth's students were from broken homes, and each student had at least one deceased parent. The school accepted children of all ages and had separate living quarters for girls and boys, as well as its own high school. It was too much for some. Many were banished for breaking rules. Some ran away. Others played football. Those who played in the 1930s formed one of South Carolina's most dominant yet unlikely dynasties.

Coached by Ernest Cornell, the Epworth team—dubbed, sadly, the Orphans—won Class C titles in 1934, 1935, 1937, 1938 and 1939. The missing year came due to a 6–0 loss to St. Paul's in the finals. Players described the team as a tough club held together by a disciplinarian staff. The players' backgrounds differed but were often tragic. One former player—a star on the 1939 team—told Babb that his father had been killed by a fellow farm friend with a plow stop in an argument over politics. The player surmised that those things sort of happened in the bad times of the 1930s.

"They were somewhat of a bunch of rag-tag boys who had gone through some rough times," Wright said. "They were put together for a lack of a better explanation that they had something in common."

They practiced and played home games on a flat patch near the campus dining hall. They wore hand-me-down uniforms from the University of South Carolina with leather helmets that players could fold twice and tuck into their back pockets when done. Exact records are hard to come by, but some of the players interviewed by Babb said they don't recall ever losing a game, but most admitted they didn't play on the 1936 team.

According to the December 5, 1936 *State*, Epworth hosted St. Paul's—a small school from outside Charleston—at Columbia's Melton Field downtown. St. Paul's scored on a desperation plunge from the one-yard line late in the third quarter. The Orphans, whose star quarterback was knocked out of the game, could not score. It should be noted that except for a few plays against Brookland-Cayce, all eleven starters played every minute of every game that season. It was a hiccup in the dynasty, but this was not a program made to last. The trophies, as far as anyone can tell, cannot be found, Wright said. While there are many photos of students, graduations and activities from the school during the 1930s, few exist of the football team. Wright, who has interviewed numerous players over the years (and invariably calls them boys because, even though they are octogenarians, they are talking about their youth), has only tracked down a handful of newspaper photos and no originals from the heyday.

The earliest original he can find is from a 1940 All-Star game that included Epworth players Troy Wadford, Hal Leonard, Milton "Buck" Hodges and Albert Smith, who would die a handful of years later as a paratrooper in the Netherlands. Football was phased out after World War II, as many of the older students began attending Dreher High, which coincidentally or not became a state power in the 1950s.

"I would assume based on what I've heard that it had a little bit to do with it," Wright said.

THE SMARTEST GUY ON THE FIELD

It is barely a footnote in state football history. Orangeburg played Rock Hill in the de facto 1931 Class A state title game when star lineman C.J. Inabinet was tossed from the game after throwing an errant punch at an opposing Bearcat. Coach Bru Bouineau called in one of his top reserves, a 150-pound youngster named Robert Furchgott.

Highway Patrol captain J.C. Pace told the *Orangeburg Times and Democrat* in October 2006 that he remembered the situation well. "Little Robert Furchgott did an admirable job coming off the bench to help Orangeburg win the game. He did a tremendous job."

Furchgott also recalled the game as being one of the highlights of his somewhat transient high school days. Of course, Furchgott had more than Xs and Os on his mind in 1931 and again when he discussed the game after winning the Nobel Prize in Medicine in 1998. At age eighty-two, Furchgott became one of the oldest recipients ever to earn the award named for the inventor of TNT. A pharmacologist by profession and a graduate of the University of South Carolina, Furchgott had discovered that blood vessels dilate because the surface cells (the endothelium) that line the inside of the vessels produce an unknown signal molecule that makes vascular smooth muscle cells relax. Furchgott didn't know the identity of the signal molecule that made the cells relax, but he named it EDRF, the endothelium-derived relaxing factor. Later research based on his work honed in on the molecule like a safety chasing down a wobbly pass, and new theories were formed on what caused cells to relax. The Nobel Assembly stated that the discovery eventually will lead to drugs for atherosclerosis, defenses against cancerous tumors and blood pressure control in intensive care situations, among others. Right now, though, its biggest draw has been Viagra.

An Inauspicious Debut

Felix "Doc" Blanchard is one of the most famous athletes in South Carolina history. The 1945 Heisman winner at Army, he was one of the most celebrated football players of his era with collegiate backfield mate Glenn Davis. Despite offers of almost $50,000 a year to play professionally, the Pentagon would not let Blanchard play in the NFL. Instead, he went on to a distinguished career as a fighter pilot.

A native of Iowa, he spent most of his formative years in Bishopville, and that is generally considered his hometown. However, he played four years of his high school football career at St. Stanislaus Academy outside New Orleans, and many believe he never played a down in South Carolina.

Not so, according to Fritz P. Hamer and John Daye's *Glory of the Gridiron*. Blanchard made the Bishopville High varsity team as an eighth grader in 1937. In a game against Bennettsville, Blanchard was thrown in at linebacker for his football debut. On the first play, Bennettsville scored a touchdown by running directly at him.

It wasn't the greatest start to a football career, but few South Carolina athletes ended up with a resulting career like Blanchard did.

Some Things Never Change

Recruiting has always been a strange business. Fans always wonder what a player "got" to sign with a certain school over another. Tales of cute coeds gushing around modern players and coaches offering sweet deals are common but not that new, as the *Charlotte Observer*'s Jake Wade noted while waiting for the start of the first Shrine Bowl in 1937. College coaches descended on the practices en masse, and many of the players looked forward to a free college education if they performed well. But free came with a price.

"They will have to pay for it with work around the schools, which is not always ringing the chapel bell, and with work on the gridiron, which is a very trying form of play, my friends," Wade wrote.

Wade went on to note that many people still believed that college athletes were some pure and noble standard. That players simply arrived on campus and came out for the team.

"The truth of the matter is, as any high school boy will tell you, these scholastic stars are sought after, recruited; arrangements are made for

them to get their education. To this bureau there is nothing wrong with the practice. As voiced here before, the wrong is in pretending the situation does not exist," he wrote.

Another common recurrence from that era that remains is out-of-state games. For example, the Columbia High team that won the 1930 Class A title played teams from Asheville, Atlanta, Charlotte and Savannah in its eight-game schedule. The 1931 Spartanburg High team played postseason games in Charlotte and Miami.

NOTES FROM THE SHRINE BOWL

Who started the Shrine Bowl? That depends on who you ask, who you believe and who's telling the story. Walter Klein gives no less than three origin tales in his history of the game, entitled *Bowl Full of Miracles*.

The official version starts with Bill Isenhour Jr. sitting around the Red Fez Club in Charlotte decades ago and listening to two old Shriners named Hix Palmer and Ernest Sifford both take credit for the start of the all-star game that has been the litmus test for numerous generations of high school football players. There have been other all-star games in the state, but none carries the weight of the Shrine Bowl.

Isenhour's version of events, as detailed by Klein, state that Palmer and Sifford first came up with the idea after hearing stories of how well the East–West Shrine Game in San Francisco was raising much-needed Depression-era funds for the Shriners' Hospitals for Crippled Children. They believed anything that could work in California could work in the Carolinas—if not work better. They approached a local North Carolina coach named Bob Allen to get his insight. Allen was not enthusiastic, noting that other all-star games hadn't been successful. However, he agreed to talk to some Charlotte officials over the winter if the Shriners set it up. According to a December 20, 1997 article in the *Charlotte Observer*, many North Carolina principals also doubted the game would succeed. Allen told Klein he thought he had heard the last of the game until the local fire chief strolled in from the cold in February 1937. He wanted to organize the game. They approached the Oasis Temple, and history was born.

Maybe.

Klein also recounted the story of Robert Sides, who claims that his brother L.R. Sides was the main man behind the event. L.R. Sides was a

local radio personality, as well as director of music for the city schools and director of the Oasis Temple band. Klein gave little other information to back up Sides's claim other than that he "worked the plans out to fruition for the first game."

However, Klein then went on to add that it was Palmer who came up with the entire idea and that the then potentate of Gastonia, J. Sidney Wingate, appointed Sifford as the game's first chairman and Palmer as vice-chair.

Regardless, the Shriners in the Carolinas took to promoting the game quickly. F.A. Haunsek put the first program together that included letters of greeting from South Carolina governor Olin Johnston, superintendent of the Greenville Hospital Luella Schloeman and W. Freeland Kendrick, chairman of the hospital board. They printed twenty-five thousand faintly blue tickets (donated by the Pure Oil Company of the Carolinas) under the original name of "North and South Carolina High School All-Star Championship Football Game." It was to be played at American Legion Field in Charlotte on December 4, 1937, with a kickoff of 2:30 p.m.

However, they sold fewer than 5,500 of those tickets. It would be a tough sell for a decade. The first few games were rather drab even by the low-scoring standards of the 1930s. The first game was a 0–0 tie played in front of a sparse crowd. Easley's James Brice coached the inaugural team. The 1938 game was a 19–0 victory for North Carolina, and the 1939 game was won by the Sandlappers 12–0. Parker's Ansel Bridwell scored the Sandlappers' first-ever touchdown on a seventy-seven-yard punt return. Bridwell scored early in the third as well on a three-yard touchdown plunge. Sid Tinsley of Spartanburg played in the first two games and, decades later, would officiate the coin toss in 2004.

The original team had twenty-two players who took part in a sixty-minute game. As opposed to the coaches, sportswriters picked the original team, which included a handful of juniors: Greenville's Buster Adams, Bill Byers, Marion Craig and Walter Payne,

James Brice led South Carolina to a tie in the first Shrine Bowl. The Easley football stadium would later be named after him. *Courtesy of Easley High School.*

Spartanburg's Tinsley and Camden's George West. Only five other juniors would be selected to the game in the later years, and none has been honored since 1947. In 1939, high schools would be limited to placing two men on the Shrine team, which was seen as a way of expanding the game throughout the state.

However, the games were an apparent financial success—or at least did well enough that no one saw a reason to stop. The first game raised $2,800 for the hospital. It is well past $50 million all-time now. The Shriners had done their job.

STATS, STORIES AND STARS

Pete Tinsley was one of the youngest players ever to take the field in state history, starting on Spartanburg's offensive line as a seventh grader. He played collegiately at Georgia and then spent almost a decade with the Green Bay Packers, winning two NFL titles as a two-way guard. He is enshrined in the Packers' Hall of Fame.

The 1936 Class C title team from Ninety Six gave up a somewhat appropriate ninety-eight points while going 7-0-1.

Coach L.F. Carson laid the groundwork for the winning Gaffney tradition in the 1930s. *Courtesy of Gaffney High School.*

Spartanburg High's Gus Hempley became one of the state's first players to ascend to the NFL. The 1937 graduate later played for the University of South Carolina (he famously got a pass from his military obligations to play in the 1941 Clemson-Carolina game and led the Gamecocks to victory) and then with the Chicago Bears.

General Joshua "June" Pruitt Jr. scored the first touchdown at the "new" Greer High Stadium in the city's downtown area in September 1938 against Seneca in front of two thousand people. Pruitt went on to star with the Clemson baseball, basketball and football teams. He was a South Carolina Coaches All-Star for three straight years as a Clemson wingback.

The Parker-Greenville game began to take on added importance as the decade wore on. More than thirteen thousand people watched the 1939 game as Greenville upset top-ranked Parker 21–0 behind a 155-yard rushing effort by Monty Byers.

In 1939, Gaffney became the first school in the state to permanently install lights on its field to hold night games.

CHAPTER 3

THE 1940s

War On and Off the Field

For most of the decade, high school sports were almost an afterthought, even in South Carolina. World War II took its toll on the game, as seniors often had to choose between the gridiron and patriotism on the fields of Europe or the islands and waters of the South Pacific. At one point in the mid-1940s, the High School League dropped its football playoffs, in part out of lack of interest and partly out of rationing. Holding playoff games took a back seat to the war effort.

But the end of the war brought a renewed interest in the game. Returning soldiers took to the gridirons as coaches who began shaping young men who had grown up in a world marked by depression and war. It was a tough group coming up in the 1940s—a group that would forever change the way the game was played. The game took a honed focus among many South Carolinians looking for a new retreat from those dark years. The 1941 Shrine Bowl drew twelve thousand fans, while ninety miles away in Greenville, an all-star game pitting top college players from the Southeast drew seven thousand on the same day. The Shrine Bowl drew twenty-five thousand in 1945. A little more than twelve thousand people filled the stands when Greenwood and Parker squared off in October 1949—just a few weeks after Clemson University had set a new attendance record of twelve thousand. The 1949 Thanksgiving game between Parker and Greenville drew twenty thousand fans. Teams routinely went out of state, with throngs of fans driving along to support them at games in Tennessee, North Carolina and Florida.

High school football had become the state's great pastime—the rallying point for communities looking ahead. But it was not always a happy rallying point. Anger and animosity started to sweep into the stands on Friday nights or, as Darlington superintendent Ralph Barbare called them, "dirty rooters," in an angry letter to *The State*'s sports department on November 23, 1946. Barbare said that too many drunks were taking over. Other newspapers reported fans shooting firecrackers off in the bleachers. On November 21, 1945, the *Greenville Piedmont*'s Gil Rowland called these kinds of people out. "There are probably several hundred persons who can scarcely wait for the big game so they can make jackasses of themselves," Rowland led off with. He then brought in the heavy ammunition by describing how someone could be a pain at the game: Wear loud clothes. Drive their cars fast and honk their horns while going to the game. Dump used peanut shells down the backs of women's shirts. Rush the sideline and "after the game, be sure everybody sees your attempts to dent a few fenders."

In November 1945, a man named F.M. Morse wrote *The State* that the game was growing too fast and people were losing their focus on the importance of education. He also wondered if some schools were using ringers—i.e., players who were not academically able but were physically skilled—to get wins on Friday nights. "The problem of high school sports will become more acute and high school sports will tend to follow the college pattern of getting bigger and better in order to win at any cost and to be a detriment of amateur sports," Morse wrote.

Morse may have had a crystal ball.

A Novel Idea

It wasn't a conspiracy, but when a group of high school coaches huddled in the Field House on the University of South Carolina campus on a cold January day in 1946, they were essentially changing the face of high school athletics in the Palmetto State forever. With Dwight Keith, who was the secretary of the Georgia Coaches' Association, giving them advice, the South Carolina Athletic Coaches Association was born with about fifty members. The basic idea, which holds true to this day, was to give coaches an outlet to share ideas, help one another and promote the game. More than sixty years later, the idea has been a success, as more than five thousand members support the organization. The group has awarded more than $520,000 in

scholarships and sponsors all-star events in football, basketball, volleyball, wrestling, tennis, baseball, softball, soccer and golf. It started a Hall of Fame in 1993 that has honored the best in all sports.

The annual high school football all-star game was added in 1948 as part of the innovation, a game which the Lower State won 7–6 with Sumter's Larry Weldon as the winning coach. But it really wasn't a unique idea, as several all-star games already dotted the high school landscape, including the Tobacco Bowl, Lions Bowl, a game between Greenville and Spartanburg schools' seniors, games between the varsity and alumni at various schools, one where the best of the state took on a team of Columbia-area all-stars and a game alone for Pickens County all-stars. Full teams also ventured out of state for special games, such as Rock Hill playing Central Charlotte in the Jaycees Carolina Bowl following the 1947 season.

The second coaches' clinic featured talks by West Virginia basketball coach Lee Patton and Carl Snavely, the gridiron coach at the University of North Carolina. By that winter, many people believed that the coaches' association, which the Greenville Piedmont opined was "the best thing to happen to high school coaches in many, many seasons," would be the force that would finally bring about a playoff system for all schools.

Somewhat amazingly, the organization has had only four executive directors: Harry Hedgepath, Bettis Herlong, Keith Richardson and the current executive director, Shell Dula. Combined, they won fourteen state football titles as head coaches ranging from the 1920s to the 2000s.

THE ULTIMATE PESSIMIST

If Pinky Babb had never coached a down of high school football, he would already own a place in the state football history books. The Princeton native was an All-State selection at Furman and starred in the Greenville's school last-ever victory against the much bigger Clemson in 1936.

However, Babb did end up coaching, and in 1943, he landed at Greenwood. He wouldn't leave until 1981 after winning 5 state championships and 346 wins against 85 losses. Along the way, he was referred to as the ultimate pessimist because he always seemed to say his team was on the verge of a loss. He later would be inducted in the first class of the state athletic hall of fame as well as the National Federation of Coaches Hall of Fame.

Jim Martin, one of his former managers who organizes a reunion of players each year, said Babb's pessimism was almost comical. Every season was presented as being a shambles in the making by the coach who never smoked, drank or swore. "'Damn' was the worst thing he ever said," Martin said. Martin compared Babb's training camps to a jaunt in the marines but said playing for the coach was definitely worth it.

"When it was over, you wouldn't trade it for anything because you knew you were a better man for having endured it," he said.

Pinky Babb's Greenwood coaching career started in 1943 and would not end for another thirty-nine years. *Courtesy of Greenwood High School.*

THE STREAK

The early 1940s had been up and down for the Rock Hill Bearcats. When the 1945 season opened, coach Walter Jenkins said he hoped for maybe six wins in the ten-game schedule. Not a bad record, but nothing really amazing. Instead of six wins, the Bearcats went on a twenty-six-game tear over the next three seasons that saw the school win its first two state titles. The nucleus of the teams was a two-year combination of players that simply ran roughshod over any team that got in its way. The line was led by tackles H.B. Starnes and Earl Jackson; guards Harold Small, Charles "Buck" Walters and Herman "Choke" Knight; and center Frank Boulware. The backfield relied on Ed Jackson, Cy Waters, Frank Carothers, Walter Gooch and Bill Estes. The ends were David Williamson, captain of the 1946 team, Jerry Ferguson and Doug Herlong.

The start of the dynasty came on a wet, muddy night in Columbia when the Bearcats beat the Capitals 6–0 on a Waters touchdown that followed a Herlong blocked punt. Whether it was rain or luck, the team kept winning. A 35–0 victory over Bennettsville would have been higher, but the starters had been pulled after the score reached 19–0. A 53–0 victory over Catawba

Rock Hill's Ed Jackson scores the winning touchdown against Chester in 1945 to essentially clinch the state title. *Courtesy of the York County Library.*

region rival Lancaster on the legs of Ed Jackson's three touchdowns soon started drawing attention to Rock Hill. A little more than five thousand people showed up in Anderson as Jackson broke open a 6–6 tie with a sixty-five-yard touchdown run for victory number four. More victories followed in the next five weeks (including a victory over Orangeburg where the team unveiled rocking new uniforms that featured dark jerseys with light-colored patches over the shoulder pads) until the season wrapped in front of twelve thousand rabid home fans who watched Jackson's third-quarter touchdown seal a 6–0 victory over Chester and the state AA title. They outscored the opposition 230–13 on the season, including eight shutouts. Charleston challenged the Bearcats to a final championship game after the season but was rebuffed.

"The State Champions–majestic words that everyone hoped for, but scarcely breathed until the final whistle," the Rock Hill yearbook noted with just a tad of overwrought melodrama at the end of the year.

As good as the 1945 team was, the 1946 team was quite simply better. Waters was named All-Southern for the second straight year, while Estes

was honorable mention. Carothers and Estes were named to the Shrine Bowl. Those three, along with Williamson and Boulware, grabbed All-State honors. This team also went 10-0 and outscored its opponents a blistering 328–18. Waters had at least nine touchdowns, but everyone seemed to take turns toting the ball to gridiron glory. Ferguson caught three touchdowns against Gaffney, Williamson scored the game winner with less than two minutes to go against Florence, Carothers scored the opening touchdown against Columbia and the defense sparkled at times, holding Gaffney to fifty-eight yards in one of Rock Hill's eight shutouts of the season. On November 30, Rock Hill hosted the North Carolina South Piedmont champions from Albemarle in front of ten thousand fans at Legion Memorial. Albemarle fans had buried a dummy with Waters's No. 66 on it earlier in the week, but the Bearcats could not be stopped, winning 14–7. After the final game, Jenkins told the *Rock Hill Evening Herald* that his was the "greatest team the state had ever seen."

Almost all of the stars graduated after the 1946 season, but it appeared the second string had learned something from playing in blowouts, as they extended the winning streak to 26 games. But on Halloween night 1947, a missed extra point late in the Sumter game ended the winning ways 14–13. Rock Hill ended 1947 with a not-up-to-their-regular-snuff record of 8-3.

Of course, Rock Hill never really fell out of favor with Jenkins at the helm. A fanatical Ware Shoals native, Jenkins was almost born to be a football coach. A letter winner at South Carolina, he was actually a better boxer, and he took that zeal to the practice field when he arrived at Rock Hill as head coach in 1942 after serving in Blackville, Dentsville and North Charleston before that. An October 2003 article in *The State* captured Jenkins's commitment to the controlled violence of football:

> *Rock Hill practices were punishing under Jenkins. He pitted best friends against each other during one-on-one drills in hopes of making them become enemies…Jenkins' teams conducted all-out scrimmages on Monday, Tuesday and Wednesday afternoons. If things didn't go to his liking on Wednesday—which more often than not was the case—the team would scrimmage again on Thursday. Then there were Tuesday and Thursday night skull sessions when Jenkins reviewed the previous game and previewed the next. Jenkins walked the practice field often with a stubby cigar in hand, thus earning the nickname of "El Ropo" from his players because of the brand he smoked. He stood only 5-foot-7 and was stoutly built at 190 pounds.*

He was known as a disciplinarian who only laughed at practice when he saw one of his players hit someone so hard that he fell to the ground in a quivering heap. Of course, the laughter stopped if the player spent too much time sprawled on the turf. According to *The State* article, he once hollered to an assistant to move an unconscious body of a player because he was going to kill the grass.

THE OTHER STREAK

As good as Rock Hill looked in the mid-1940s, there was a team a few counties over that put up a much longer streak. However, the winning streak by Sims High in Union is not in the record books, in part because no one can really say how long it lasted and in part because the players were all black.

But for eight years starting in 1946, no one beat the Sims Tigers for a streak of what is officially called ninety-six games, but there are question marks as to whether it was really ninety-three, ninety-four or ninety-five. The mastermind of the team was James Moorer, who had played at South Carolina State with Pro Football Hall of Famer Marion Motley a few years earlier before heading to Union County to coach. Despite the lack of opportunities allowed to blacks, Moorer attended clinics put on by the likes of Vince Lombardi, Bobby Dodd and Frank Leahy over the years, and that tutelage helped form the great Sims dynasty.

He started from the ground up at Sims, having to install a locker room shower, get transportation for players, get multiple sets of uniforms (it was not uncommon for the team to switch from purple to gold midgame for some added luck) and have players paint their helmets the day before a game in a show of solidarity.

Practices were tough, as Moorer and assistant John MacAllister preached a steady diet of physical, moral and spiritual fitness built through constant repetition. It was common for players to practice well past 9:00 p.m. to make sure plays were correct. Each play had to be perfect before moving on to learning the next idea. And these were not simple plays, as Moorer experimented with multiple formations and checking off plays at the line of scrimmage.

The Tigers lost their first two games under Moorer before taking off and not losing again until 1952. They started the streak in a rundown city park but soon were splitting their home turf with the all-white Union High.

Players have said for years that there were as many whites as blacks in the stands by the late 1940s. That included Union football players showing up to watch as a team, knowing full well that the Sims players would do the same. While segregation reigned, several larger black schools often refused to play Sims, players said.

The streak was snapped as it approached one hundred by Carver, which was Moore's alma mater. Carver's coach, Roy Henderson, said it took two years of him coaching at the Spartanburg school before they were ready to beat the Tigers. They did it 19–7. Moorer stayed on as coach at Sims through 1959 and later became the first black coach elected to the state athletic hall of fame. One of his stars at Sims was Willie Jeffries, who later built a legendary coaching career at South Carolina State. Sandy Gilliam, who later coached at Maryland State and tutored NFL greats such as Art Shell, Emerson Boozer and Bill Thompson, was one of Moorer's quarterbacks.

"We didn't even think about losing. We didn't go out there worrying about being the ones who ended it. Losing never crossed our minds. We just knew we were going to win," Gilliam told *The State* in April 1989.

Sadly, while the South Carolina High School League moved to recognize the streak in 2005, it is still not listed on the National High School Sports Record Book or even on the SCHSL's website of longest winning streaks. Part of that is because the streak includes four ties, which the SCHSL does not recognize in compiling its streaks.

OTHER GREAT TEAMS

After the number-two Greenwood team led by Pat Williams and Nat Edmunds beat the number-three Parker team 19–0 in the last week of the 1948 season, it was generally believed that the Emeralds (as they were then known) would be deemed the AA champion in the poll the next week. They were, but by the slimmest of margins, 88–87 over Chester. The Red Cyclones' coach, Joe Collins, challenged Greenwood for the state title, but coach Pinky Babb demurred. He had his championship. The team was led by captain William "Hootie" Johnson, who later became famous as the president of Augusta National. He also starred on the 1947 team that was selected to play in the Blind Bowl in Clearwater, Florida. He was the "Mr. Outside" to teammate Sonny Horton's "Mr. Inside." Johnson played

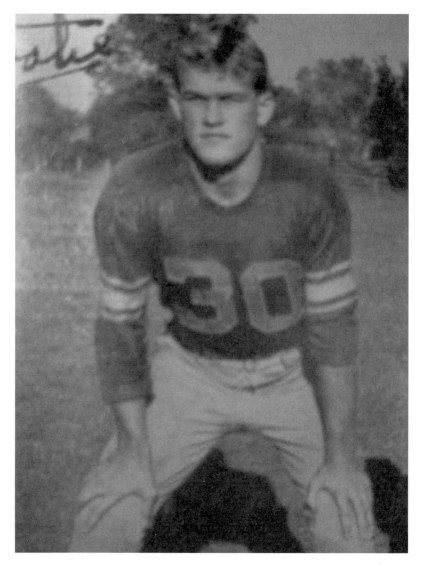

Hootie Johnson showed the drive that would lead him in business and as the head of the Masters while starring at Greenwood High in the late 1940s. *Courtesy of Greenwood High School.*

collegiately at South Carolina and then had a famed banking career, but he likely best is remembered as the man who battled hard to keep women from membership at Augusta in the 2000s, or as he put it, he would not be forced into admitting a female member "at the point of a bayonet." The Emeralds also won the AA title in 1949.

Central High had ten players show up for summer practice in 1949, but somehow first-year coach Fleming Thornton pulled that team together, added some more players and rode them to a Class C title over Olar. Lancaster High won the 1941 Class A title after fashioning an 11-1 record while outscoring its opponents 431–28. The lone loss was to Camden. Lancaster nabbed the title after a lukewarm Columbia team upset the top-ranked Charleston squad in the last week of the season.

One final team of note is the 1943 Fairfax team, which won the six-man championship by beating Jenkinsville 40–9. Six-man football was added by many schools during the war years to defray costs.

THE STRANGE CHAMPIONSHIP

While many state title games were not held in the 1940s because of the war, the 1946 Class B title was cancelled because of a puritanical strict reliance on the rules. The quagmire started on November 23, when Olympia and Liberty batted to a 14–14 tie. There was no overtime rule then, and the two coaches decided to play a second game three days later. Olympia won 13–6 and got the right to play Mullins for the state title in Sumter (it was fairly typical for smaller classifications to hold their championship bouts at neutral sites during the era). The game was scheduled for November 29, which meant that Lil Durham's Olympia team would be playing its third game in seven days. He naturally asked for an extension, but was denied. When Olympia officials hinted that they may not show up, they got a stern letter from the High School League stating that if a team didn't show, Mullins would win. Mullins showed up with its fans and marching band on Friday night, but Olympia was nowhere to be seen. And just like that, Mullins had its second state title of the decade, and strangely enough, both came against Olympia. It wasn't all bad news for Olympia in 1946; the team was invited to play an exhibition game in Miami Beach after the season and won.

SOME THINGS NEVER CHANGE

If you think referees have their hands full now, try the 1940s. Screaming and cursing of the men in stripes (yes, they already were vertically

fashion-conscious back then) was so prevalent that T.B. "Dad" Adams told the *Greenville Piedmont* on December 1, 1948, that the end of football was nigh if criticism of referees from fans and writers didn't stop. However, football continued to grow, as did the vitriol fired at the refs. In the same piece, Adams also predicted that pro football would never succeed in the South. Can't win them all. Predicting movement by the High School League also proved as faulty as ever. The *Greenville Piedmont*'s esteemed Anthon Foy predicted on October 28, 1948, that the league would solve the "Prep Grid Problem," aka the lack of a state title game for the largest schools in South Carolina, within five years. He was off by thirteen years.

Kicking at the high school level was an adventure. Westville High tied three games in the 1949 season, all of them 6–6—all because of missed extra points.

Unruly crowds still got out of hand as well. More than six hundred people nearly rioted and demanded their tickets back when Granard High School didn't show up for a game in Greenville against Sterling High. The crowd started making its way toward Sterling's principal, J.L. Beck, when a city cop, G.H. Godfrey, and a professional boxer named Noah Robinson, who was helping security, managed to regain calm. The crowd was appeased when they were told the game would be played at a later date, according to a November 22, 1942 *Greenville Piedmont*.

They Were Playing a Different Game

During the 1943 Parker-Greenville High game, with the score 52–6 in favor of the Red Raiders, the public address announcer intoned that if a Parker player scored he would get a twenty-five-dollar war bond. It quickly went from one to two to three to four. The Greenville players apparently conspired to let Jack Williams, a close friend of several of them, get the prize. Williams charged through the Greenville offensive line, and quarterback J.W. Brown handed him the ball. Williams ran it in for a lucrative defensive touchdown. The final score ended up being 58–13. The schools also auctioned off the game ball signed by all of the players in the game that would be used to buy $10,000 worth of war bonds. The end of the 1945 game saw a fan strip to his waist, give his shirt to the man next to him and then put back on his tie, vest and

overcoat. It was presumed the man had lost his shirt betting on Parker that day, which lost 28–6, according to the *Greenville Piedmont*. Why did the writer presume it was a gambling debt? It also was common for the *Piedmont* to print betting lines on high school games during this era

Notes from the Shrine Bowl

By the 1940s, the game had become more than just a fundraiser that allowed fans to watch some good football. Many South Carolina players were seeing a world that they had never experienced. Most of the players had never left the state, and all of a sudden they were being thrust into the largest city in the two states for an entire week. It must have been like waking up in Oz for some of the players as they experienced new marvels, according to Walter Klein's *Bowl Full of Miracles*.

> *Young men picked for the two squads never had anyone chauffeur them around before. Never had anyone buy their meals three times a day for a week and never had to pay for it. Never saw the traffic, lights and crowds of a city as big as Charlotte. Never stayed in a hotel, no less one as big as this. They may never have had a decent pair of football shoes to play in. Shrine Bowl player escorts quietly admit that they've seen more than a few boys from underprivileged homes arrive for the game with clothes that shouted poverty and shoes that would not carry them into the second quarter. The remedy was always simple, direct and dignified. The escorts took them privately to Charlotte retailers and bought them everything they needed, smiled, shook their hands and wished them a beautiful week of memory-building.*

The games provided some amazing highlights. The 1941 game produced a 0–0 tie. The Sandlappers only gained one first down and thirty-five yards on the ground, but the punting of two future Shrine Bowl coaches—Bobby Giles of Olympia and Bettis Herlong of Saluda—saved the day. The then largest crowd in the history of the game (fourteen thousand) saw South Carolina win for just the second time in 1944. This time, it was a blocked punt by Camden's Ted Marshall that was recovered by Allendale's William Prevaux, who ran into the end zone with ten minutes to go. That was good enough to preserve a 6–0 victory.

Florence's Lewis "Lukie" Brunson was the MVP of the 1946 Shrine Bowl and later starred at the University of Georgia. *Courtesy of the Florence County Library South Carolina Room.*

The big crowd in 1944 could be considered a precursor to the 1945 game, when twenty-five thousand people saw North Carolina win 8–0. Florence's Lewis Brunson dazzled in the 1946 game. Named the team captain heading into the game, he delivered. He picked off a pass that led to South Carolina's first score and then scampered thirty-three yards for the second in what the *Charlotte Observer* dubbed the "best ground play of the day. Taking off around his own right end, it looked like he would be swarmed under a host of Tar Heel [*sic*] tacklers, but by some miracle or twisting and turning he came out in the clear at the 25 and went all the way, eluding two other tacklers at the five yard line." He later scored an extra point to make the score 19–12 for the Sandlappers. Greenville's O.O. Crowe intercepted a tipped pass in the 1947 game and ran it back eighty-one yards for a score in a game that ended in a 7–7 tie. The Tarheels won the decade 4-3-3.

STATS, STORIES AND STARS

Parker earned a measure of revenge on its crosstown rivals in 1940 by beating Greenville High for the first time since the series began in 1925. It was especially sweet since the Red Electrics were undefeated heading into the Thanksgiving Day game with a roster filled with all-state players, including Wilbur Ellis, Bill Hunter, Albert Farress and Monty Byers. More than nine thousand people attended the game where Parker's Burnett Morrow and W.T. Martin scored to clinch a 13–6 victory.

Gaffney's Lewis Elliott won the award for grittiest play of the decade. The 185-pound runner broke his collarbone against Savannah in 1940 but stayed in the rest of the game and ran back a kick for fifty yards.

Saluda won the 1941 Class B state title led by a young back named Bettis Herlong, who, of course, would go on to great success as a coach.

On November 19, 1943, York got its first victory over Chester in school history. A player named Bennett scored two touchdowns in the win.

Camden's Carol Cox scored nineteen touchdowns and added six extra points during a brilliant 1944 season.

Greenville's Dick Hendley was one of the most celebrated players of the 1940s. He made the Red Raiders' roster as an eighth grader in 1941 and scored the winning touchdown against rival Parker that year. As a senior, he again scored the winning touchdown against Parker with a thirty-three-yard run. The *Greenville Piedmont* referred to him as "snake-hipped." That ability led him to Clemson, where he became a star lineman on the 1950 Orange Bowl champions. One of his grandsons is 2009 U.S. Open winner Lucas Glover.

Chester's Marion Campbell wrapped up a brilliant high school career in the summer of 1948 by taking part in the All-American Prep Bowl in Boston before heading off to the University of Georgia. Campbell became a Bulldog legend on the defensive line and then played almost a decade in the NFL. He later did two stints as head coach of the Atlanta Falcons sandwiched around several seasons leading the Philadelphia Eagles.

Greer's James Cox rushed for nine touchdowns, passed for one, returned a kickoff for another and returned two blocked punts (he blocked them) for touchdowns in 1949.

In 1949, Sterling coach J.D. Mathis called his running back "Rabbit" Johnson "as fleet a halfback as you'll see in these parts." While statistics are hard to come by, Johnson's name was the measure for all black running backs to come along in the next decade.

CHAPTER 4

THE 1950s

The Dawn of the Professional Age

The 1950s were a pivotal time in the growth of football. When the decade began, the average high school football player saw the game as an outlet for getting into college and turning that into a degree he could broker into a career away from the textile mills and peach orchards. By the end of the decade, the NFL had become part of the American sports psyche, and young South Carolina athletes could hope to play the game on Sundays in front of massive audiences at stadiums and on the bluish glow of televisions.

However, the high school game did not lose its stranglehold on the fan bases in the Palmetto State. Newspapers gave weekly skull sessions on the intricacies of the game by explaining lingo such as a mousetrap, which was when a defensive lineman was allowed to bust through to the backfield only to be sideswiped by a back and the runner scooting through the hole in the defensive line. The Good Fellows Charity held a "Football Night in Spartanburg" in September1950 (beating NBC to *Football Night in America* by about half a century), an event which featured more than five hundred players from Greer, Pacolet, Boiling Springs, Chesnee, Roebuck, Woodruff, Fairforest, Inman, "District 5" and Gaffney high schools at Wofford's stadium for a series of fifteen-minute scrimmages. The *Spartanburg Herald* said the event was standing room only.

Newspapers began to expand coverage as well. Previews of big games included panoramic shots of stadiums with cutout photos of the key players superimposed over the cheering masses. Game photos often included white lines added to them to show the movement of the ball between shots. It

wasn't uncommon after a major game for newspapers to recount key scoring drives in graphics that showed the football field with little Xs and Os on it. The first day of summer practice almost always included photos of timid-looking teens pulling practically cardboard shoulder pads over their heads. The stories were from a simpler time, as they shared their space on sports pages with the cartoons, wrestling results (the fluttering cape and mask kind—high school wrestling was almost unknown at the time) and ads for cigarettes and alcohol.

The high school game also began drawing interest from national sports figures. The likes of Frank Leahy and Clair Bee attended the coaches' convention in Columbia. Players also got great little bon mots from writers that sounded like they were written by Dick Vitale. Parker's Shrine Bowler Billy Joe Robertson was a "dandy don" of a quarterback, as just one example of players known by nicknames such as Speedy, Red and Hefty.

And the game was starting to change offensively, or as the *Greenville Piedmont*'s Anthon Foy put it, "I've found passing is the easiest and quickest offensive weapon available" if you have the right people. The 1950s had those right people.

HYSTERIA AT THE TOP

While teams in the A, B and C classes played for a state title each year using a region-playoff format, a small subset of the biggest schools referred to as the Big Ten in 1950 were left in somewhat of a football drift each season. The High School League deemed them too big and therefore too powerful to play their A brethren but had not set up a way of declaring a champion. Instead, an intrepid group of writers pulled together by the *Greenville Piedmont* took it upon themselves to declare a defacto winner. They used a point system based on what they felt was the best team each year, and that normally went to the team with the best record. College football fans should recognize this system, and they should also recognize the faults that come with it. For example, Florence appeared to be running away with the AA title in 1950 through the first seven weeks of the season, with Parker in second. But when an undefeated Anderson team coached by Ralph Jenkins demolished Parker 21–0, the Anderson Yellow Jackets vaulted into the championship equation. Florence and Anderson ended the season tied on top at 11-0, and the writers declared both state champs even if they weren't happy about it.

On November 23, Doc Baker of the *Charleston News and Courier* called for a title game, but it fell on deaf ears among administrators. The *Piedmont*'s Foy took it a step further when he called for the formation of an AA league in a heated column on November 20. He said voters loved their opportunity to declare a winner but said it was the wrong way. The teams needed to play each other. "Why would it be so illogical?" he wrote. On the same day, the *Anderson Daily Mail*'s Brent Breedin said the current system was splitting the voters in two. Lowcountry writers often were siding with their teams, and the same was happening with the other sections of the state. When teams ended with the same record, Breedin somewhat esoterically asked, "How can one judge the merits of the two teams' schedules?"

The Big 10 grew to the Big 12 by 1952, but the challenges remained. By 1953, Foy referred to the situation as "the old, but burning question" in the *Piedmont* of November 13. There was no logical reason not to switch to a playoff, but Foy surmised that "some people dodge logic like they dodge a rattlesnake." The Big 13 was a Big 15 by the start of 1955, when the High School League announced it was examining its playoff rules in November of that year. Many assumed that would lead to a playoff for the AA schools, and Greenwood principal Madison Breland said he expected a "favorable" plan by December. The fans and coaches got a AA, but it was a new conference alignment with playoffs, while the biggest schools remained in playoff purgatory. The AAA schools would have 1,001 and more students, AA would be 501 to 1,000, A would be 251 to 500, B would be 126 to 150 and C would be 125 and below. Needless to say, the writers still weren't happy. Orangeburg's Bill Moore intentionally left Greer and Dreher off his 1956 AA title ballot, writing that the "results show the poll to be a sectional joke."

The Black Shirts

It didn't take long for the 1953 Rock Hill Bearcats to serve notice that they were going to be special—a forty-one-yard touchdown on the first play of scrimmage showed that this team was destined for greatness. There have been many great dynasties over the years in South Carolina, but when it comes to one-year wonders, few compare to the 1953 Rock Hill Bearcats, an undefeated state title team better known as the Black Shirts. While their record is impressive, it is the talent that makes this team unlike any other in state history—boasting twelve players who grabbed

Rock Hill's Cy Waters (number 66) barrels for a touchdown while tackle H.C. Starnes (number 55) looks on in 1953. *Courtesy of the York County Library.*

some kind of all-state honors. That non-dirty dozen of superstars was led by running back Raymond Head and flanker Broadus Thomasson, who both made All-Southern and the Shrine Bowl, while Ronnie Gordon was a near unanimous All-State selection as an end. After that came a host of players who grabbed either second- or third-team honors, including tackles Grady Lyle and Willie Smith, guards Gene Cathcart and Bobby Thompson, center Bill Neely and backs Jimmy Grant, Bobby Stevenson and Bill Jordan. Quarterback and captain Bill Few also grabbed some All-State honors and likely would have had more if injuries didn't hamper him in the latter part of the season. In all, twenty-five men from that team would get college scholarships, with fifteen playing.

However, one of the odder facts about this team is they hadn't been particularly great the year before and were expected to be mediocre in 1953. They were just 4-5, and they lost fourteen lettermen to graduation in 1952 when camp broke on the 1953 team coached by Walter Jenkins and assisted by Calvin McCaw and Gene Avery. The team quickly showed that it was much better than its predecessor by scoring eight touchdowns in the opener, or as the school yearbook stated blithely, it was the same amount the 1952

team registered in the first six games. Tough wins against Greenwood and Gaffney were followed by a 40–0 blowout of Anderson, where the team scored touchdowns in each quarter highlighted by Jordan's sixty-yard punt return for six and a sixty-five-yard touchdown run by Head. The next week was extra special because longtime rival Lancaster had returned to the schedule with a vaunted passing game that was predicted to befuddle the Bearcat defense. Instead, four Rock Hill interceptions led to a 47–6 dismantling of Lancaster, including Thomasson's fifty-yard interception return for a touchdown. Few also added two touchdowns on the ground and one in the air. The team stretched its record to 8-0 with a game against Parker High looming. The 1951 team took a 9-0 slate into the final game, only to get upset by Greenville High 13–6 and lose out on a state title. Head and Thomasson started in that game, while Few, Cathcart and Stevenson had played key roles. Any chance of an upset was squelched against Parker when Head went seventy-eight yards for a score on the second play of the game and later hit Thomasson for a nineteen-yard touchdown to seal a 13–6 win and a state title.

But why were they called the Black Shirts? Part of it had to do with their ominous-colored jerseys, and according to an October 14, 2003 article in *The State*, a lot had to do with their punishing reputation. The team played only nine games because most other schools refused to play them, according to the article. The meanest player may have been Few, who missed the Dreher game because of injury but may have been a bigger factor when the team ended the first half down 2–0. Few shook a fist in each player's face and said he would fight them after the game if they lost. Fearful of Few, the team rallied for a victory, according to *The State.*

Teammate Bill Simpson later became a high school principal in the Rock Hill area and kept a picture of Few on his desk. It was a reminder that if he survived three years playing against Few, whom *The State* called "180 pounds of the meanest, nastiest, orneriest flesh South Carolina high school football had ever seen," he could handle any problem in the classroom.

But the Rock Hill team also had style, in part thanks to Jenkins's mercurial ways. The coach known for smoking thick cigars used gate receipts to spend $75,000 on new locker rooms just before the 1953 season that included tiled floors, eleven showers, ninety-nine lockers (up from the old forty-four) and a treatment room with whirlpools. He also "did not allow his players to smoke cigarettes or drink sodas, and he didn't like the idea that they often danced to beach music in their dungarees and white socks at Darlene's Grill on Indian Hook Road," according to *The State*.

The reward for playing well was steak dinners with a quart of milk after each game and traveling in a rented Greyhound bus. The team also wore specially fitted black and silver satin uniforms at a time when most teams wore canvas and cotton.

"ALL I WANT TO DO IS PLAY FOOTBALL AND RACE CARS"

The freshman was no more than five feet, five inches from the bottom of his feet to the top of his sandy blond brush cut and, at 130 pounds, weighed a little less than the alligators he sometimes wrestled along the Lynches River when he walked into the coach's office at Timmonsville High and asked for a uniform.

Wallace Walkup, the Tornadoes' salty coach and former Presbyterian College star, smiled and told the boy to head to homeroom. Uniforms would be handed out after school as part of practice. The young man was incredulous. They wanted him to go to homeroom? He was ready to play football that minute. If Walkup had not already heard of Cale Yarborough, the son of a sharecropper and already known around Sardis for his skills as a snake catcher and soapbox derby driver, he soon, like the rest of South Carolina, would never forget him.

As Yarborough related in his own 1986 autobiography, *Cale*, he was ready for football, even if it wasn't quite ready for him. He vividly detailed picking out his uniform and equipment from small piles on the gymnasium floor. Looking over the worn-down equipment and tattered jerseys, he proclaimed that the team would be the "Timmonsville Bums" until a teammate said this was just the practice gear. Once assembled on the practice field behind the school with fourteen other players, Walkup said the first day would be about running. The players lined up for one-hundred-yard, goal line–to–goal line sprints, and Yarborough won the first two easily. The coaches moved him back five yards for the third sprint, and he won again. He was given a ten-yard disadvantage for the fourth run and barely won again. Walkup gave him a once-over, said "good job" and ordered the team to the showers. Yarborough promptly vomited.

Things quickly got easier on the field, but off the field, Yarborough struggled in the classroom. He admits he studied plays in American history class, which prompted a call to his mother, Annie Mae Yarborough, who

came to the school to scold her son. Yarborough said he hid his face from his coach so Walkup couldn't see him cry.

"All I want to do is play football and race cars," he explained to his unmoved mother.

Mother Yarborough won the battle, and her son became one of the state's top running backs by the time he was a senior. And, more importantly, she was never called back to the school over grades, he noted. Yarborough's bio also sheds some light on early 1950s' football in the rural parts of the state, from the camaraderie of teammates to the vendettas of opposing teams. Bishopville players, for example, scrawled Yarborough's name on one of their tackling dummies. Yarborough recalled team meals in the gym that featured a meat, veggies and baked potatoes. He often carried out a second potato to eat on the bus ride to road games while Walkup led the team in songs and chants. Yarborough said the team wanted so badly to win that they "won before the whistle even blew." The wins kept coming as the Tornadoes made the Lower State finals against Summerville. All week, photographers and fans flooded practices until Walkup banned them. Yarborough said he never heard a crowd roar louder than when the Tornadoes ran onto the field like they were on fire—until the Summerville team came out a few seconds later. In comparison, Timmonsville's applause sounded like "polite" clapping. Walkup soon explained the game plan. If Timmonsville received the opening kick, the ball would go straight to Yarborough.

"Oh Lord, I thought. What if blow it?" Yarborough remembered.

Summerville kicked the ball to Timmonsville's Randy Mellette, who started running right and tossed the ball to the left-running Yarborough at the fifteen-yard line. Spinning and juking defenders and finding the speed that had won him those four races as a freshman, he barreled eighty-five yards into the end zone. As the stands erupted in cheers, Yarborough looked back to see a yellow flag on the field. It was a clip. The touchdown was called back, and Timmonsville never recovered and ended up losing by two touchdowns. After the season, Yarborough was named All-State and soon started his driving career that would see him win three straight NASCAR championships in the 1970s and four Daytona 500s, but he still regretted losing the Summerville game.

"All of it was a tad hollow," he said after that season.

THERE WERE OTHER GAMES

Black schools also played during this era and, occasionally, saw the same coverage that white teams got from the local dailies. However, the coverage rarely, if ever, mentioned that schools such as Carver, Sterling and others were for black students. Pictures were rare, but at least they told a story when shown, such as Sterling star Herman Griffin standing next to the school's homecoming queen, Claudia Garrett, in a November 17, 1954 *Greenville Piedmont*. This shouldn't be blamed on sportswriters per se; really, it was a product of the times. A young Jesse Jackson was rarely mentioned in the sports pages while starring at Sterling in the late 1950s, but behind the scenes the powerful *Greenville Piedmont* and later *News* sports columnist Dan Foster was constantly promoting the gifted athlete to college coaches in the North. Jackson later often credited Foster with giving him the opportunity to attend the University of Illinois. The Lions' Club began sponsoring a black championship game of sorts. Dubbed the Lions' Bowl, it usually featured two top-tier black schools playing at Greenville's Sirrine Stadium. The game was a major fundraiser, and whites were often encouraged to attend with the reminder that they would sit opposite the black fans. Many games featured out-of-state teams that helped defray costs by staying with local black families.

However, the teams from the black schools had to fight for recognition. James Talley starred for the Carver teams in Spartanburg and coached at Spartanburg High and then Wofford years later. The 1958 Carver Bears won the black state championship, scoring 389 points while giving up a paltry 32. Talley chuckled when asked about the stadium they played in. The Bears didn't have a field at their school but played home games at historic Duncan Park in Spartanburg. The classic-style baseball stadium was home to the local minor league teams over the years. "We had the nicest field of anyone," he said.

Talley, who also served two terms as the city's mayor, could still recall the Carver schedule even fifty years later. The season started with New Bethel in lower Spartanburg County and included Granard in Gaffney, Sims in Union, Coleman in Newberry, Emmitt Scott in Rock Hill and C.A. Johnson in Columbia, with a couple of out-of-state teams thrown in for good measure. Winning the state title was something that carried over from the football season. Even though Carver had strong teams in other sports, the football championship meant bragging rights throughout the

year. School booster clubs helped buy team meals and varsity jackets. "We took a great deal of pride in that," he said.

He said he and his teammates felt they best represented their hometown and would often play members of the all-white Spartanburg High at Cleveland Park on weekends. However, he added that they knew a real game was out of the question under the strict rules of segregation. "We weren't frustrated by it," he said. "It was part of how everything was."

THE NEW GUY

A young John McKissick replaced the legendary Harvey Kirkland in 1952. *Courtesy of Summerville High School.*

High school football would have been changed forever if John McKissick could have collected money.

When he came to Summerville in 1952 as the new head football coach, there was no inkling of the greatness to come. There even was some fear that this dark-haired, slender young man in his mid-twenties could replace the school's legendary Harvey Kirkland, who had led the Green Wave to two state titles before leaving for Newberry College.

But McKissick was no ordinary young man. One of his earliest memories was of Christmas 1929, when his family home burned down. He was three years old. The family moved around for several years before settling in Kingstree, where he played practically every sport. A pool hustler as well, he was drafted in 1944 and opted to become a paratrooper. He was about to be shipped out when the first atomic bomb was dropped. He spent two years in Europe stationed with the occupying forces, came back to the states, played linebacker at Presbyterian and then went into business as a money collector.

He stunk at it. When a friend called to say a high school in North Carolina was looking for a coach, he jumped at the opportunity. He didn't even fully realize it was six-man football until he got there. He won seven games and heard about an opening in Summerville.

Many were interviewed, but McKissick landed the job. The secret, he would say years later, was that the superintendent was impressed that McKissick didn't ask about the money. Summerville found success under McKissick, and he won his first title in 1956. Offers of more money from bigger schools came pouring in. He interviewed, but he had an epiphany of sorts driving back down Summerville's quaint, tree-lined Main Street. This was where he was meant to be, no matter the money he could get elsewhere.

More than five hundred wins later, McKissick's inabilities with money changed the game.

THE DREHER DYNASTY

The 1950s' Dreher dynasty is one of the most peculiar in state history. The Blue Devils won five state titles but never played in a championship game because of the arcane rules of the era. They used three coaches, who all went on to greater things outside the world of football coaching.

The school was formed in 1938, but Dreher students played on the Columbia team until 1946. After a few years under J.K. Henry, the school hired Lynn Kalmbach—and that is when the fortunes really began to rise, said Carl "Buddy" Dubose, a halfback on the 1950–51 teams.

An Ohio native, Kalmbach had played football at South Carolina in the 1930s. He was a basketball coach when he took the Dreher grid job, but he quickly modernized the Blue Devils' attack. They scrapped the single-wing offense and went to the T but created multiple formations for games, Dubose said. That was almost unheard of in 1950. "Defensive coaches really couldn't adjust at the time, so we would put in new wrinkles on offense," he said. "We were killing teams."

The 1950 team went 6-3, but all three losses were by a touchdown or less. With a core of players coming back in 1951—including future All-State selections B.C. Inabinet and Carl Brazell and All-City selections Crosby Lewis, Lee Tapp and Ken Stiles—the team deemed themselves the team to beat in 1951. They did not disappoint. Dubose scored the first touchdown of the season in a rain-soaked victory over Camden and never slowed down.

They finished the season 10-0, which was the best record of the big schools. They outscored opponents 305–40. Dubose remembers Greenville, which had one loss, challenging them, but Kalmbach turned them down. They were the champs. The team figured they had sewn up the title after their last victory of the season, but they didn't find out for sure until a few days later. The writers' poll normally came out on Wednesdays, but Kalmbach got the call early that the Blue Devils were number one on ten of twelve ballots. Dubose doesn't remember any particular celebrations other than the annual end-of-the-year banquet.

Dubose praised Kalmbach's forward thinking. Dreher didn't have great athletes, but they were better prepared, Dubose said. They were the first team in the state to cross block on the line of the scrimmage. That element of surprise allowed 160-pound guards to knock over 210-pound defensive tackles. Each player would call out the number of the man he was blocking when they broke the huddle. Dubose said one team started hollering out numbers to confuse them, but the referees made them stop. "I don't think they had the power to do that, but they did it anyway," he said.

The second innovation was game films. Dreher was the first team to film other squads to look for tendencies, said Dubose, whose grandson, Richard Mounce, won the Mr. Football award in 2007. The films allowed the Blue Devils to figure out how fast their opponents might be or how far they could throw the ball. Nothing surprised them, he said. The 1951 team still meets up at least once a year to watch the old tapes of their long-ago championship.

Kalmbach wasn't interested in creating a dynasty (he later would become the founding director of what is now SCETV) and soon handed the program reins over to his assistant, Red Myers, who was named the state coach of the year in 1954 and 1956 when the Blue Devils won state titles. In 1957, he left to coach basketball at Erskine, where he had a long and outstanding career winning more than four hundred games and was named to the state athletic hall of fame.

He was replaced by Charlie Stuart, who coached the Blue Devils to AAA titles in 1957 and 1959. The 1957 team was led by stars John Hooker, Dan Lewis and Walter Robinson. The latter was led by All-State quarterback Jack McCathern. But like the coaches before him, Stuart would be best known for his career outside of the gridiron. As a track coach, he led Dreher to five consecutive unbeaten seasons, won three state championships and finished second twice. In addition, he served as the starter for the South Carolina state track meet for decades. Later, he was named the national athletic director of the year three times.

THE NORTH AUGUSTA STREAK

Cally Gault is best remembered in South Carolina history as the longtime coach at Presbyterian, but in the 1950s, he put in a legendary, but somewhat forgotten, run at North Augusta High. The Fighting Yellow Jackets won or tied 42 straight games between 1954 and 1958. That included 11-0 records in 1955 and 1956 and a 10-0-1 record in 1957. However, it was only the 1958 team, which went 9-1-1, that ended up taking home a state title.

Gault starred at Greenville High in the early 1940s and then at Presbyterian College, where he graduated from in 1948. He went to North Augusta in 1950 as an assistant and became head coach in 1953. Dick Sheridan played for Gault in the late 1950s at North Augusta and later coached Orangeburg-Wilkinson to a state title and had great success at Furman after that. He said Gault was one of the main reasons he became a coach.

Other North Augusta stars of that era included Bobby Stillwell, Sammy Anderson, Gene Williams, Charlie Williams, Charlie Britt, Tommy Lowe, Dick Day, Charles Overstreet, Bill Kenworthy and Larry Baynham, who was twice named All-State and All-Southern once.

Sheridan said he doesn't remember a lot being made about the streak in terms of celebrations or praise while they were playing. The streak ended somewhat anticlimactically in early November 1958 in a 14–13 game to a Greenville High team led by Dick Dietz, who a few years later would sign a $85,000 bonus out of high school with the San Francisco Giants.

Gault, though, vowed to start another streak, according to the next day's *Aiken Standard and Review*. He never came close to 42 again, but his career record ended up an impressive 88-14-7, which at the time was the best winning percentage of any coach with a minimum of 100 games.

THEY WERE PLAYING A DIFFERENT GAME

Johnny Mack Brown spent more than forty years in law enforcement as an investigator and Greenville County sheriff and then eight years as the U.S. Marshal for South Carolina. He's seen a lot of characters, but he reserved some great stories about James "Slick" Moore, his head coach in the early 1950s at Greenville High School. The first thing out of Brown's mouth when discussing his former coach was, "His favorite word was shit." It was an exclamation point for things good and bad. It rolled off the coach's tongue so

much that Brown and his teammates took it as part of their daily vocabulary from Moore. The second memory was "butt cuts," and Brown and his teammates didn't think so well of that one. Basically, if Moore found out that a player had misbehaved off the field in a way that reflected badly on the school, he was subject to getting a leather strap—almost akin to a barber's sharpener—slapped across his rear during practice. The strap hung from a hook in Moore's office, and it was never a good sign when he showed up at practice with the instrument. "It was a reminder to keep in line," Brown said. "There is no way that could happen today."

However, Brown had extremely fond memories of Moore. He credited Moore for working with him to become an All-State lineman and Shrine Bowl player. Brown wrote a college paper on the person he admired most and chose Moore. The relationship lasted well into the 1970s, when Moore would show up at Brown's office every few months to say that his Sheriff's Office cap had worn out and he needed a new one. "He was like a second father to me," Brown said. "He was like a second father to a lot of guys."

Greenville's Brown talked about the reverie of football on Friday afternoons. The Red Raiders would stay after school—saving Brown his daily three-mile walk home—to eat a meal of tomato soup, fruit cocktail and hot tea. It was the same meal every week, and Brown—who made a career of asking questions to criminals—to this day has no idea why they ate that concoction. The team would walk in unison to their home stadium two blocks from the school but took the "Red Raider Bus" to away games against Welcome, Greenwood, Anderson and Lee Edwards in North Carolina every season. Halftime would bring a Coke to give the players some energy for the second half. A victory meant a meal of veal cutlets in the second-floor private dining room at Charlie's Steakhouse in downtown Greenville, with Moore smiling on as they ate. "We were on our own if we lost," Brown said.

THE PARKER-GREENVILLE GAME

Most people in Greenville fondly remember the annual Turkey Day game between Parker and Greenville High as the social event of the season. Johnny Mack Brown, who played in the '52, '53 and '54 games, recalled looking out into the stands. One side was solidly red and white, while the other was a fluctuating sea of purple and gold. Coaches' wives and girlfriends, players' mothers and high school friends would all be in that crowd cheering out

Greenville's Slick Moore and Parker's Whitey Kendall had a four-decades-long coaching feud that belied their friendship off the gridiron. *Courtesy of Greenville High School.*

songs and waving pennants. Afterward, the winners' fan base would drive up and down Greenville's four-lane Main Street to honk horns and cheer. "Oh Lord, it was a tradition," Brown said.

However, the game really didn't become a rivalry—as opposed to a one-sided victory lap for Greenville High every year—until Forrest "Whitey" Kendall arrived on campus in 1947. He immediately won his first two games with Greenville High and tied a third. Up until then, Greenville had gone 15-2-2 against its crosstown rivals, often referred to in newspapers simply as "The District." The game took on a new dimension when Kendall became a full-fledged devotee to the single wing and began dominating teams week after week in 1950. Greenville was using the double wing. That, coupled with an off-field friendship with Greenville's Slick Moore, made the annual battle that much more intense. It was old Greenville versus new. Rich versus poor. Boy versus boy. Coach versus coach.

The 1950 game was all Parker, as eighteen thousand people watched as the team beat Greenville 20–0. The 1952 game saw a duel essentially for the state title. At 10-1, Parker was tops in the state, but Greenville was

third with a 9-1 record. Parker featured Jack Dean, Clint Cooper (who saved the season with a blocked punt that led to a touchdown against Rock Hill), Carroll Clevenger, Muggs Patterson and Bill Floyd, who was a Shrine Bowler at guard. Greenville featured Tommy Roper, Perry Nichols, Bill Adams, Dana Graham and, most importantly on game day, Shrine Bowl tailback Charles Carter. A smooth running redhead, Carter almost singlehandedly upset the Tornadoes 21–0 with two passing touchdowns that combined for fifty-nine yards, seventy yards rushing and a sixty-five-yard punt. A week later, the Red Raiders were the state AA champs. The game lost some of its luster as the programs slumped in the latter part of the decade, but it remained a major draw for years to come because of the intensity rooted in those early 1950s' games.

Johnny Mack Brown starred in the first televised high school football in state history. *Courtesy of Greenville High School.*

THE FIRST TELEVISED GAME

History was made on November 23, 1954. That is when cameras crews set up for the first time on the sidelines of a high school football game in South Carolina. WFBC—the local NBC affiliate in Greenville—had worked a deal to show the Friday game between the hometown Red Raiders and the visiting Riverside Academy, a military school from Georgia. It is lucky the game wasn't beamed back to Georgia, as the visiting team was overrun 46–7. Actually, Greenville fans who tuned in late for the 3:30 p.m. start would have missed Barry Henley's seventy-five-yard touchdown on the opening kickoff. Johnny Mack Brown, Buddy Greenway and Walter Ball also scored in the game. The cameras and lights had no effect on the players, Brown said. It hardly came up leading into the game. "I can't remember being overly excited," he said. "Our mission was to beat Riverside."

NOTES FROM THE SHRINE BOWL

North Carolina scored 47 points in the 1950 Shrine Bowl. That remains the Tarheels' all-time best scoring output in the annual All-Star game and wouldn't be bested by South Carolina until 2000, when the Sandlappers put up 66 points. However, South Carolina did score 47 points in the 1985 game. North Carolina went 6-4 during the decade. This would be the last time North Carolina did not lose a decade until the 2000s.

The game drew extremely well in this era, which led some to discuss the idea of moving it to a bigger venue such as USC's thirty-thousand-seat stadium. Nothing came of this proposal. The decade saw the start of a unique Shrine Bowl "tradition." The 1956 game was a rather ho-hum affair, a 20–13

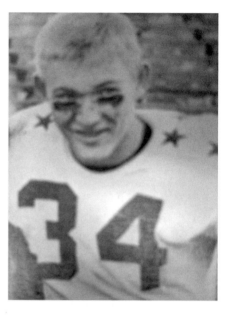

Chester's Keith Richardson was said to be "always be in good humor" while in high school and, apparently, after the 1958 Shrine Bowl as well. *Courtesy of the Chester County Library.*

victory for North Carolina, but it started what Walter Klein called the "Wilson Curse" in his book, *Bowl Full of Miracles*. Chester's R.E. "Ears" Wilson was one of the South Carolina coaches, and his team lost. In 1958, Shirley "Red" Wilson was on the Tarheel staff, and his team lost. It happened again in 1962 when Red and "Jug" Wilson contributed to the curse for North Carolina. In 1969, Ears Wilson was back, and his Sandlappers lost. The 1974 game included a North Carolina coach named Woody Wilson, and, you guessed it, the Tarheels got whooped.

Stars continued to shine in this decade. All-American King Dixon of Laurens starred in the 1954 game. He later played at South Carolina before spending twenty-two years with the U.S. Marines and then serving as the Gamecocks' athletic director The 1959 game featured a young Keith Richardson, whose normally flattop blond hair was crushed down in a clamp of sweat. Richardson, of course, would go on to a legendary coaching career at Clinton.

OVER AT THE NORTH-SOUTH GAME

There technically wasn't a "North-South," as the teams in the Coaches' Association All-Star game were the Upper and Lower State teams in the early 1950s. The decade got off to a rousing start when the Lower State team erupted for 46 points in a rout of the North in 1950. The main reason was the South's Bill Clark of Orangeburg implementing the T formation, which dismantled the North team so quickly that the game was essentially over by the time the Greenwood and Beaufort marching bands strutted their stuff for the halftime show. The 1951 game was a South defensive gem, as the North never made it past the opposition's 42 in a 20–0 victory. The 1952 game was a showcase for Greenwood's Budgie Broome, whose ninety-five-yard kickoff return for a touchdown sparked a North victory 12–6 in front of eight thousand rain-soaked fans. Easley quarterback Larry Bagwell scored the winning touchdown in the 6–2 North victory in 1955. Bagwell later would coach his hometown team to 161 wins and 2 state titles. The 1957 game saw Summerville's John McKissick lead the South to a 14–6 victory. The North and South teams split the games 5-5 during the decade.

STATS, STORIES AND STARS

Florence beat Sumter 20–14 in 1950 for its first victory over the Gamecocks since 1931.

Anderson's Don King ran for 315 yards in a November 1951 game against Chester. Anderson still lost, though, 24–20. King was no one-game wonder. He ran for 77 yards in that year's Shrine Bowl and then scored two touchdowns in the North-South game in August. He then had a stellar career as Clemson's starting quarterback in the 1950s.

Booker T. Washington's J.C. Caroline finished his high school career with fifty touchdowns. He later became an All-American at Illinois and then had a long career with the Chicago Bears and was one of the stars of the 1963 NFL championship team.

Tom Addison was a star fullback at Lancaster High in the early 1950s, but that is about as simple as his football career would be. He played offensive line and linebacker at USC and then was drafted by the Baltimore Colts in 1958. He didn't make the team, but he latched onto the Philadelphia Eagles'

taxi squad in 1959. And then things got really crazy. He started the 1960 training camp with the Eagles, was cut and sent to the Denver Broncos in the new AFL, was traded a few days later to the Buffalo Bills, was traded again a few days afterward to the then Boston Patriots and finally got into a game. He went on to make four AFL All-Star games and pick off sixteen passes in an eight-year career.

The 1952 state finals saw some exemplary performances. Billy Nalley scored three touchdowns and three extra points to lead Central over St. John's for the Class C title, while on the same day Pickens's Rudy Hayes ran for 210 yards and five touchdowns in a 51–7 victory over Lake City in the Class A game. Hayes also played defensive tackle that afternoon.

Harry Parone is considered the father of football in northeast Richland County, as the stadium he helped build at Spring Valley now bears his name. However, in the 1950s, he was just another young coach trying to make ends meet. At Dentsville High, Parone served as athletic director, unofficial groundskeeper and head coach of the football, basketball, baseball and track teams. He also taught five classes and drove the school bus. His salary was $3,000 a year, and his office was often a tarpaper shack.

The 1954 Simpsonville Whirlwinds could have been dubbed the Cardiac Kids, long before the term became popular in the NFL. The team won one game on a hook-and-ladder play in the final minutes and won a playoff game against Whitmire on a forty-yard touchdown pass from Phillip McGill to Sammy Cox in the last minute.

The 1954 Class A title game may go down as one of the strangest in state history. Played in Rock Hill, Pickens and Mullins were tied 14–14 at the end of the game. Each team got five chances from the fifty-yard line (almost like a hockey shootout) to score. Under the rules of the day, the team with the most yards gained won if neither scored. Mullins won by 17 yards, but Pickens fans had to wonder what would have happened if star Rudy Hayes hadn't broken his collarbone. Hayes had run for 1,879 yards and twenty-five touchdowns on 169 carries, which included 5 that spanned more than 80 yards.

Greer's Murray Hall powered the Yellow Jackets in 1956. The senior Shrine Bowl player ran for eighteen touchdowns, threw for one and returned three punts and one kickoff for touchdowns.

Bishop England's Pug Ravenel led the Battling Bishops to an 18-1 record as starting quarterback in 1955 and 1956 and capped his prep career by being named MVP of the North-South game. Ravenel would later become a major political player in the state.

Sterling's Nat Boston scored four touchdowns and put up 364 yards of total offense in a victory over Matthews Academy in 1957. His scores came on a 20-yard pass, a 90-yard kickoff, a 47-yard run and a 40-yard run. It was part of the reason that Boston made All-State that year.

Winnsboro's Ronnie Collins threw for 324 yards and five touchdowns in the playoffs against Taylors in 1959. Two of those passes went to future Myrtle Beach coach Doug Shaw, while future Eastside coach John Carlisle played fullback for Taylors.

Woodruff's Bob Ivey was one of the most dominant players of the late 1950s. Nicknamed Poison (as in poison ivy), he played on two football state champions, played in the Shrine Bowl and was named a high school All-American. Three times he rushed for more than one thousand yards and passed for more than five hundred yards. On defense, he scored six touchdowns on interceptions during his career.

CHAPTER 5

THE 1960s

The Decade of Dominance

Tonto Coleman must have smiled as he strode to the podium at Eppes Eating Place in Greenville. There in the converted house where each room served as a separate dining area were 150 high school football coaches. This was Coleman's kind of crowd—150 men in short-sleeve shirts eating catfish and chicken at long, sparsely adorned tables. As the assistant athletic director at Georgia Tech, Coleman was in constant contact with high school coaches, and truth be known, he thought the world of them. And on a steamy August night in 1960, he let them know it. The best coaches in the world were at the high school level, he said, according to a *Greenville News* article on August 17. They handled more players, had to do their own scouting and couldn't handpick their players like college or pro coaches did. A high school coach, instead, had to mold a team composed of "kids from the wrong side of the tracks" and kids from "the silk stocking district" into a cohesive unit. The account doesn't say how the coaches reacted to such high praise, but Coleman may have had an ulterior motive. South Carolina was solidly an ACC state in the early 1960s, as Clemson and USC both played in the conference. Coleman was soon to defect to the SEC as commissioner, and maybe he realized he needed to start making inroads in the state.

Regardless, the 1960s were about change, and that was often felt on the football field as well. When the 1960s dawned, there were 157 teams playing in the High School League. That number would be 193 by the end of the decade, but major changes were afoot heading into the 1970s as integration began to occur in parts of the state. Coverage of high school sports continued

to expand throughout the decade as the sports pages began to rely less on racing and textile ball results in favor of what was happening on Friday nights. For coaches, though, little had changed over the course of twenty years, as winning teams relied on the same vanilla formula of running the ball with a few passes sprinkled in to catch the other team napping combined with stifling defenses. Coaching staffs remained small, as few headmen hired more than two assistants even as the decade wore on. When Woodruff's legendary Willie Varner needed to replace Keith Richardson after the 1968 season, he hired two men. Shell Dula was one of those two men. Dula, of course, went on to his own Hall of Fame coaching career and later succeeded Richardson as head of the South Carolina Athletic Coaches Association. Three assistant coaches at one school in 1969? That was a coaching revolution for the 1960s.

THE INDIAN UPRISING

The return to prominence of the Gaffney Indians was a long time coming when the Atomic Age came around. Gaffney had been one of the early state powers, led by the likes of running back Earl Clary and coach L.F. Carson. The Indians brought five titles home to Cherokee County between 1922 and 1935 and made the finals four other times as Upper State champs. The school's tradition of running through "The Tunnel" started in this era, when W.K. Brumback Stadium was built in 1936. Coaches and players have labeled rushing through the long corridor, as fans scream like crazy and the band strikes up a tune, an experience that they will never forget. However, the 1940s and 1950s brought little joy to the Indian faithful, as no championships were brought home.

Things started to change when the school board hired former Wofford star (Best Blocker Award in 1948 and the Jacobs Blocking Trophy in 1949) Bob Prevatte in 1956. Prevatte had run up a good record in North Carolina, where one of his players was future Carolina Panthers owner Jerry Richardson, before heading to Gaffney. The mid-1960s' Indians were one of the state's major dynasties. Prevatte had won the AAA title in 1960 (9-0-1 against state competition), and the Indians went undefeated in 1961, but finished second in the polls to undefeated Greenwood. They were 10-2 in 1962 before embarking on a three-year odyssey to the top of the state charts. The Indians went a combined 28-3-3 (or 30-1-3 depending on the

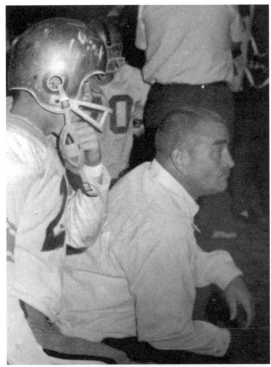

Left: Bob Prevatte starred at Wofford before revitalizing the Gaffney program in the 1960s. *Courtesy of Gaffney High School.*

Below: Henry Porter shows why he was an All-State guard as he roll blocks for Gaffney teammate Jimmy Fowler. *Courtesy of Gaffney High School.*

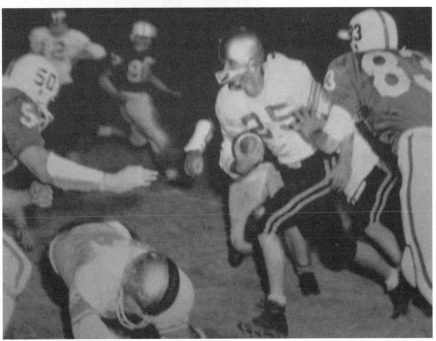

source) using an aggressive defense and high-powered running game. They registered nineteen shutouts over the three seasons and missed a twentieth due to a safety in the 1965 game against Parker.

The 1963 team was led by senior captains Rodney Sprouse, a guard, and Rodney Camp, a quarterback, who both nabbed All-State honors; senior Henry Porter, who was All-State and a Shrine Bowl selection; and junior end Benny Lemmons. Prevatte was the AAA coach of the year in 1963 and, two years later, coached in the Shrine Bowl, bringing his 1965 team captains—Johnny Sarratt and Jimmy Hamrick—with him. The team remained competitive for the next few years but could never reach the top again. The Indians were 9-2 in 1966 and 1967, 7-4 in 1968 and 11-2 in 1969 (the final loss was in the playoffs to eventual state champ Edmunds), and then Prevatte retired. Two years later, the Indians were a losing program.

The Rematch

The 1964 Class AA state title game was one of the most hyped matches in South Carolina history as Easley and Camden faced off the first time since the 1937 title game. Not lost in the hype was the fact that Camden's coach, Red Lynch, had played in that long-ago game that Easley won 13–7 thanks to two first-half touchdowns in front of 1,500 people at Melton Field in Columbia. However, both teams came into 1964 as superpowers. Actually, they were ranked number one and number two in most of the polls, making this a rare Goliath versus Goliath matchup. In fact, Lynch pushed for the game to be moved from Easley's 6,000-seat Brice Field (named after the winning coach in the 1937 game) because it figured to be such a special event. Under head coach Bill Carr, the Green Wave was 11-0 and had given up 44 points all season and scored 326—or almost 30 points a game, which was an amazing total at the time. The defense had put up five shutouts, and the offense had broken 30 points on five occasions. The '64 squad was drawing rave comparisons to the 1962 team that gone 12-0 and outscored opponents 407–27. Sam Mirvos, a scout for the University of Georgia, had been sent to watch every game that season to observe Green Wave talent, including backs Leo Hunter and Tommy Nix, who both ran the one-hundred-yard dash in 10.2 seconds, and massive tackle Beattie Wilson.

Mirvos told the *Greenville Piedmont* on November 21 that Easley would beat Camden by three touchdowns. A bemused Carr overheard this and

shook his head in skeptical amusement. Mirvos then predicted that the Green Wave could beat Georgia by three touchdowns. This came after Nix ran for 163 yards and three touchdowns in the 1964 Upper State AA title game against Woodruff. He did that on four carries. Easley fans were so excited that they hired special cameras to film the game in color for posterity's sake. Camden fans, though, must have found all of this amusing. The Bulldogs were 12-0 and had just given up their first touchdown of the season the week before the title game, and it had been somewhat of a fluke. A Stall runner snuck through the defense and went 78 yards for a score. The offense was led by quarterback Billy Ammons, who had scored fourteen touchdowns in the season.

Ammons said that the coaches read Mirvos's quotes to the players before the game. "It was a great motivational tool," he said. The game was not even close. Camden won 26–0, and afterward Carr called it the "biggest disappointment I ever had," but praised Ammons as the best quarterback in the state.

THE GREATEST TEAM?

Just how good was the team that "upset" Easley? There are many contenders for the title of the best in South Carolina history, but *The State*'s Bob Gillespie wrote in June 2000 that the 1964 Camden team perhaps may have been greatest. The team went a perfect 13-0, but what set these Bulldogs apart was defense. Coach Wallace "Red" Lynch's team gave up (drum roll please) six points all season. And that lone touchdown didn't come until the Lower State title game against R.B. Stall. On the season, they outscored their opponents 307–6. Not that there weren't scares. Rival Sumter scored twice, but both touchdowns were called back in the second game of the season. It seems destiny was in Camden's corner. It was a magical season for thirty-two young men, including Roger Williams, Art Hudson, Ray Robinson and Bob Lynch, one of the coach's two sons.

"Every day, I talk to someone who brings up that season, that championship game," Lynch told Gillespie in 2000.

The team practiced for the season in the mountains of North Carolina, where almost twenty players quit before the season began rather than endure the repetitive grind under the Tarheel sun for two weeks. The practices were hard and physical—even when the players wore only shorts and shoulder

pads, which is normally the cue for a light day. There was no water to drink. Players passed around a sweaty towel to suck on or pulled their T-shirts to their mouths for some nourishment. They often finished practices with sprints up a hill that had to be at least a sixty-degree incline, Ammons said. One player said marine boot camp at Parris Island was a piece of cake compared to those practices. "He was definitely what you would call an old-school coach," said Ammons, who later would succeed Lynch as head coach in the 1970s.

But something clicked.

The 1964 Bulldogs came down from the mountains ready to growl and destroyed Winnsboro 25–0 in the first game. Using an early version of the veer offense that would dominate the 1970s and multiple formation defenses, Lynch's team befuddled every squad they came in contact with. Lynch was ahead of his time in strategy and maybe a little out there when it came to nutrients. He doled out a concoction of milk, sugar and vitamins that he forced players to drink in the locker room before games. Ammons said it was a premade package that Lynch had picked up at a clinic somewhere. Gatorade this was not, and most players saw it going out of their mouths almost as soon as it hit their stomachs.

The defensive streak was the story, and players said they were relieved when it was finally snapped, Ammons said. The next game was against Easley. While the Green Wave were going nuts with anticipation, Lynch used emotion to drive his players. He reminded the seniors that this was their last game and had all of the underclassmen shake their hands. There was not a dry eye when they took the field.

However, this was no dynasty. The 1963 team went 3-8, and the 1965 team went 1-10.

THE START OF SOMETHING NEW

The realm of high school cleared its last major playoff hurdle in 1968. The call for a playoff to decide a championship amongst the biggest schools in the state had been debated, demanded and decried since the late 1940s. Every year, fans complained about the so-called AAA champion (or AA in the earlier years), saying that leaving it up to win-loss records and writers was not the best option. Echoing the debate over a college playoff system two generations later, the reason it was held up for so long was economics. Don

Linn, who was principal at Greenville High at the time, told *The State* in 1997 that schools such as Greenville, Parker, Columbia, Anderson, Greenwood and Dreher were reluctant because they normally played their rivalry game on Thanksgiving Day (or weekend) to packed houses that would make or break their athletic programs for the year. A playoff system would cramp those games. By 1968, the schools took a new stance (possibly due to declining revenues), and the SCHSL adopted its modern AAAA classification.

"The idea was that we didn't really have a champion and the other classifications did. This argument gained strength until finally enough people were interested in it to adopt it," Linn said.

When 1968 unfolded, 190 teams lined up for High School League games. The Class A and AA teams were sorted out into eight regions, the new AAA became five (Eastern, Western, Upper Atlantic, Middle Atlantic and Lower Atlantic) and AAAA had four regions. Of course, things weren't quite equal. Two Class A regions had 3 teams in them, while the Western AAA had 14. However, the big story was AAAA and the first-ever playoffs that put the winners of each region into a lower and upstate bracket. The historic first game came on November 22 as Eau Claire (the defending AAA champs) played Hartsville in Lancaster, and the game was memorable even without the historic context. Down 12–6 with twelve seconds to go, Hartsville's Paul Camarello heaved a pass into the end zone that was batted around several times before teammate Howard Barfield came down with it for six points. The extra point was good, and Hartsville moved on. Meanwhile, Greenwood beat Wade Hampton, whose fans chanted a preemptive and ultimately wrong rallying cry of "We're No. 1," by a score of 17–6. The finals, though, were anticlimactic, as Greenwood rushed for 365 yards in downing Hartsville 41–13 for the 228th win of Pinky Babb's career. The Emeralds saw eleven of twelve seniors go on to play college ball, including Robin Carey at Alabama, Neville File (who later coached West Florence) at South Carolina and Chuck Hundley at Clemson.

Attendance Matters

More than 12,000 people crammed into Greenville's Sirrine Stadium for the annual Thanksgiving afternoon showdown between Parker and Greenville in 1960. The Oakland Raiders averaged 12,469 that year. A few weeks after that game, 23,000 people attended the Shrine Bowl. To put that in

perspective, 16,538 people showed up on average for AFL games in 1960. These games weren't flukes either. More than 8,000 people attended the 1961 Parker-Greenville game even though a heavy rainstorm blanketed the city. The 1963 Shrine Bowl saw 22,500 fans. The 1964 North-South game drew 16,000 people on a sweltering Columbia summer night. It was 15,000 in 1965 and again in 1968. In terms of percentage of popularity, high school football may have been at its attendance peak in the early 1960s. While many schools routinely draw 10,000 people in the early 2000s (yes, we are looking at you, Byrnes and Gaffney), the pro teams average more than 60,000 a game now. When it came down to it, hometown pride trumped pro football dollars in the early 1960s.

FEAR OF THE DIRTY JERSEY

Liberty High coach Stan Honeycutt devised an ingenious way of motivating his players in practice. Starters wore white jerseys, the second team wore red and the rest of the club got blue jerseys at the start of the 1962 season, Honeycutt's third year. The trick was that the white and red jerseys were laundered after every practice, while the blues were allowed to keep the smell of summer stink day after day. Needless to say, the scrub players didn't want to wear the blue, but the options to get rid of them came in two flavors (and they weren't vanilla and chocolate). A player could either quit the team (thus handing in the jersey) or play well enough to get one of the clean red or white jerseys. The handing over of a jersey could occur in mid-practice, Honeycutt told the *Greenville Piedmont* on August 28, 1962. A clean jersey for a dirty jersey. It was a motivational tool that worked, as the Red Devils went 10-1 that season.

THE END OF AN ERA

The 1960s saw black high schools become more organized than ever, as a playoff system was started for state title matches and a popular All-Star game was born in the middle part of the decade. Some of the biggest stars in South Carolina football history played at black schools in this era, including future Pro Football Hall of Famer Art Shell of Charleston's Bonds-Wilson, fellow Hall of Famer Harry Carson at Wilson in Florence, future AFL Hall

of Fame linebacker George Webster of Anderson's Westside and Denver Broncos star Barney Chavous at Schofield in Aiken. But much like the Negro Leagues reaching their apex just as the color barrier was broken by Jackie Robinson and Branch Rickey a generation before in baseball, the black high school football teams were heading toward oblivion due to the changing world around them.

Even if players were separated on Friday nights, they managed to find one another on the sandlots. Ulysses "Pic" Dawkins was a star at Granard High, which was the state's top black power, in the mid-1960s, while across town, Gaffney High was the state's top white team. He said players from each school would often meet for integrated pickup games on Saturday afternoons. It wasn't any political battle, he told the *Spartanburg Herald-Journal* in March 2010. It was about guys playing football. They joked that if the two teams combined for real, they would never lose a game.

Carson remembered the togetherness of the black schools. Wilson brought kids in from across Florence, which created a melting pot of sorts. "It was a lot like family," he said. He tried out for the team as a freshman simply to meet girls but realized that he was not in shape to play. He quit after the first day. However, he came back the second year and became a star defensive end. He remembers the marching bands would play contemporary music that was being heard on the radio, such as the Jackson Five, as opposed to the typical souzas played elsewhere.

Things started to change almost by accident against the backdrop of the civil rights movement. The all-black New Bethel High in lower Spartanburg burned partially down right before the 1966 school year. Faced with what to do with black students, the Woodruff-area school board voted to integrate. Head coach Willie Varner got down to business almost immediately, said Keith Richardson, who was an assistant at Woodruff that year. He said the new players would be treated as equals. Initially, only two black players joined the varsity roster: Butch Stephens and Larry Fryer. The team picture shows them standing in the second row between Joey Cox and Barry Burke. The 1967 yearbook mentions that their hard running was a key to the team's successful 8-2-2 record and a conference championship. Wayne Sloan, who was one of three generations of Sloans to play in a Woodruff state championship, was one of the team's cocaptains that year. He doesn't remember Varner giving any stirring speeches about integration, but the legendary coach made his will known. Stephens and Fryer were part of the team and would be treated the same as anyone else. "They were good guys, and pretty good football players," Sloan said. "There was no problem."

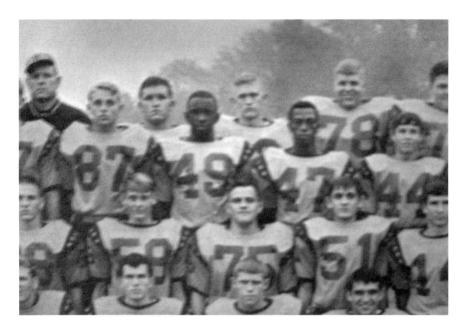

Butch Stephens (49) and Larry Fryer (47) integrated high school football in 1966 at Woodruff. *Courtesy of Woodruff High School.*

Stephens played fullback and kicker, while Fryer was the tailback. While Sloan said teammates accepted them, there was one incident against Newberry. A defensive player was hurling insults along the line at Fryer. If Fryer lined up left, the Newberry player would yell, "N-word left." The same derogatory term would come up if Fryer was on the right side. Did the Woodruff players come to their teammates' defense? "We won 40–0. That proved our point," Sloan said more than forty years later.

Despite the start of integration at Woodruff, black schools were getting more interest than ever. The 1967 All-Star game was played at Benedict College in front of eight thousand fans. The Lower State team beat the Upper State team 7–6 to even the series at two each. There was no mention of skin color in *The State* recap on August 4 (which was the same day the North-South recap occurred).

The 1969 season was the last season of segregated play, and there were warning clouds forming. Perennial powers Booker T. Washington and C.A. Johnson were barred from the playoffs for using ineligible players, according to a November 21 edition of *The State*. The final game of the era came on November 27, when Wilkinson beat Barr Street 28–15 for the last state title.

RADIO

There have been many stories of exuberant fans, but few have become as well known as T.L. Hanna superfan James "Radio" Kennedy. Sure, some have made their way onto ESPN2, as Kennedy has, and some have even been interviewed on the *Today Show*, just like Kennedy, but how many can claim a movie and a statue? Well, that's just Kennedy.

Mentally disabled at birth in 1946, Radio got his nickname because he often was seen with a small radio up to his ear as he traveled around Anderson pushing (and sometimes riding) a metal grocery store cart. Barely able to speak, he was almost killed twice after being hit by cars and was bullied by many people. Family assumed the radio to his ear was his only outlet to the rest of the world. He happened upon the Hanna (then known as Anderson High) junior varsity practice in 1964 and became entranced. Many people would have shooed away the strange young man (the players themselves laughed when they saw the eighteen-year-old Kennedy mimicking their movements), but the team's coach, Harold Jones, offered him something to drink. The white coach and the black disabled youth formed a bond, and soon Kennedy became a fixture as the football team's manager and then as a student in special education classes. When he became too old to be a student, he began "working" at the school but kept up the appearance of a "perpetual junior." It was puzzling to the families of both in the beginning, but Gary Smith got to the heart of the matter in his 1996 *Sports Illustrated* article that first let the rest of the world know about South Carolina's most famous fan. For all of his stoic, hard-as-nails appearance, Jones had always been about helping underdogs. He used to fight anyone who picked on a neighbor when he was a youth and used to sneak a disabled man into his grandfather's theatre free of charge.

And Kennedy loved the attention. His halftime show became part of Hanna games, as he would burst onto the field like a deer, bend into the center's crouch, snap the ball to himself, run some errant circles that would have made Fran Tarkenton proud and then run for an imaginary score as the real crowd cheered in amazement. There are many tales of Kennedy's honored place amongst students. He sometimes would run track in the lower heats only to stop after barely running a few feet. Players protected Kennedy from any kind of bullying and brought him hamburgers on game days. Kennedy cut up with them on the sidelines. There was a time when there was no room on the bus in the 1970s, and Kennedy stood crying as the

team drove away without him. Jim Fraser, the head coach at the time, vowed afterward that Kennedy would be the first person on the bus ever after.

By the 1990s, Kennedy was more than just a fan, though, as Smith wrote:

> *He would start out as the official greeter, holding open the Hanna program to make sure all arriving fans saw his photograph and hoisting up his pants legs to make sure everyone got a gander at his new pair of shoes—"Wook at my Weeboks!"—along with his socks, one white and one black. Then, dropping one drumstick and seizing another, he would commandeer the bass drum as the Hanna band made its knee-pumping entrance, quickly double back to wolf down a free hot dog and then scurry up to the press box to become the radio color commentator, barking over the WAIM airwaves, "We gon' beat dey butt!" All at once it would occur to Radio that he was also Hanna's coach, and he'd bolt down onto the field to yelp stretching instructions to the team during warmups—"You roll dat neck, boy!"—and then back to the bleachers to scarf some free popcorn and sign his autograph.*

But there was a much larger effect on Kennedy. Former assistant Dennis Patterson told the *Anderson Independent-Mail* in 1983 that "you could see Radio's mannerisms and personality change the longer he attended practice. It was as if exposure to athletics and young people was a kind of therapy for him."

A movie about his life was filmed partly in Anderson as well as Walterboro and was released in 2003 starring Cuba Gooding Jr. and Ed Harris. A bronze statue of him was erected in 2004.

THE ALMOST UNSTOPPABLE BENNY GALLOWAY

In the 1962 AA state title game, the only thing to stop Benny Galloway was Benny Galloway. The junior speedster scored on a sixty-four-yard screen pass, picked off a Garrett High pass and then made a forty-six-yard run to the goal line. He scored on a touchdown pass a few plays later but had to leave the game. He landed on the football on the score and had the wind knocked out of him. Galloway may or may not have been lying afterward when he stated, "They're tough, tougher than anybody we've played." Garrett coach Gene Limehouse remarked afterward how well Galloway played. "On every one of those runs by Galloway we had boys in position

Benny Galloway's speed was legendary at Easley. *Courtesy of Easley High School.*

and they didn't make the tackle," he told the *Greenville News* after the game. "Getaway" Galloway was named All-Southern and All-American that season but missed almost the entire 1963 season with a leg injury. The *Greenville Piedmont* stated that despite the injury, Galloway was one of the most sought-after players in state history, and he ended up at USC. He was selected to the North-South game in 1964 despite barely playing the season before. The *Piedmont* noted that a "distinctive yell" went up from Easley fans every time he entered the game. He later was inducted into the City of Easley Hall of Fame.

"WE HAD 23 AND THAT WAS GOOD ENOUGH"

Parker's Mike Fair was a quarterback like few others in the 1960s. Some were nearly as fast on their feet as Fair, and some could throw the ball as far, but few could do both as well or mean as much to their team. For two seasons in 1962 and 1963, Fair was essentially a one-man show for coach Whitey Kendall's last truly great team. And at 180 pounds, he outweighed his offensive linemen, who averaged 175 pounds to a man. Greer's Phil Clark called him the "best quarterback I've seen" after Fair led the Golden Tornadoes to their first ever victory over the Yellow Jackets in a 20–10 1962 game. It was one of many highlights for Fair, who went five of seven for 112 yards in a 17–0 win against the dominating Gaffney team and then went seven of eleven for 212 yards in the annual Lions Bowl against Carolina High. The Lions Bowl was famous for its postgame fireworks, but the November 3 *Piedmont* said that the fireworks were ignited early by Fair. Parker ended the season 9-3, its best record since 1956. Almost twenty years later, Kendall referred to Fair as his "knight in shining armor" in a story in the *Greenville News*.

Fair was a marked man in 1963, but that did not stop the highlights. He scored a seventy-one-yard touchdown on a fake punt to beat Spartanburg 7–0. However, the Golden Tornadoes struggled as teams relentlessly attacked Fair on the ground and developed defenses to prevent his long passes. All of this led to the final time at which he was to wear number 12, the annual Thanksgiving Day game for the Jaycee Trophy against Greenville. The *Piedmont* and the *News* covered every aspect of the practices that week but apparently missed one key thing. Fair wrenched his knee in a tackling drill that Monday and likely wasn't going to play. Fair even added to the subterfuge by being quoted in the papers about how excited he was to be playing his final game. On Turkey Day, he watched the entire first half as Parker fell hopelessly behind. He came in during the third quarter and briefly rallied his teammates on almost sheer will alone. Barely able to move, he tossed one touchdown, but it was too little too late as Greenville won 48–20. Fair was still limping around when the Shrine Bowl game kicked off a few weeks later. As the state's Big 16 Back of the Year, he decided to play anyway but sat out the first half. However, Clark, who was the game's coach, decided to install Fair to see what would happen. "Each time he went in, the players fell right behind," Clark told the *Piedmont* on December 9.

Wearing number 23, Fair tossed one touchdown and bowled over a tackler on a six-yard touchdown in the fourth quarter to seal the 23–13 victory. Walking off the field, a late-arriving fan allegedly yelled to Fair asking what had happened in the game. Tugging out his jersey and pointing to the scoreboard, Fair hollered, "We had 23 and that was good enough."

Fair would go on to be a three-year starter at quarterback for South Carolina, playing for the famed 1965 team that forfeited the ACC championship because of ineligible players. It would have been the school's first ever title. He would later spend two seasons on the San Diego Chargers' taxi squad before being shipped to the Oakland Raiders. His time with the Raiders was extremely brief, he said. He showed up, Davis interrogated him for the Chargers' playbook and he was cut again. Fair jokes now that he was gone from the Raiders before the announcement that he had joined them made the East Coast wire services. He later would get elected to the state House of Representatives in 1985 and the state Senate in 1995.

SOME THINGS NEVER CHANGE

While many fans now prefer to fight one another in cyberspace via message boards, tempers periodically flare on game night in the modern era, and that leads to enough punches, head butts and eye gouges in the stands to make a pro wrestler take notice. Afterward, there are many tsks, tsks and clucking of tongues about how violent society has become, but a fight after the 1961 Parker-Greenville game shows that nothing is new. Angry over a fourth-quarter penalty against Parker, fans on both sides jumped railings and filtered down the steps that lead directly to the Sirrine Stadium field to do battle. The November 24 *Greenville News* reported that at least one police officer was struck by a fan, and the referees hid in a dressing room until order was restored.

Fans also found a way to make their voices known even without their fists. The *Greenville Piedmont* had been conducting a poll of sportswriters since 1947 to declare an annual state champion. Originally, the poll was dominated by the largest schools that did not take part in the playoff, but many of the smaller schools began to creep into the polls in the late 1950s and early 1960s. Soon their fans were wondering why their teams were treated as second-class schools because they were never declared the state champ. The November 27, 1962 *Piedmont* was flooded with letters from the fans of the undefeated AA state champion Easley Green Wave. It included a formal letter from the school's booster club charging that the polls were rigged. The *Piedmont* staff fired back that the poll was the opinion of the writers and asked how could one man "be wrong about his opinion." It should be noted that Easley was atop the final poll that came out two days later. There were no angry letters from the 29640 zip code afterward.

NOTES FROM THE SHRINE BOWL

The big Shrine story of the decade was a lawsuit filed in November 1965 against the Charlotte-Mecklenburg School Board and the Charlotte Parks Department claiming that the Shrine Bowl should not be held because it prevented blacks from playing. The lawsuit was filed on behalf of forty-one blacks by an attorney named Julius Chambers, who reasoned in court papers that since the game took place in the city stadium, it was a city-sponsored event and should not be segregated. While he represented forty-one people,

the main plaintiff was Jimmy Kirkpatrick, a Myers Park High star, whom the *Spartanburg Herald* referred to as one of the top running backs in North Carolina on November 10, 1965. Myers Park was an integrated school, and two white players were on the Shrine Bowl roster. The North Carolina coach, as well as Shrine Bowl officials, denied any charges of racial discrimination in the press that same day. Charles Hancock, the game's general manager, said there was no ban on black players but said any decisions were left up to coaches. Judge J. Braxton Craven's ruling on November 19 alluded to the fact that blacks were at a disadvantage but did not block the game. Instead, he postponed any ruling until March 1966. Needless to say, it was not going to be a pretty situation. Chambers, who was the first black editor-in-chief of the law review at the University of North Carolina School of Law and graduated first in his class in 1962, was very active in the civil rights movement of the mid-1960s. A few months before filing the Shrine Bowl suit, his car was blown up with dynamite as he met with families at a nearby church. A few days after filing the suit, his house was firebombed, along with those of three other prominent black leaders in the Charlotte area. Chambers said in a documentary on North Carolina television that he believed it was due to the suit. The case was eventually settled out of court, and the game was integrated as West Charlotte's Titus Ivory and Sylvia-Webster's Tommy Love broke the color barrier the next year.

By the way, South Carolina won the 1965 game 31–27.

Other years, though, weren't as contentious but did offer some memorable moments. A young John McKissick was the head coach in the 1960 game, and it's hard to believe that McKissick remains at Summerville fifty years later. It's also hard to believe that he has not coached in the game since but has sent sixty-nine players to the Shrine Bowl in the past half century. McKissick's team won 19–3. Greer coach Phil Clark summed up the coaching experience when heading into the 1963 Shrine Bowl. The game itself was easy; "it's picking the players, that's the hard part." For example, Clark had more than sixty recommendations for halfback. Clemson's Frank Howard apparently agreed. He was quoted in the *Greenville Piedmont* on December 8, 1963, stating that he "would like to have a good many of them." Despite the changes in the strategy, though, the Shrine Bowl offense stayed behind the times. For example, the 1966 South Carolina team still used the single-wing offense.

There were other story lines. The 1964 game was a mess, as rain covered the Greater Charlotte area on the first Saturday of December. The downpour started just as the singer finished the National Anthem,

and suddenly it was pouring "cats, dogs and skunks on 22,000 spectators, who quickly became 10,000 spectators," according to Walter Klein's *Bowl Full of Miracles*. While South Carolina slipped, slid and scored enough to win 20–6, the halftime show that was to feature two thousand members of local marching bands was called off.

There were thirty-three players on the 1968 team coached by Olympia's Bobby Giles. South Carolina won the 1969 game 21–7 on a tremendous defensive effort that included four interceptions and two blocked punts along with a little late 1960s moxie. Parker's Mike Hawkins, who snared one of those interceptions with a leaping grab showed frame by frame in the next day's *Charlotte Observer*, recalled almost forty years later, when he was about to coach in the game for the first time, that the Sandlappers all dyed their cleats white before the game for good luck.

In 1969, Chapin's Marty Woolbright was named to the South Carolina team, making him and his father, Cecil, the fourth such father-son combo. The other three were Bettis and Rod Herlong, Ken and Mike DuBard and Bobby and Glenn Giles. Of course, the Woolbrights and Gileses weren't done filling Shrine Bowl rosters until the 1970s. Some stars of the decade included North Augusta's Charlie Waters in 1965 (Waters played quarterback in the game but gained fame as a hard-hitting All-Pro safety in the 1970s with the Dallas Cowboys); Pickens's Rick Anthony in 1967, who later played in the WFL; and Union's Darrell Austin and Columbia's Mel Baxley in 1969. Both played in the pros. Another recognizable name and voice is Tommy Suggs of Lamar, who played quarterback in the 1966 game and later started for USC and then became their longtime radio announcer.

On a final note, the Sandlappers won seven of ten games in the 1960s.

Over at the North-South Game

More than eleven thousand people packed into Columbia's Memorial Stadium in 1960 and witnessed one of the most thrilling North-South All-Star games ever recorded. With twenty-five seconds left and the clock ticking away, Sammy Anderson of North Augusta and Florence's George Corbin hooked up for a four-yard touchdown pass to secure a 14–14 tie, the first stalemate in the game's history. It was a harbinger of things to come, as the 1960s proved to be consistently the game's best decade. The 1963 game was a 14–0 victory for the North in eighty-five-degree heat.

The 1964 game came down to a last-second push. The North led 3–0, when the South drove to the two-yard line with two seconds on the clock at Carolina Stadium. On the last play, Saluda's six-foot, three-inch, 180-pound quarterback, Ray Hesse, plowed into the thriving, thrashing line. Pumping his legs for two seconds, he slipped through a crack and fell forward for the touchdown. Lancaster's Wade Corn, who coached the North team, told the *Greenville Piedmont* afterward that he was crushed. Hesse and Ken Ackis of Daniel were players in the game.

The 1966 game was another South victory, 21–14. The 1967 game was plagued by injuries from the start as several players, including Whitmire's Jack Rose, Chicora's Jimmy Ruppert and Walterboro's Bob Cave, were knocked out during practices that week. However, Lower Richland's Allen McNeill, wearing a white jersey with the number 10 on it, was healthy as ever and rolled over the North offense for 133 yards and a touchdown to lead the South to a 20–7 victory. It was another South victory in 1968—this time 22–14—after the teams had spent the week practicing at the Rex Enright Athletic Center in Columbia. Florence's George Tyson led the South offense with eleven of sixteen passing for 181 yards and one touchdown. The South ended up with seven wins in the 1960s, making it their best decade in the game's history.

STATS, STORIES AND STARS

Conway's star player, Buddy Gore, and head coach Buddy Sasser had a relationship that went beyond the same nickname. Sasser first met Gore in 1956 when the latter hired him to work at his boiled peanut stand in Myrtle Beach. When Sasser took over the Conway program in 1960, his first star was Gore, who scored five touchdowns in a game that season and later at Clemson became the first player to lead the ACC in rushing twice.

Curtis Lee Felkel was the smallest player in the state when practice opened on August 13, 1961. The sophomore quarterback at Cameron was listed as 85 pounds. The biggest player in the state likely was Swansea tackle Leonard Jeffcoat, who weighed 342 pounds.

One of the strangest playoff games in state history occurred on November 3, 1961. After a scoreless regulation, Winnsboro and Union went to overtime, which was decided on the team that gained the most yards on four plays. Union's Alonzo Jackson recovered a fumble on Winnsboro's first snap, and

the Yellow Jackets proceeded to produce a whopping five yards on four carries to win the game.

Heading into the final seconds of their 1962 opener, Wade Hampton's Joe Clark returned an interception ninety-seven yards for a needed six points to break a 0–0 tie. As Anderson's Howard Bagwell tried to rally his team for another play, the fans at McCants Stadium poured over the walls. Bagwell saw the mayhem, said, "Forget it" and walked off the field.

Brewer's John Gilliam may have been one of the best basketball players in the state in 1962, but he kept fouling out of games because of constant double teaming. Looking to channel his anger and hit someone without getting called for a foul, he went out for football as a senior. He broke his nose on the first day of practice and absolutely loved it. He went on to become the first player ever selected in the NFL draft from South Carolina State, scored the first touchdown in New Orleans Saints history and then made All-Pro with the Minnesota Vikings.

Union mayor Bill Stribling vowed he would walk home if the 2-2-1 Yellow Jackets lost to the 5-0 Gaffney Indians on October 4, 1963. Stribling was "rescued" by the local fire squad in the waning moments of Union's 25–6 loss. It is unknown if Stribling ever made another prediction.

Greenville High's Freddy Kelley scored on touchdown runs of fifty-nine, seventy-seven and fourteen yards, caught a forty-yard touchdown pass and picked off an Asheville High pass in the Red Raiders' 27–14 victory in 1963.

The Bamberg Red Raiders won twenty-five straight games in 1963–64. Their streak was snapped in the 1964 Class B title game to Kershaw. The aftermath was that the Indians came out of nowhere to end up ranked sixth in the state. Meanwhile, Bamberg High merged with Ehrhardt in 1965, but went 4-4.

One of the decade's biggest upsets was in the 1966 AA title game when Daniel routed the state's number-one ranked Berkeley Stags 20–6 on the strength of its "ghost defense" that picked off four passes and recovered two fumbles. On offense, Shrine Bowler Johnny Campbell galloped for 157 yards, including a 72-yard touchdown run.

Greenville coach James Moore was so giddy following his team's 1966 victory over Parker that he gave all thirty-five players a block letter for the year.

Jim Youngblood started five seasons for tiny Jonesville in the late 1960s. He went on to become an All-American at Tennessee Tech and then spent twelve years in the NFL, mainly with the Los Angeles Rams, where he played in the Pro Bowl and Super Bowl following the 1979 season.

Nowadays, sports teams visit political figures in office, but Governor Robert McNair took his daughters Corrine and Claudia to the 1967 Richland Sertoma Club's Sportsarama, which was a preseason super scrimmage among Columbia-area schools.

Crescent's Bob Alexander ran for a then state record of 2,609 yards in 1967. The record lasted until 1984.

Allendale-Fairfax rolled over Kershaw 39–6 in the 1967 Class C title game as running back Don Houck ground out 195 yards and four touchdowns.

THE 1970s

A New Era Marked by Dynasties

If there was a story of the 1970s, it was race. From the challenges of desegregation in 1970 to a controversy over the number of black players on the Shrine Bowl roster in 1979, racial battles served as near tragic bookends for the decade. The mixing of black and white players was on everyone's minds. Desegregation came about due to a federal order in the winter of 1970 ending the state's mostly strict adherence to "separate, but equal." Basically, "freedom of choice" would become the rule of the land. There had been some white schools that already were using black players, most notably Steeler great Donnie Shell at Whitmire and Terry Smith quarterbacking the Easley Green Wave to the Upper State AAA finals in 1969. Woodruff had integrated in 1966, when the area's black school, New Bethel, burned down. Keith Richardson was an assistant coach when Woodruff integrated and was heading into his second season as Clinton's head coach in 1970. The mood was definitely more ominous in 1970 than it had been four years earlier. While he said there were no problems amongst players, there was a definite animosity off the field amongst fans. "One group was on one side of the practice field and another was on the opposite side, and they both wanted us to lose," he said.

On the playing field, that meant for an interesting summer in 1970 as teams reported to camp across the state. Scores of schools were no more— gone because of the end of the predominantly black schools. The handful that survived were in somewhat of a precarious situation. In Anderson, school officials integrated the previous all-white Anderson High (now known as T.L.

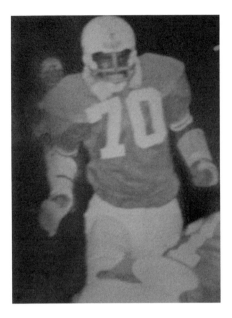

Harry Carson was one of many star football players who switched schools during integration in 1970. *Courtesy of the Florence County Library South Carolina Room.*

Hanna) and the previously all-black Westside. However, coaches on both teams expressed concern even as camps started on August 11 about not knowing what players were going where. One of the biggest names was rising senior receiver Ed Rice, who was coming off a summer of starring in the state American Legion tournament. Rice would make the Shrine Bowl that season and cap his career thirty-eight years later when he went into the Baseball Hall of Fame in Cooperstown, better known as Boston Red Sox slugger Jim Rice. It was a similar story in Florence, where coaches were unsure if defensive tackle/ linebacker Harry Carson and fullback Ulysses Lee would play at Wilson, the former all-black school, or McClenaghan, which had been all-white. In the end, Carson went to McClenaghan (and later the Pro Football Hall of Fame) and Lee stayed at Wilson. Carson said there was some trepidation because there were no black coaches at the new school, and things came to a head late in the season. He was running on a sprained ankle when the coach barked at him to run harder or go home. Carson took it literally and walked off the field. The coaches kicked him off the team for the last two games. Carson was labeled a malcontent, which was odd considering he was chairman of the school's biracial committee, senior class president and an ROTC commander. Using the hindsight of forty years, he wonders if things would have been better if there had been a black coach on staff. Ultimately, the missed games kept him out of the all-star games, and he had no solid offers from colleges. It wasn't until that May that a black teacher named Dorothy Jo McDuffie drove him to South Carolina State, where he got a scholarship to play. "The rest, as they say, is history," Carson said.

While black schools such as Wilson, Westside and Booker T. Washington survived segregation (though Washington would close as a high school within a few years), the vast majority of the 125 all-black schools were

rolled into white schools. Whittemore merged with Conway and went to AAAA; Camden got Jackson High; Hannah-Pamplico drew Gibbes and changed its mascot from the Rebels to the Raiders; Winyah got Howard; Loris gained Finklea; Aiken added students from Schofield; Pacolet grabbed Mays; and Spartanburg took on Carver and changed its name shortly after from the Crimson Tide to the Vikings. One of the new coaches, James Talley, who later became Spartanburg's mayor, said there was a lot of tension over how many whites and how many blacks would start. Other schools formed anew from the changes, including North Myrtle Beach, which had been Wampee-Little River and Chestnut; Spring Valley was formed from Dentsville and Blythewood and hired Joe Turbeville from Winnsboro as its coach; and Eastside formed from a host of different schools, but as of August 14 of that year—three weeks from the start of the season—it had no colors, nickname or coach. Mack Edwards, however, would be hired a few days later, according to the *Greenville News*. And then there was the story of Bonds-Wilson in Charleston. It went from all-black in 1969 as a dominant football team to opening 1970 with just a 30 percent black population and just four lettermen coming back under new head coach Joe Thompson. The *Greenville News* succinctly summed up the upcoming season and the massive changes ahead simply by saying that "new problems" await in the August 13 edition.

Moses Rabb, a staff member at the Center for Integrated Education in South Carolina in the early 1970s, told *The State* in August 1990 how many blacks felt about the decision to integrate:

> *What would happen, typically, is that there would be a meeting someplace, usually at the board level, and the decision to close schools would take place. The black high school, typically, would become the middle school—sometimes it would not be used as a school—and the former white high school would become the integrated school. Blacks were expected to move into the white high school, and it was supposed to be one happy family…The compromises were expected, naturally, to be made by blacks, under the guise of "We're getting a better educational opportunity." The pride and joy one takes in having a high school in his community got lost; the black kids were going to the "white" high school. The ownership thing got lost.*

A Decade of Dynasties

One of the unusual things about the 1970s was the number of dynasties that emerged. Most decades had two or three teams make serious runs at history, but this decade had much more. Spring Valley won AAAA state titles in '73, '74 and '75 and made a title game appearance in 1977; Clinton made six title game appearances between 1972 and 1978 and won three times; Woodruff made a run for the modern national record of five straight titles (the all-time record at the time was six by the legendary Paul Brown in Ohio) in the late 1970s, but fell short when Batesburg-Leesville dropped the Wolverines in the 1979 title game. Woodruff also made a sixth AA title game appearance in 1972. Lake View, Chapin, Swansea and Summerville all won back-to-back titles in this decade as well. A lot of it had to do with attitude, many coaches and players from the era said. Each of the championship teams had a singular persona. Richardson's Clinton team ran his famed power wishbone that more or less is still employed by the Red Devils three decades later. Richardson said his offense was a continuation of what he had learned under Varner at Woodruff and, before that, as a player at Presbyterian College. It often produced great results, including Millard Dawson's then state record 353 yards in one game in 1973. Yet, even Hall of Fame coaches sometimes make mistakes. According to a November 2009 *State* article, when Clinton absorbed the all-black Bell Street High in 1970, one of the incoming players was a sophomore named Kevin Long. Richardson took a look at the young man and projected him as a guard. Long had other thoughts.

"I always felt in my heart I wanted to be a running back. I can remember seeing Jim Brown on a black-and-white TV, and I said, 'That's cool. I want to do that,'" he told *The State*.

Long took off the 1971 season and ran track to show his coaches what he could with his legs other than serve as a pulling guard. An assistant coach who worked with both the football and track teams recruited him back to the football squad in 1972, with Richardson taking him back on the condition that if he didn't tote the rock well enough he would head back to the line. Long was not long for playing the line. He became a vital cog in the 1972 championship running game, including scoring what Richardson called the most famous play in Clinton football history. Playing in the Upper State championship against Pickens, Long vaulted a Blue Fame defender in stride while rushing for the winning touchdown. The University of South Carolina coaches took notice and brought Long to Columbia as a running back. He rewarded the Gamecock faithful with the program's first ever one-thousand-

Joe Turbeville successfully led two programs to state titles in the 1970s. *Courtesy of Spring Valley High School.*

yard rushing season in 1975 and then eight years in the NFL and USFL, which included one-thousand-yard seasons with the Chicago Blitz in 1983 and the Arizona Wranglers in 1984. His honors include induction into the USC Athletic Hall of Fame in 2002 and the South Carolina Athletic Hall of Fame in 2003.

The Woodruff teams relied on stifling strong defenses. From 1975 through 1979, the Wolverines went 59-8-1 with 37 shutouts. The undefeated 1976 team blanked nine of thirteen opponents and gave up 39 points on the season. The 1977 team shut out its last five regular season opponents on the way to an 11-2-1 record. The 1979 team, though, may have had the strangest season. They lost their first two games but ran off 10 straight, including 3 straight shutouts, and were leading Batesburg-Leesville 21–15 in the final when the bottom fell out. The Panthers broke the Woodruff hegemony on AA 42–21. Afterward, a surly sounding Varner told the *Greenville News*, "I think that's the first time I ever saw a Woodruff team quit." Varner's fame spread to the pages of *Sports Illustrated*, where he was profiled in the iconic "Faces in the Crowd" section in December 1978.

Spring Valley won its first two state titles while playing at home (the AAAA title game was annually hosted at Harry Parone Stadium), but harkening back to the days when Gaffney fans complained that the state title favored the home Columbia team in the 1920s, the 1975 game was moved to Williams-Brice and ushered in the modern era of the championship being held in a major college stadium. It made no difference, as the Vikings rolled again on a defense led by linebacker Rick D'Eredita. Turbeville said it was passion and determination that had as much to do with the team's success as anything. "They all played as one…they played hard for each other," he said.

The '78–'79 Summerville teams were an example of a team coming together after a frustrating decade for John McKissick's Green Wave. They had lost in the first rounds of the 1970 and 1971 playoffs after dominating their regions. The 1972 edition lost in the second round, as did the 1973 team. The 1974 team lost in the first round, and the 1976 team had been absolutely devastating, going 13-0 (including a 73–0 rout of Goose Creek) before getting crushed itself 47–7 in the title game by Greenwood. However, there would be no misses in the decade's last two years, as the Green Wave went 28-0 on the way to its state record 41 straight victories. In August 2002, *The State* ranked the 1979 Summerville team as the fourth best in South Carolina history and the 1978 team as the eleventh. The late disco-era Green Wave were powered by Perry Cuda, a *Parade* All-American quarterback who went to Alabama, and tailback Stanford Jennings, who would go on to play on four Southern Conference championship teams at Furman while rushing for a then Paladin record 3,868 yards and thirty-nine touchdowns. He later would bring back a kickoff 93 yards for a touchdown in Super Bowl XXIII. McKissick told *The State* in 2008 that Jennings was a strong runner—not the fastest, but always the most driven.

"I remember us being behind in a game at Middleton [High] his sophomore year," McKissick said. "He was so determined to win that doggone game, he wouldn't go down. After we won, I thought, 'We've got something good coming here.'"

THE BEST TEAM NEVER TO WIN A TITLE

Missing from that list of dynasties is Spartanburg High, which in 1973 and 1974 rolled up points quicker and faster than any team in state history before or since. The 1974 team averaged 57 points a game through the first eleven

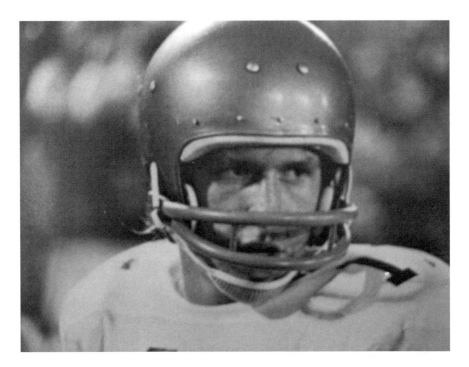

Steve Fuller surveys the action while at Spartanburg High. *Courtesy of Spartanburg High School.*

weeks of the year, including putting up 70 or more in three straight games. The 1973 team was dangerous but looks anemic when compared to the '74 squad. It averaged 36.3 a game while rolling to a 12-0 record. The problem was the offense went flat in their two losses during those two seasons, both of which came in the playoffs. That meant that despite all of the numbers put up by Bill Carr's team, they took home no state titles. The 1973 team lost in the state final, and the 1974 team was upset 24–6 by T.L. Hanna in the second round when the Yellow Jackets deciphered the Vikings' line signals and shut down their running game. The team's star, Steve Fuller, told the *Herald-Journal* in 2009 that it was just bad luck.

"We dressed about 100 players, which was a lot of kids, and were about two- or three-deep [at each position]. We ran a pretty consistent offense that a lot of teams couldn't cope with. But all that was for naught because we didn't win the state championship," Fuller said.

Fuller was called the ideal of the "ancient, Greek athlete" by *The State*, and the accolades have not waned in the past thirty-five years. The six-foot, three-inch, 190-pound signal caller was a gifted runner with an arm

that fired laserlike passes downfield—many times to future pro baseball star Wayne Tolleson. Fuller passed for 2,082 yards and rushed for 1,538 in just two varsity seasons. Against archrival Dorman in 1973, he scored five touchdowns (two on the ground and three in the air) while running for 139 yards and passing for 82 in the 35–0 victory. He upped the ante in 1974, throwing for three and running for three in the Vikes' 63–13 blowout. O'Neil Poteat, who worked the chains for Wofford and Spartanburg games for forty-two years, told the *Herald-Journal* in November 2000 that Fuller was the best he had ever seen. "He would get to play the first quarter, and they'd take him out," Poteat said. "Of course, the score would already be 24–0 or something."

Fuller had talents off the gridiron as well. He was ranked first academically in his senior class of almost eight hundred students, he was considered a top baseball prospect and he entertained basketball offers from Dean Smith at North Carolina. A recruiting frenzy grew around Fuller. A legend is passed down that Fuller bought a junker of a car after the season ended that was red with a black door (or black with a red door), and immediately Georgia fans were ecstatic at the thought of him being a Bulldog. However, he chose Clemson. Les Timms, the *Herald-Journal*'s longtime sports editor, wrote in December 1999 that his decision changed recruiting in the state forever. "It was Fuller who made a major impact on sports in this state, in my opinion. His decision helped convince many athletes to stay in the state and play for Clemson or Carolina," Timms wrote.

Fuller truly blossomed at Clemson. He led a resurgence in a waning Tigers' program that paved the groundwork for a 1981 National Championship. He was third-team All-American and first-team Academic All-American in 1978 and was ACC Player of the Year in 1977 and 1978. He was picked in the first round of the 1979 draft and later sang in the Chicago Bears' infamous "Super Bowl Shuffle" rap video that predicted the team's Super Bowl XX victory. Clemson retired his number 4 jersey and put his name in its Ring of Honor. Spartanburg High encased his former locker in Lucite and put it on permanent display outside the basketball gymnasium in 1996.

"Spartanburg High School is very special and always has been to me. One thing I learned playing at Arrowhead Stadium and Soldier Field is that it's overrated. It was never as much fun as getting on the bus on Friday night and going to play at Snyder Field. It's sports in the true spirit of the game. Being out there with my buddies will always hold a special place in my heart," Fuller said during the ceremony honoring his career.

THE TEAM THAT CAME TO PLAY

Integration flooded many schools with new players and caused many "small" schools to suddenly get "big." That included Lower Richland, which won the tiny Class A championship in 1967 but all of a sudden was in the gigantic AAAA in 1970 based on attendance, if not roster.

The team had just thirty players, and none was heavier than two hundred pounds. They were roughly the size of a 1930s state championship team—not a team trying to beat the likes of Gaffney, Hartsville and Greenwood in 1970. What they lacked in size, they made up in attitude. According to a November 26, 1996 article in *The State*, the team wore shirts emblazoned with "Can't Beat the Creek" on one side and "No. 1" on the other when they broke preseason camp in an effort to announce to the rest of the state that the AAAA title was their goal. Bob Spear eloquently spoke about the team:

> *Still, they could dream, couldn't they? They could dream of a rerun of David and Goliath, couldn't they? They could dream of winning the state championship after losing in the Class AAA semifinals a year earlier by one skinny point, couldn't they? They did more than dream. They won. They won the state championship, and galvanized a community like never before and probably never again.*

Maybe a tad melodramatic at the end, but Spear found a team with a memory and surprising talent. The offense scored 381 points on a little more than five thousand yards. The defense allowed less than one hundred yards per game rushing while forcing nineteen fumbles and intercepting twenty-nine passes. Led by Tommy Middlebrooks and Homer Dinkins, who each went over one thousand yards, and a 125-pound quarterback named Thomas Edmonds, the team out-duked and out-hustled everyone it played.

The team inspired a fan base that did things such as attach a horn to a car battery in the stands to give amplification to their cheers. Businessmen went on vacation to attend the preseason camp. More than twenty-five years after winning the title for coach Mooney Player, the offensive team could still recall all of their assignments on the championship-winning drive. They told stories of sitting on their helmets as the dawn sun broke over the horizon at the start of practices, having a full scrimmage before the state semifinals against Sumter and doing forty-yard wind sprints at the end of practice, twenty of the dreaded runs at a time. Anyone who ever played football can tell about the horror of such runs, but then some Diamond Hornet player

Mooney Player gets a ride from his team after they won the 1970 AAAA title. *Courtesy of the Richland County Library.*

would holler after their score of runs to run some more and they would peel off eight one-hundred-yards sprint. Crazy? Psychotic? Delirious? Not for a team coached by Player, who had been grooming the team for a state title since the ninth grade. "Our team was the one that he wanted to coach," center Tommy Utsey told *The State* in 1995.

According to *The State*:

> *Player remains the master of motivation, and he built unity like few ever have. His offense wore white helmets, his defense black helmets. All black uniforms called for the ultimate effort. Good performances might earn a player a haircut or $1 in gas from a neighborhood business. Play bad, though, and the grade sheet would include "Tina" or "Mildred" substituted for a player's first name. When the team was losing 28–16 to Sumter at the half, he walked in, lit a cigar and declared they would win. They did, 31–30.*

Player also showed an odd sense of humor. Middlebrooks scored three touchdowns on 143 yards in the title game. Those numbers came despite a separated shoulder and a broken rib after a devastating collision. Player remarked immediately after the game that he had thought Middlebrooks was dead after the hit or, at best, "wouldn't get up until Christmas."

SEEING TRIPLE

Back in the early 1970s, when the fans would line the almost fifteen-mile stretch of roadway to jeer and cheer the buses heading between the Mid-Carolina and Chapin rivalry game, the Mid-Carolina fans had a particular feeling of hope and speculation while losing eight straight. Maybe they would start winning once Chapin stopped producing Woolbright quarterbacks.

To Mid-Carolina fans, it must have seemed like a bad movie, as every year head coach Cecil Woolbright would seemingly trot out another one of his sons at quarterback. It was the sequel that would not end. They seemed like clones. Each was tall. Each had a rifle of an arm. Each loved to hit. Each wore number 11 if for no other reason than it was the only jersey in the pile that could fit their long frames (the three—Marty, Roger and Rex—all stood between six feet, two inches, and six feet, five inches). Each played in the Shrine Bowl. Each played college. Combined, they went a mind-boggling 88-8.

"We always had a winning attitude," Rex Woolbright explained. "We never knew about losing."

He credits that to their father, Cecil. A member of the USC Sports Hall of Fame, the elder Woolbright coached at several coastal schools before taking over at Cardinal Newman in the early 1960s. His sons quickly grew with the program, going from team managers to junior varsity to varsity. Marty was the oldest and actually began his career at Cardinal Newman. He remembered his first start in an exhibition as a freshman and his father giving him a forearm to his chest that knocked him to the ground. The wounded teen looked up and felt reassured when his father said that was the hardest hit he was going to get that night. "It loosened me up," Marty said.

When Woolbright took the job at Chapin in 1968, he, of course, took his sons with him. Marty immediately became the quarterback, and the school's fortunes changed overnight. The Eagles went from 2-8 to 10-0-1 and would

Above, left: Rex Woolbright talks strategy with his father, Cecil, in 1974. *Courtesy of Chapin High School.*

Above, right: Marty Woolbright was All-State in 1969. *Courtesy of Chapin High School.*

Below: Roger Woolbright shows the form that led him to the Shrine Bowl in 1973. *Courtesy of Chapin High School.*

win double digits in six of the next seven years, including state titles in 1973 and 1974. Marty was long gone by then, but it was Roger who led the way in 1973 as a senior (when he passed for thirteen touchdowns and ran for thirteen more) and then Rex the next year as a junior. Rex would extend the school winning streak to 30 games before the Eagles lost in the 1975 playoffs to Fort Mill.

"We played with a lot of emotion," Marty said. "People really bought into what dad was doing. They got behind it."

The trio also played defense. Marty was a defensive end, where his height and size helped him intercept passes at the line of scrimmage, while Roger and Rex were linebackers because they "loved to hit," Rex said. Their house practically touched the stadium, and they often went there to practice and just run. Their home's proximity to the stadium made it the perfect postgame gathering spot, as their mother, Lee, cooked up hamburgers and French fries provided by one of their uncles in the restaurant business.

There also was a sense of added pressure. Their dad didn't tell them so, but they knew they had to be the clear-cut top player at their position or they wouldn't have started. That means they always had to work a little harder when getting ready. Rex said there definitely was added pressure being the coach's son but not really in living up to his brothers. Marty, who played defensive end at South Carolina, would often come back and give pointers to his siblings. They always watched him on Saturdays, and he made sure to be there on Fridays. "It was low-key. He might say 'work on this pass or watch how you run,'" Rex said. "He gave us hints. Almost shortcuts."

They needed the help when running their father's gadget-heavy offense. One was the "whammy." This was used to start second halves when Woolbright felt the team could pull off the big play. The entire team would take their positions to one side of the center, who would then toss (not snap) the ball to the quarterback. The quarterback (or that year's Woolbright) would then toss it downfield to a streaking halfback for a touchdown past a group of befuddled defenders. "Ask any Chapin player of that era and they remember the whammy," Rex said.

Another was a fake punt that was particularly lethal yet almost as dangerous to execute. If punting from their own end zone, the ball would be snapped directly to the upback. Meanwhile, the punter would dive, fall, jump—anything to make the defense think the ball had gone over his head. In all of the confusion, the back would take off through a hole in the defense for long yardage. Rex credits the play for helping to beat Woodruff in the 1975 playoffs.

Coaching apparently ran in the family's blood. Cecil's brothers both became coaches, while Roger coached for a few years before going into the private sector. Marty had a long, successful career as a coach, and now his son, Perry, will be the head coach at North Myrtle Beach starting in 2010. Rex, for the record, went into the family's other major pastime and now runs the family floral shop in Newberry.

THE WEIGHT GAME

The 1970s were about beef as players started to take the shape of the modern football player, aka big. Blacksburg's coaches bragged they had four players weighing more than 200 pounds to start the 1970 season. The starting line in the 1970 North-South game averaged 202.6 pounds for the Upstate team, and the Lowcountry team was 199. The 1971 team saw the North line averaging 204.4 pounds, and the South line averaged 217 pounds. The North line was 211.6 pounds in 1973, and the South line was 217. Those totals don't include Seneca tight end Bennie Cunningham, who was six feet, four inches, 230 pounds and on the way to an All-American career at Clemson and two Super Bowl rings with the Pittsburgh Steelers. The 1973 Thornwell team that won the SCISA state title averaged 224 pounds along the line. In 1975, the North line weighed in at an average of 235 pounds per man, while the South was 240. The 1977 Shrine Bowl line was 218 pounds on average, but that was skewed by a 185-pound guard, as three players were above 230. In 1979, Wren's Ricky Hagood was the North-South game's biggest player when he tipped the scales at 253 pounds on his six-foot, four-inch frame. Of course, an Aiken junior named William Perry was already pushing 300 pounds. People would soon know him as "The Fridge."

THE WISDOM OF SOLOMON

The majority of South Carolina's schoolyard legends had four-year careers during which they shattered record after record and won multiple titles, but the man often hailed as the best the state ever produced did it all in one season. The August 2, 1970 *State* remarked that while Freddie Solomon had been a letterman on the 1969 AAAA state title team at Sumter's Edmunds High,

he never started, as the team's offense was led by quarterback Jimmy Eaves and running back C.A. Wilson. In reality, Solomon had played at the all-black Lincoln High, which shows how little was known of him. Coach Steve Satterfield said it would be a tough season for the Gamecocks and said nothing else about Solomon. By the end of the year, he was the most talked about player in the state and the most heavily recruited. Solomon accomplished this by rushing for more than 1,685 yards using an elusive, twisting style of running coupled with 4.4 speed and a cannon of an arm to throw for 809 more yards. He scored 154 points using the vernacular of the day. Summerville's John McKissick described Solomon's ability in the November 13 *State* as "so elusive, you can lock him a broom closet with the Green Bay Packers and offer $200 to the first man to two-hand tag him and keep your money." He capped his season by running for Shrine Bowl records with 29 carries and 129 yards. He tied a Shrine Bowl record with three rushing touchdowns in leading the Sandlappers to a 35–23 victory. *The State* reported that "he galloped and scrambled, twisted and turned, dodged and deceived. He wrote his name indelibly on the pages of Shrine Bowl history. He surpassed the achievements of Charlie 'Choo Choo' Justice, Sonny Jurgensen, Mike McGee and Marion Campbell." He capped his career on the South Carolina gridiron in August 1971 at the North-South game when he ran for 274 yards, which included a 67-yard touchdown scamper and a 64-yard one using his "gliding, deceptive speed." He added 78 yards in the air on four completions—three of which went for touchdowns. Hanahan's Billy Seigler, who coached the South team, remarked that "he must have radar."

However, that was not supposed to be Solomon's last game on Palmetto State turf. In January, he signed a grant-in-aid to go to the University of South Carolina and star on Columbia Saturdays. Instead, he was found academically ineligible. He eventually enrolled in the University of Tampa. He was picked in the second round of the 1975 NFL draft, spent the next eleven seasons in the pros and won two Super Bowl titles with the San Francisco 49ers. But the question remains in the mind of some South Carolinians of what might have happened if he had played at USC. *The State*'s venerable sports editor, Herman Helms, made a bold statement on the state of education and sports in South Carolina in an August 12, 1971 edition: "quality of education is not the same for everyone." He then ended with a quote from Clemson's Hootie Ingram, who said Solomon was the best runner he had ever seen.

Almost forty years later, Keith Richardson summed up Solomon succinctly: "I saw him play. He was phenomenal." Lower Richland's Terry Wooten told

The State in 1995 that Solomon scored on the first play of a game against the Diamond Hornets that season. When his coach asked him what happened, Wooten responded, "I don't know; I never saw him."

More than twenty years after the last time he pulled a Sumter jersey over his shoulder pads, Solomon's abilities were still the topic of heavy discussion. In December 1991, *The State*'s sports editor, Bob Spear, addressed it when Spartanburg's Stephen Davis was finishing up his record-setting preps career:

> *He's been alone at the top for a generation, the unchallenged standard of excellence against which South Carolina high school football players are measured. Even today, all these years later, a veteran coach evaluating a prospect might get a faraway look in his eyes, remembering yesterday. "Well, this guy's good," he finally says, "but he's no Freddie." No, South Carolina high school football has not seen the likes of Sumter High quarterback Freddie Solomon, Shrine Bowl class of 1970, before or since. Never will, some old-timers insist.*

Davis had just finished a fifteen-game season during which he ran for 2,449 yards and 30 scores, but Spear was unconvinced heading into the Shrine Bowl that year, where some speculated that Davis would soon break Solomon's game records. Solomon was the 1991 game's honorary captain and watched Davis intently during the game, according to Spear. Davis scored the winning touchdown, but the records and the lure stayed with Solomon, according to Spear. The gridiron great simply smiled when Spear pressed him on whether he was better than Davis.

THE GROWING GAME

While integration created a new template for football, it also led to numerous changes in the way the game was played during the decade. In 1974, the number of playoff teams doubled from thirty-two to sixty-four as SCHSL leaders decided that more teams were needed because of a financial squeeze facing the game due to rising costs and declining fans, according to *The State* of August 11, 1971. That allowed for teams that didn't win region titles to make the playoff chase. By the late 1970s, the SCHSL was starting to see the seeds of its expanded playoffs take hold. In 1977, Eastside High became the first non-region winner to take home a state title when they beat Spring

Valley 31–20 for the AAAA state title. The Eagles did so with a defensive gem of a game led by nose guard John Hollow as the team picked off one pass, blocked two kicks and forced three fumbles.

Meanwhile, the South Carolina Independent Schools Association (SCISA) started its own football league in 1973 and, in 1975, held its first All-Star football showcase at The Citadel's Johnson Hagood Stadium. The South won 26–8. SCISA would eventually grow to as many as five classifications and today sanctions four titles, which include eight-man football. Its top players also play their equivalents from North Carolina in the Oasis Shrine Bowl.

SOME THINGS NEVER CHANGE

Boiling Springs's Tom McIntyre best summed up the life of a high school football coach. Coming off a 7-4 1971, he told *The State* newspaper in August 1972, "We didn't win enough to make the playoffs and we didn't lose enough to get the coach fired." McIntyre went 4-6 in 1972 and then 7-4 in 1973, which was his last season as a head coach in South Carolina. However, the life of a football coach was precarious at best—just like in any other decade. Woodruff won the 1975 AA title 14–7 over Bishop England. Afterward, the Battling Bishops' Leon Maxwell blamed a holding penalty late in the game followed by an offensive pass interference call as the reason his team lost. It was a refrain spoken by many coaches before and since.

Coaches also grew more skeptical of their players' dedication to the game. Coming off being named National Coach of the Year in 1976, Greenwood's Pinky Babb noted in the December 26 *State* that "work had gone out of style" and the current crop of athletes didn't like to "get dirty" like the old days. He also said it was harder now to motivate kids because they had more distractions and too many coaches were filling personnel to a system. However, something must have worked for Babb's players, because they went 12-2 in 1976 and won the state title with a 47–7 drubbing of Summerville.

Coaches moving around was also common. Jimmy Satterfield (Irmo) and Dick Sheridan (Airport) jumped to the college ranks in 1972 to join the staff of Furman's Art Baker, who had left Eau Claire a few years before. Player left Lower Richland after an aborted attempt to land the USC job in 1972 and never returned to the sidelines. In 1977, Conway's Buddy Sasser jumped to Wofford. Following the end of the 1977 season, Spring Valley's Joe Turbeville, who at the time had a record of 106-38 in eleven seasons, left to take a job at Irmo.

THEY WERE PLAYING A DIFFERENT GAME

Lower Richland's Mooney Player again showed why he was considered one of the state's top coaches during a preseason game in 1971. As the teams lined up for the opening kickoff, the Diamond Hornets' Rufus Stroud took his place when two teammates lifted him onto the crossbars, where he dangled until the whistle sounded. He then ran down the field and fell down as he approached the ball sitting on its tee. As he lay prone on the turf, teammate Danny Young snuck over and pooched an onside kick that was recovered by the Diamond Hornets. Keenan head coach Bill Simpson did not complain about the trickery. He glibly explained to *The State* on August 28 that he should have known what was going on. He had taught the Player the trick.

NOTES FROM THE SHRINE BOWL

In 1971, A.C. Flora's Mark Giles played in the Shrine Bowl. His brother Glenn had played in the 1969 game, and their father, Bobby, was on the 1941 roster. However, the youngest Giles almost didn't get to play, and it had nothing to do with ability. According to Walter Klein's *Bowl Full of Miracles*, the 1971 game was almost cancelled due to a snowstorm the day before that dumped six inches of snow on Charlotte. It was decided the night before to try to clear the stadium.

> *City equipment went to work on the disastrously disabled stadium. They moved tons of fresh, heavy snow. A $30,000 canvas protected the grassy field. The idea was that if the snow could be neatly pushed off that canvas, the covering could be rolled back and a fresh lawn would reveal itself to the waiting players.*
>
> *Well, that isn't precisely what occurred. The tarpaulin stuck, frozen to the ground. When the power equipment pushed, it tore chunks of canvas. A quick and painful decision to sacrifice the canvas led to its destruction and removal with the snow. Goodbye $30,000. The field didn't look quite like the Augusta National fairways, either. But the real ulcer factory was the stands. Getting that snow removed meant working it one square foot at a time.*

Less than half of the expected fans attended, and South Carolina won 3–0. The 1972 game was won by the Sandlappers when Clinton's Robert Scott booted a 30-yard field goal with fifty-three seconds left to secure the 17–14 victory. The 1976 game featured one of the odder psyche jobs in sports history. The North Carolina team beat South Carolina to the pregame luncheon, and that apparently angered the Sandlappers. Greer's Charles Fowler told *The State* after the game that the slight came up in the locker room and helped them to a 39–27 victory. It's hard to tell if Fowler was kidding, but with 107 yards rushing, he helped lead South Carolina to victory. Clover's Chris Cobb added 135 yards, while Hanna's Dean Swaim threw for three touchdowns and was named the outstanding player of the game. The 1978 game raised $1.4 million for the Shriners Hospitals. However, the decade ended on a sour note. The *Durham Sun* wrote on December 5, 1979, citing anonymous sources, that there was pressure to keep black players out of the game. The North Carolina team had fifteen of thirty-five, and the South Carolina team had twelve of thirty-five. Officials denied the charges. Seneca's Clarence Kay was quoted in the *Greenville News* the next day saying that "football gives black kids a chance to do something else besides work in a mill." Kay went on to toss a 35-yard touchdown to Airport's Ty Rietkovich in the Shrine Bowl and later played in three Super Bowls with the Denver Broncos.

Some of the prominent names from the 1970s Shrine Bowls include Rice and Solomon in 1970; future Steeler Bennie Cunningham in 1971; Easley's Stanley Morgan, a future All-Pro wide receiver, and Hanna's Ken Helms, who played for the Colts, Giants and Jets, in 1972; Spartanburg's Wayne Tolleson, who decided to play pro baseball and had stints with the New York Yankees and Texas Rangers, in 1973; Ware Shoals's Jerry Butler, who gained fame for "the Catch" while at Clemson and played with the Buffalo Bills, Spartanburg's Fuller, who threw the pass that led to "the Catch" in 1977 before being drafted in the first round by the Kansas City Chiefs, and Northwestern's Rick Sanford, who later played for the New England Patriots, in 1974; Airport and later San Francisco 49ers defensive lineman Jim Stuckey in 1975; and a 1976 team that included future Chiefs player Willie Scott and future Giant Terry Kinard, who was ranked by *Sports Illustrated* as one of the fifty greatest athletes in state history in 1999. South Carolina won seven of ten games in the 1970s, including shutouts in 1971 and 1976.

OVER AT THE NORTH-SOUTH GAME

The game started the decade strong, but by the end of the 1970s, it would see major changes. The early 1970s games were noted for their heat—especially the practices, as teams routinely lost players due to illness while learning plays under the blazing Columbia sun. *The State*'s legendary Ernie Trubiano started a short story on the 1970s practices by joking that the Sun God Apollo was the most important player. Pageland's Bill Few, who coached the North team in 1971, glumly remarked about the heat that "all you can do is pray." However, the last great players of the 1960s started off the 1970 season when Chapin's Marty Woolbright led a fourth-quarter comeback to lead the North to a 13–10 victory over the South. The winning score was Woolbright's thirty-three-yard touchdown pass to Belton Honea-Path's Gene Cooley with a minute and nineteen seconds to go. Parker's venerable Whitey Kendall is said to have hopped and skipped off the field afterward.

The 1971 game was a showcase for Sumter's Solomon, and 1972 was the last hurrah for Orangeburg-Wilkinson's Mike O'Cain. The "spindly passing whiz" was fourteen of twenty-four for 220 yards with two touchdowns in the air and two with his legs. O'Cain was a highly touted prospect and chose Clemson to play collegiately.

The 1974 game featured an extraordinary effort by Brookland-Cayce's Kenny Brown, who scampered for two forty-yard touchdowns, but at five feet, six inches, 163 pounds, he had not gotten any offers to play college ball. The 1975 game was won by the North when Northwestern's Jerry Kizer hit Ware Shoals's Butler for a ninety-yard touchdown pass to secure a 14–12 North victory.

The game was moved, however, to after the regular season in 1978, in part because of declining fan support and also because many of the top players were facing college commitments in the summer. To help generate buzz, the team practiced at Wofford College and played the game in Easley. The North won 10–6. The 1979 game was held in Summerville and ended in a ho-hum 3–0 yawner of a win for the North. For the decade, the North won the series 7-3.

STATS, STORIES AND STARS

Dorman head coach Paul Leroy hired a local barber named Sonny Bright to clip off all the hair of his incoming players at the start of practice in August

1970. He reasoned that if a player was willing to give up his hair, he would give up anything.

Palmetto High forced eight turnovers and held South Florence to 136 yards in a 34–8 victory in the 1970 AAA final.

Irmo's Gary Talbert snared 11 catches in the 1971 North-South All-Star game, which was interrupted when lightning knocked out the game clock at Memorial Stadium.

Stanley Morgan scored twenty-two touchdowns and averaged 13.5 yards a carry while leading the Easley Green Wave to the AAAA state title in 1972. The last of those was an 18-yard run where he started left, reversed field and turned up the right side against the Lower Richland defense for the winning score in the title game. Morgan went on to the University of Tennessee and then a lengthy NFL career, where he caught 577 passes for 10,716 yards and 76 touchdowns and made four Pro Bowls.

In 1972, Lockhart defensive tackle Mickey Sims became the state's first player selected to the prestigious *Parade* All-American list. The Red Devils won a state title with Sims anchoring the defense and had a school record twenty-one-game win streak.

Clinton's Harold Goggins ran for 2,172 yards and banged out twenty-five touchdowns in 1974.

James Island's Marty Crosby made a run for the record books in the 1970s. He completed a then state record forty passes in a single game in 1972, and the record lasted for more than a decade. He tossed twenty-two touchdowns that year (many of them to Jerome Williams, who had sixty-four catches) and followed it up with a then record twenty-seven in 1973.

Doug Bennett led Swansea to twenty-one straight wins between 1974 and 1976. That streak included two state titles.

Whitmire's Jerry Vanlue carried the ball twenty-nine times for 242 yards and two touchdowns in the 1978 Class A title game.

Stanley Morgan was a running back at Easley before becoming a wide receiver in college and then in the NFL. *Courtesy of Easley High School.*

From 1973 to 1980, Joe Turbeville coached teams in seven of the eight Class AAAA state championship games, winning four times: '73, '74, and '75 at Spring Valley and '80 at Irmo.

Middleton's John LaBord ended the decade as the state's all-time leading rusher with 6,466 yards between 1975 and 1978.

The Abbeville Panthers went through the regular season undefeated four times in the 1970s, only to lose to the Woodruff Wolverines. It was something of a habit for Woodruff coach Willie Varner, whose first ever playoff victory in 1956 came against Abbeville.

THE 1980s

The Game Airs Out

The *Greenville News* pointed out in its 1989 football preview that four of the state's best programs at the time—Hartsville, Barnwell, Daniel and Spring Valley—were all located within a few miles of a nuclear power plant. The article, which was done tongue firmly in cheek by the paper's legendary prep writer Tom Layton, wondered if something in the water was creating a new breed of football player. How else can you explain the game's sudden surge in ability in the 1980s? Layton may have been on to something, because something was happening in Palmetto State stadiums on Friday nights. While not resembling the San Diego Chargers' Air Coryell offenses, teams were definitely starting to air the ball out more and more.

Belton Honea-Path's Marshall Crawford threw for 417 yards in a 1980 game, breaking the old state record by more than 60 yards. The normally run first, run all-the-time Woodruff Wolverines unveiled a passing attack in 1982 centered on future Notre Dame star Tony Rice. As a sophomore, Rice threw for a school record 1,201 yards. He followed that up with 1,095 in 1984 (and 960 on the ground, lest we forget Rice's main weapon). For his career, he ran and passed for 6,807 yards and scored 460 points. Wesley Tate, who stood five feet, eleven inches and 164 pounds, threw for 2,028 yards and thirteen touchdowns in leading Gaffney to an Upper Sate championship in 1988.

Bobby Bentley may be biased, but when it comes to the creation of the modern passing game that dominates modern high school football, he credits his Byrnes mentor and predecessor, Bo Corne. While many teams started to

throw more and more in the early 1980s, no one seemed to throw as much or as well as the Rebels did as they rolled out high-octane offenses every season. Bentley notes that many of the offensive schemes that he unveiled in the 2000s were variations of what the Corne-era Rebels did. And for the record, Bentley threw for a then unworldly 2,179 yards and seventeen touchdowns as a senior in 1985 after only taking ten offensive snaps the season before behind All-State Steve Betsill, who completed a then state record 213 passes in 1984 that included a 26 of 30 game. Betsill's top target was Kelvin Richardson, who tied a state record with sixteen receptions in a game (since eclipsed) and set a state record of ninety-seven catches in a season, which has since been broken as well, in 1984. After Bentley came Archie Irby, who threw for 2,289 yards and eighteen touchdowns in 1986.

Maybe Bentley was right.

The rise in passing also led to a rise in interceptions. The 1983 Woodruff Wolverines picked off a then national record forty-three passes, led by All-American Mike Smith with fifteen. They also swiped ten in one game, which was a national record as well. Smith tied the record held by Mayo's Ronnie Blue set in 1977 and would be matched by Summerville's Barry McCabe in 1983. Cross's Michael Jenkins would top them all when he snared sixteen in 1988. In addition, Swansea's Sam Hallman, Byrnes's Scott Simmons and York's Robert Barking all snared thirteen at some point in the decade. Woodruff's Smith, Manning's Mike Bradley, Timmonsville's Mike Hamlin and Northwestern's Cookie Massey all picked off five passes in a game during decade, which is a single-game record that has not been broken or tied since the decade ended.

THE EXPANDING GAME

The number of athletes suiting up on Friday night exploded in the 1980s. In 1988, there were 27,272 football players in the state. In contrast, there were 20,330 in 1985 and fewer than 18,000 in 1980. High School League officials noticed that the major increases were coming at the AAAA schools and began looking for ways to make things more fair when it came to awarding championships. Basically, it seemed stilted that half of the athletes in the state were playing in AAAA schools for one title while the rest of the state played for three. To remedy this, the High School League created the Big 16 championship series in 1981 to allow the largest sixteen schools in the

state to play for a separate AAAA title. Also, the SCHSL came very close to near perfection in balance with the 1983 realignment when the schools were split into fifty in AAAA, fifty in AAA, fifty in AA and fifty in A. The biggest schools in the state were Spartanburg and Summerville with a little more 3,000 students, while Lockhart was the smallest with 105. The 1980s also brought about some changes in how championships games were held, as AAA moved its title to Williams-Brice in 1985. In 1987, Clemson hosted the AAAA finals. Finally, the SCHSL allowed teams to play eleven regular-season games for the first time in 1988. Almost 90 percent took the offer, with state champions Spring Valley and Barnwell among the dissenters.

A Lost Season in Conway

Chuck Jordan and the Conway Tigers had been on a roll of sorts in the 1980s with region titles in '84, '85 and '86 and strong 8-4 records in '87 and '88. Many fans expected another big year in 1989, but instead, they got a nightmare season that tore their community apart. According to an August 1990 story in *The State*, "before the football season was halfway over, the town of 10,000 was consumed by a racial storm that brought thousands of protest marchers, national leaders from the NAACP and reporters from across the country."

It started when Jordan decided to switch his starting quarterback from rising senior Carlos Hunt, who had been 37 of 92 for 605 in 1988, to junior Mickey Wilson in the spring. Hunt was black. Wilson was white. Hunt tried to transfer, but when he couldn't, he became the focal point of a boycott. Thirty-six players, including Hunt and All-American candidate Lawrence Mitchell, refused to play just two days before the first game. Instead of being on the field for the opener against Hillcrest, they climbed into the wooden bleachers at their home field, dubbed the Graveyard, and heckled their teammates, which included six black players, and cheered their opponents, according to an August 25, 1989 *Greenville News*. The players on the Hillcrest team would later complain that they felt uneasy and slighted because of that. There were cameras and satellite trucks parked around the stadium. When Wilson scored the lone Conway touchdown, the black players broke into a cheer of "We want Carlos." Afterward, the NAACP's Rudolph Brown said the players still supported the school but not the coach. H.H. Singleton, a Conway Middle School teacher, became

the de facto voice of the boycotters and said that Jordan had reneged on his promises. The losses mounted as the Tigers fell to 1-11, and the complaints grew. Several times, the boycotting players were close to coming back, but community pressure kept them away.

The cries of racism were strong, but Jordan's defenders said they were unfounded, if not bizarre. A former Conway quarterback himself, who played for a black coach in Cleveland Flagler, Jordan was known as a fair man with many black friends in the town a few miles from the coast. He had gotten the Conway job at age twenty-six—just four years out of college. He actually had been coaching at his college alma mater, Presbyterian, when the Conway job became available. He started a black quarterback in three of his seasons as head coach, including replacing a white signal caller with a black in his first season, according to the September 3, 1989 *State*. The same article stated that Jordan had lent Hunt (whom his mother, Kathy Thomas, described by saying, "He comes home from football practice, he eats oatmeal cookies and a quart of milk and he hits the books") eighty dollars to buy his class ring. Singleton alleged in the article that Hunt's slowness in repaying the coach was another reason for the switch, but that was proven false. Hunt got the money from a booster club and repaid it. Several white players also got money for rings and were sanctioned by Jordan for not paying it back. College coaches, though, said they believed Hunt had more upside as a defensive back and that is why the move was made. Jordan said little about the case publicly at the time, but it was later learned that he had promoted a reluctant Hunt to quarterback in the first place. Twenty years later, he described the situation as one of the toughest in his life because he was wrongfully accused. However, he felt he had to battle because he was representing every coach in the state who faced scrutiny at any time. "The coach has got to be the coach," he said.

Wilson was the son of head basketball coach Mickey Sr., who also was a football assistant. Wilson grew up loving basketball and was a self-described gym rat until he found football in middle school. Wilson passed for 901 yards, completing 52.2 percent of his passes, but none for touchdowns in the lost season. Looking back twenty years later, and now a successful coach himself, Wilson said it doesn't seem that it really happened to him. "It's like watching a movie and you think was that really me?" he said. "I know it made me tougher. It made me realize how important football is to people."

But the reality was that the battle was about more than a quarterback and a coach. While residents said Conway had been a relatively peaceful town,

a powder keg of simmering racial tensions had been building underneath for decades. Hunt became the symbol for every complaint and slight, both justified and imagined, for black residents—limited business opportunities, white control of schools and government and white indifference to long-standing black complaints.

The fall of 1989 was filled with rallies, protests, calls for Jordan's firing, a boycott of white parents who had children in Singleton's class, Singleton's dismissal, a federal lawsuit and an investigation by the state Human Affairs Commission. Sent by Governor Carroll Campbell to investigate, James Clyburn, the agency's head and now as a congressman one of the most powerful men in Washington, said there was racism in Conway but it had nothing to do with Jordan. "It's just as far from being race as anything you've ever seen. You can stay down there from now until next year, and you will not find race involved in this football incident," Clyburn told his governing board that November.

However, the boycott and the racial tensions continued to escalate as William Gibson, president of the NAACP's national office and a Greenville native, blasted Clyburn. Singleton returned to the classroom in 1990 after winning his lawsuit, saying that his dismissal violated his freedom of speech. Eventually, things returned to seminormal. Despite not playing a down during his senior year, Mitchell signed a scholarship offer to play at South Carolina. Hunt went on to Fayetteville State in North Carolina. The team rebounded to 8-4 in 1990 with Wilson at the helm. Michael Farewell, a senior receiver who had boycotted the previous season, told the *Myrtle Beach Sun News*, "It's over, I hope. It's done. Last year was messed up. I wanted to play. A lot of us did. I should've played. I wanted to come back, but my parents told me to stick with the others, so I did. This year is a comeback."

Wilson played one year of football at Charleston Southern University (then called Baptist College) before transferring to Coastal Carolina, where he returned to playing basketball. He would go on to coach first as an assistant at Conway and then as offensive coordinator at Myrtle Beach. He took over as Myrtle Beach's headman in 2009. In his fifth game, he squared off with Jordan and Conway. He won, 24–7. He said it really wasn't that strange facing his old coach because he had been away so long. He also has come to understand the trying 1989 season better. "I look back and realize this had nothing to do with me," he said.

THE FRIDGE

Few players dominated a season like Aiken's William Perry did in 1980. *Courtesy of Aiken High School.*

When did the media phenomenon of William "The Refrigerator" Perry really start? Was it on a January Sunday in New Orleans when he rumbled for a one-yard touchdown in Super Bowl XX? Or was it when he rapped in the Bears' famed "Super Bowl Shuffle" video? How about him carrying Walter Payton across the goal line (illegally) in a Bears game in 1985? How about when he was at Clemson and he legendarily dieted on mountains of bananas in an effort to lose weight? I'm going to say the real start came in the run-up to the 1980 Shrine Bowl, when the Aiken star lined up on the defensive line for practice. It didn't last long. Aiken was so talented that he simply overwhelmed the offense. Coaches took him out of scrimmages because he broke up too many plays. Needless to say, Perry was the state's lineman of the year. At six feet, three inches, 285 pounds, but with a surprising twenty-seven-inch vertical jump, there were few players in state history up to that point who mixed his raw size and ability. As a four-year starter, he helped Aiken to two region titles, including an undefeated regular season in 1980. To put his size in perspective, the offensive line on the 1980 Shrine Bowl averaged 217 pounds. Eddie Buck, one of his high school coaches, said players of his caliber were extreme rarities. He called him the "Secretariat of Southern Linemen" and predicted that in college he could "be to lineman what Herschel Walker was to running backs."

Oh, Brother Where Art Thou?

The 1980s saw several great brother acts, including several last thirds of triple sets of brothers. Wren's Kent Hagood made the 1980 Shrine Bowl team, making him the second member of his family to do so. Brother Joe Lewis started for Wren in the early 1970s, and brother Ricky was on the 1979 Shrine squad. In 1981, Wallace Mays ran for 1,792 while helping Woodruff to an 8-5 record and, more importantly, family bragging rights. He topped the rushing numbers of eldest brother Terry, who had 1,178 yards in 1978, and Reggie with 980 in 1980. Meanwhile, the 1982 Myrtle Beach team featured Nate, Lavon and Roger Samptex, as well as Robert, Paul and John Abraham. Alex and Bobo Holoman were also on the team. Spartanburg's Clyde Norris carried the Vikings to the 1984 AAAA Upper State title and made the North-South Game. His brothers Charlie and Carnie had both starred for the Vikings in the late 1970s. Carnie Norris had been ranked the second-best back in the nation in the 1979 recruiting class (behind Hall of Famer Eric Dickerson) and went to Georgia to play football. Clyde Norris, who always said his brothers were the reason he got into sports, became a world-class bodybuilder. Of course, in addition to the Fridge in Aiken, there was his equally talented younger brother Michael Dean Perry. As legendary as William was, his younger brother ended up with more sacks at Clemson and more Pro Bowl and All-Pro appearances in the NFL.

However, Marion's John and Johnny Lester may have been the most unique. The pair of identical twins played running back and quarterback for coach Bob Rankin in the latter part of the decade. The two were so similar that they could pass off each other's handwriting for the other. Because of their first name, it was common for people to mix up who scored when and where. But they couldn't match each other on the field. They once switched jerseys in practice, but their teammates knew there was a ruse by the way they took to their positions.

The Summerville Dynasty

Summerville had been a state power since the 1940s, when Harvey Kirkland was calling the shots for the Green Wave, but the early 1980s were when the team truly cemented its place in state history as well as the legendary status of head coach John McKissick. The 1980 team, led

Summerville's Johnny Williamson looks on while teammate John Bagwell plunges for a score. *Courtesy of Summerville High School.*

by All-American Perry Cuda, went to the state finals but lost to Irmo in front of sixteen thousand people and ended the state record 41-game winning streak. After an 8-3 1981, the team went on a new tear led by quarterback Brad Walsh. The Green Wave won three straight state titles, going 50-2 between 1982 and 1984. There were few superstars—just a bunch of well-coached and hungry players who would do anything for a victory. Keith Jennings started for four years on those teams and was a *Parade* All-American in 1985 and later played in the NFL. He grew up watching the late 1970s teams that included his brother Stanford and said that every kid in the tiny little town north of Charleston wanted to play for the Green Wave one day. The team transcended racial lines and was a unifying force, he said. "It's all we knew. We all wanted to play for McKissick. He was a legend. He made you work hard."

The first title came in 1982, when the Green Wave beat Spartanburg 23–13 with some aid from a missed holding call in the third quarter that ended a Vikings drive, according to the December 5, 1983 *Greenville Piedmont.* Spartanburg's Fred Kyzer said afterward, "I don't like to look for spilled

118

milk, but I hate it for our kids." A 21–7 victory over Gaffney capped the 1983 title and a 13-1 season.

The team went undefeated in 1984 and became the first school in state history to be ranked in the *USA Today* poll at the end of the season. The *Charleston News and Courier* wrote in its December 2, 1984 edition after the Green Wave again beat Spartanburg for their third straight title that there was no team in South Carolina that compared to Summerville. The players had their names on the backs of their jerseys, and all aspects of the program were similar to a college one. It had been fourteen years at that time since one of McKissick's assistants had left (Reed Charpia), as Dickey Dingle, Pinky Guerard, William Penn, Sam Clark and Fred Edwards formed an ever-tightening bond.

If there was one rub, it was the stories that McKissick would order promising athletes to stay behind a year in order to make them nineteen (and a little bit stronger) as seniors. McKissick retorted in the *News and Courier* article that it wasn't true per se but said that the players benefited because they got college scholarships by playing that extra season. The team slipped to 9-4 in 1985 but still made the AAAA semifinals, with Jennings leading the way. The Green Wave went 13-1 in 1986 with six shutouts and rolled to their fourth title in the last five years with a new cast of players. Jennings said it was a magical time, to some extent. "Football was a lot of fun in those days," he said. "You didn't have the worries of college or the pros. You just played."

OTHER TOP TEAMS

If Summerville was the state's football champ in the early 1980s, Myrtle Beach could make a claim to being its king in waiting. Doug Shaw's Seahawks turned AAA into their own personal playground between 1980 and 1984, making five title games and winning four times. The team went 63-6-1 over the five seasons, using a deadly combination of offensive pyrotechnics with a defense that was at times unbeatable. The 1981 team shut out nine opponents while allowing just 30 points. Doug Shaw Jr. spent his formative years watching those teams as the ball boy for his father before going on to star for the Seahawks as well and later becoming a successful coach. He still shows a VHS copy of the 1984 championship team to his Mauldin teams almost twenty-five years later. "It was simply great to be around those teams," he said.

Players such as running back George Dow, quarterback Wayne Gray, free safety Buddy Cribb and defensive back Tyrone Simmons, who played the entire 1984 season with a broken thumb and blocked a punt in the state semis against Cheraw to lead to victory, were among the stars.

And sometimes, Shaw wasn't afraid to look for talent in an unusual place. He discovered a Canadian named Paul Mullen, who had never played football until he came to Myrtle Beach when his family moved there, and coaxed a Shrine Bowl season out of him in 1984 as a kicker. He was the school's first soccer-style kicker and connected on thirty-five of thirty-six extra points and eight field goals, including the game winner in the playoffs over Cheraw. Shaw knew he had a good thing in Mullen and told the *Charleston News and Courier* in November 1984 that he didn't try to correct Mullen's kicking at any time.

The younger Shaw remembered Mullen showing up in the weight room looking for the soccer coach. Coach Shaw quickly saw the answer to a potential kicking problem. The younger Shaw remembered Mullen's season as a coach and now looks to the soccer team for kickers at Mauldin. "I guess it is déjà vu in some ways," he said.

Woodruff players hoist legendary coach Willie Varner after his 300th career win. *Courtesy of Woodruff High School.*

Meanwhile, Woodruff was up to its usual tricks in AA. The Wolverines won twenty-eight straight games while rolling to consecutive state titles in 1983 and 1984, led by the likes of Tony Rice, who was being sought by many of the top collegiate programs in the nation, and Mike Smith, who was named All-American after his big year in 1983, when the defense put up nine shutouts and allowed 56 points in fourteen games. The offense scored 421 points, which was good for 30 per game. The 1984 defense was slightly better, again posting nine shutouts and giving up 49 points, while the offense scored 37.5 a game, including 84 against Liberty. Woodruff shut out St. John's in both title games. On a side note, the 1980 Woodruff team also shut out nine teams, with seven straight to end the season, including the title game against Swansea.

SOME THINGS NEVER CHANGE

Coaches remained highly quotable in the face of adversity. Strom Thurmond coach Keith McAlister noted dryly that when his team fell behind 14–0 to Broome in the 1980 playoffs, "I wasn't ready to run up the white flag, but I was ready to hide under it." McAlister had the last laugh, though, as his Rebels rallied behind Arthur Jenkins's 144 yards and one touchdown to win 23–20. After his Red Devils scored three times in the last nine minutes of the 1987 AAA state title game, Keith Richardson was doused with Gatorade (thanks, Harry Carson). The winning coach retorted, "That is gonna become no tradition," according to the December 5 *Greenville News*. However, no one recorded what Hartsville coach Lewis Lineberger said when the police showed up just before the start of the 1988 state finals. Lineberger was arrested and hauled off as his stunned players looked on. Wishie Parker, a 1936 Hartsville grad and fan, took over practice. Lineberger returned a few minutes later and told the players it had been a ruse to see how they would react. The Red Foxes won the AAAA-II title a few days later.

And sometimes coaches got in trouble for reasons beyond their control. Daniel's Dick Singleton was fired after the 1983 season. Singleton had gone 162-108-6 in twenty-four seasons, including a 1966 state title. According to a December 9, 1983 article in the *Greenville News*, Singleton was let go for a "ripple of trouble" that stemmed from him swearing on the field. McAlister abruptly retired in 1988 with a career record of 103-25, including 7 region titles at Strom Thurmond. He told the *Spartanburg Herald-Journal*

on December 3, "I'm kind of burned out." He had just finished his second season at Byrnes.

Weather was also always a factor, including at the 1981 AAAA title game, when Berkeley beat Gaffney 18–15. A whopping 4.78 inches of rain fell on Williams-Brice Stadium the day of the game, and both teams wore sneakers to gain traction.

A minor scandal erupted in Spartanburg when new coach Allen Sitterle arrived from Independence High School in Charlotte with his old school's quarterback, Chip Ferguson, in tow for the 1984 season. The Ferguson family moved all of their belongings into a Spartanburg apartment and promptly moved back to Charlotte at the end of the year. Ferguson helped the Vikings to a state title game appearance, made the Shrine Bowl and grabbed a scholarship to Florida State. However, many fans were upset with the move and cried foul at the Vikings.

They Were Playing a Different Game

Brookland-Cayce started the 1987 campaign 1-7 and ended the regular year at 3-7. However, coach John Daye's Bearcats chose the right time to get hot. They upset Byrnes 14–7 and Wade Hampton 18–0 in the first two rounds of the playoffs before losing the Upper State title game 8–6 to Westside.

That was nothing compared to the 1989 North Augusta team. Bill Utsey's Yellow Jackets started 0-6 (though two were one-point losses) before taking eight of the next nine. That included the last four in the playoffs, which resulted in an improbable AAAA-II state title. Defense had a lot to do with the turnaround. Hartsville recovered forty-two fumbles in 1989, which remains a national record.

Notes from the Shrine Bowl

The 1980 Shrine Bowl was the personal showcase for Spartanburg quarterback Bill Bradshaw, who was 12 of 17 for 152 yards with two touchdowns, plus a third score on a 54-yard run. However, the Sandlappers still lost 35–33 when a last-minute field goal was missed after a bad snap. A little more than twenty-five thousand people saw the 1981 game that the

Sandlappers won 7–6 after twelve grueling practices under Myrtle Beach's Doug Shaw. South Carolina lost five fumbles in the 1982 game but still won 14–10. Future Clemson great Rodney Williams threw for 232 yards to help lead South Carolina to a 45–7 victory in 1983. North Carolina blew a 24–0 lead in the 1984 game as South Carolina won 34–28 in overtime.

The mid-1980s also saw North Carolina move back its playoffs, which meant that some of the players from the top teams could not partake in the Shrine Bowl. The 1987 game featured Conway's Norris Brown, who had worn leg braces when he was little that came from the Shriners to help his pigeon-toed feet. The December 13 *Greenville News* noted that during the team's visit to the Shriners Hospital in Greenville, Brown openly played and visited with almost every child he met. The 1989 Shrine Bowl saw the South Carolina playoffs overlap, and players from five teams were unable to go to Charlotte. Greer's Nelson Welch and Chad Hannon, North Augusta's Mathew Campbell and Chris MacInnis, Northwestern's Jeff Burris and Chris Nichols, Lancaster's Mark Anthony and Lower Richland's Vince Dinkins all switched to the North-South game a week later. South Carolina still won the game 12–0.

Stars of the decade include Perry in 1980; Stratford's Harold Green, who later played for USC and the Cincinnati Bengals, in 1985; Woodruff's Rice, Lower Richland's David Davis, who later played for the Giants, and Pageland's Corey Miller, who also would play for the Giants, in 1986; Greenwood's Robert Brooks, who later starred for the Packers and would be named one of the state's fifty greatest athletes of all time by *Sports Illustrated*, in 1987; Pickens punter Harold Alexander, who later played for the Atlanta Falcons, Greenwood's Ernest Dye, who later played for the Cardinals, Riverside's Jon Kirksey, a future Raider, and Broome stars Mike Reid, who later played for the Eagles, and Gabe Wilkins, who later played for the Packers, in 1988.

This was South Carolina's dominant decade, going 8-2 against the Tarheels, including 7 straight.

OVER AT THE NORTH-SOUTH GAME

While normal games were becoming high octane in the 1980s, the North-South game became a defensive stalemate simultaneously. Between 1976 and 1985, neither team scored more than two touchdowns in any game. And

that high score was just in the 1980 game in front of ten thousand people at Clinton High, when the South team won 14–3. The rest of the games saw typical scores of 10–7 or 7–3. Actually, the average game was 9.3–4.2, so not a lot of scoring was going on. Things finally heated up in 1986, when the North erupted for 28 points led by future NFL linebacker Ed McDaniel of Batesburg-Leesville. Other game highlights included a 7–7 tie in the 1981 game, when the South couldn't make a last-second field goal. Hanna's Jim Fraser led the North team to a 10–7 win in the 1982 game, which gave him a perfect 4-0 record in postseason all-star games for his career (1968 as a North-South assistant, 1970 as a Shrine assistant, 1976 as a Shrine head coach).

More than 2,500 people and 50 scouts were in the stands when the North beat the South 10–6 in the 1983 game. Dillon's Otis Washington was denied glory in the 1984 game. With the South trailing 6–0, Washington took a handoff at the thirteen-yard line with three seconds to go, weaved through traffic, was hit at the three and appeared to drag two defenders across the goal line as one of the refs signaled a touchdown. However, a second referee overruled the score. The 1987 game featured a magnetic performance by Greer's Anthony Williams, who ran for 149 yards and two scores and added a 59-yard touchdown catch in the North's 42–7 victory.

The North won the decade series 6-3-1.

STATS, STORIES AND STARS

Summerville's Perry Cuda's high school career came to an end with a 51-2 record as a starter (including 41 straight), but his last game was a 23–0 loss to Irmo in the AAAA state championship. Cuda was picked off an unheard, for him, three times. As a junior in 1979, he was intercepted only once.

The Whitmire Wolverines shut out opponents in eight straight games in 1980. Coach Jim Rich's team blanked opponents ten times that season.

The 1981 Abbeville Panthers defense gave up eight touchdowns on the way to a state title, while scoring seven off turnovers.

Abbeville beat Woodruff 14–12 on November 28, 1981, which was the Panthers' first victory over the Wolverines since 1960. That seven-game losing streak included six times in the playoffs. Woodruff coach Willie Varner showed his class by sending Abbeville coach Mike Hendricks a congratulatory letter. However, Woodruff would not beat Abbeville again until 2008—an eleven-game streak.

Byrnes fans helped spread thirty-six tons of sand on Nixon Field prior to the 1982 AAA state title game to help deal with wet conditions. It helped, as the Rebels upset two-time defending champ Myrtle Beach 9–6. The game's star was Byron Barnette, a cocaptain who was missing his right forearm but kicked and played receiver. His twenty-three-yard field goal in the inch-thick mire won the game with less than two minutes to play.

Laurens's Lonnie Pulley ran for 2,353 yards with thirty-one touchdowns in 1983. He capped the season by being named MVP of the Shrine Bowl.

Blackville-Hilda scored a record 63 points in the 1983 Class A state title game, but this really wasn't an example of running up the score. The Hawks were leading 26–20 over Ware Shoals when the fourth quarter began and then erupted for 36 in the final stanza. Barry Armstrong led the attack with 165 yards and four touchdowns.

Lewisville's Wesley McFadden ran for 2,220 yards and twenty-eight touchdowns in 1984 to bring his career total to 6,665, which was a state record that would last for more than a decade. In addition, East Clarendon's Jimmy Fleming ran for a state record forty-eight touchdowns that season, and that record still stands. He also sprinted for 2,609 yards, which was the single-season record for more than a decade as well.

Berkeley's Mike Dingle made a run for the record books in the 1980s. *Courtesy of Berkeley High School.*

A week after playing each other in the state AAAA title game as rival quarterbacks, Summerville's Brad Walsh and Spartanburg's Chip Ferguson roomed together at the Shrine Bowl in 1984.

East Clarendon lies south of Timmonsville but, for reasons that only make sense in the playoffs, represented the Upstate in the Class A state title game in 1985 against Timmonsville, which was the Lower State team. East Clarendon won the geographic mismatch 33–0 on the strength of three touchdowns by Ed Bodgon.

Berkeley's Mike Dingle was a six-foot, three-inch, 230-pound Stag, and almost impossible to tackle in the mid-1980s. In 1986,

he ran for 2,304 yards and thirty-one touchdowns. That gave him seventy-seven for his career, which was a state record that would last for more than a decade.

Eighteen teams started the 1986 playoffs undefeated, and seven of them lost in the first round.

In 1987, Blacksburg's Doug Boil became the first Wildcat since 1972 to make the Shrine Bowl. Bolin carried the ball 271 times for 1,999 yards and twenty-three touchdowns.

Spartanburg lost three state championship games in the 1980s by close scores, but most agonizingly in 1987, when Sumter sophomore Derrick Witherspoon scored the winning touchdown with two seconds left to cap a 91-yard drive. The score negated an amazing game for Spartanburg's Daniel Geatter, who scored three times and ran for 181 yards.

The 1987 AAAA-II title game could have been dubbed Clash of the Titans, as Hartsville's Aubrey Shaw ran for 259 yards and three touchdowns, while Westside's Demetric McMullin ran for 213. Hartsville won 29–10.

Pageland Central fans finally had something to cheer about in 1989 after losing in the AA finals the two previous seasons. The fans tore down the goal posts in the north end zone, and children turned the toppled bars into a sliding board as the Eagles received their gold medallions at midfield. Pageland Central defeated Bamberg-Ehrhardt 21–0.

CHAPTER 8

THE 1990s

An Assault on the Record Books

If there was a common theme to the 1990s, it was that no record was safe. Summerville's John McKissick became the winningest coach in national high school football history. Spartanburg made a run at being the best program in state history. Palmetto's Derek Watson shattered every major career rushing record, almost like a heavyweight boxer uniting all the major championship belts. Dorman started a Big 16 playoff streak that has yet to be snapped. Passing records fell every season in the second half of the decade as stats began to look like those accumulated in a video game.

But the 1990s weren't all about numbers. There were winners and losers. Games won and games lost. Revitalization of coaching careers and programs. The ends of others. The records were being etched in stone only to see a new engraver come the next day, chisel in hand.

Northwestern's Jimmy Wallace, who won 104 games during the decade, said the 1990s were part of the sport's continuing evolution. Teams once were focused solely on the run and would line up with three running backs and two tight ends and try to overpower opponents, but they had switched to a more offensive style by the end of the decade and would continue to grow well into the next one. Despite the changes from a blood-and-guts style to a more push-and-shove style, Wallace said the game was still unchanged at its core. "You will never replace the physical aspect of the game," he said.

THE WINNING COACH

The number 406 was everywhere when John McKissick brought his Summerville team onto the field on a crisp October night in 1993, and he was sorry for that. He apologized to his team for all of the scrutiny, the boom mike trailing him everywhere he walked along the sidelines, the reporters at practice and during the pregame pep talk, the wires poking out of every corner of his shirt trying to catch him in his moment of glory.

McKissick was about to set the national record for high school coaching victories, but in his classic fashion, he felt he needed to say he was sorry to his players. They would never have to face this kind of scrutiny again. They took his apology, demolished Wando 42–0 and grinned the rest of the night. They hadn't been around for win number 1—some of their fathers weren't even around—but they were there for the one that mattered, number 406.

McKissick had been delivering victories in the same way his wife, Joan, had delivered the mail in downtown Summerville—fast, efficiently and

Summerville's John McKissick got a lift from his players after breaking the all-time wins record for a high school coach. *Courtesy of Summerville High School.*

consistently. Along the way, he won nine state titles, twenty-three region conference championships, twenty seasons with more than ten victories, the forty-one-game winning streak and all of those wins. All week, a media legion descended on Summerville, which before McKissick was best known for its azaleas. They wanted to know what made McKissick tick. He gave them everything he could think of as to why he had stayed around so long—he liked the idea of molding young men, he liked the small town feel of Summerville, he really didn't have anything else to do. "I'm not the fella you'd have found in the gold rush. I'm the one back home plowin' with the mule," McKissick told *Sports Illustrated* that month.

But the town's residents were stuck on how to honor him. He wasn't a showy person, and they didn't want offend his sensibilities with anything overtly grand, so they went simple. All the lights on the historic town square were lit day and night heading into the game. A simple gesture for a man who now, seventeen years later, has added 176 more wins to that résumé, 1 more state title and 8 more region titles and has coached all three of his grandchildren. And maybe the most amazing accomplishment is that he has had only two losing seasons in fifty-seven years on the sidelines. Keith Jennings, who starred for Summerville's early 1980s team when McKissick hit the thirty-year mark, sees no reason for the coach to step down as he enters a seventh decade on the sidelines. "I hope he never leaves," Jennings said. "If he is still enjoying what he does, I hope he keeps going."

THE VIKINGS ARE COMING, THE VIKINGS ARE COMING, THE VIKINGS CAME

Spartanburg High quite simply bullied their way through the rest of the state in the mid-1990s, winning three straight state titles from 1994 to 1996 and adding a fourth title in 2001, all while playing in the vaunted AAAA Region II. It was somewhat of karmic vengeance for the Vikings, who three times lost heartbreakers in the state finals in the 1980s and whose 1970s' teams dominated in the regular season but somehow never managed to get it done in the playoffs.

The Vikings won 37 straight at one point, including consecutive undefeated seasons, and went 79-7 between 1991 and 1996. They were the first school in state history to post back-to-back 15-0 seasons. According to an August 2002 article in *The State*, the 1995 team was deemed the greatest single-year

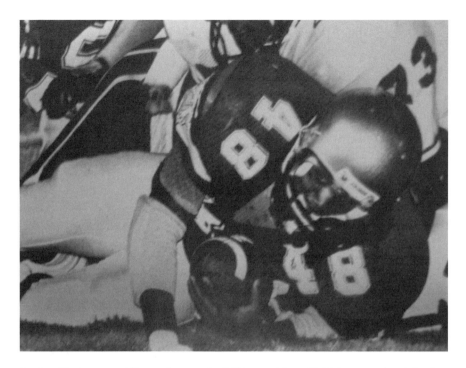

Stephen Davis powered Spartanburg to the 1991 state title and laid the groundwork for the dynasty to come. *Courtesy of Spartanburg High School.*

squad in South Carolina history, even though many players on both of those squads said they felt the 1994 team was better. Coach Doc Davis said *The State* came to him about picking which was the better and said at the time he chose 1995 because so many of the seniors had gone 30-0. In 2010, he was less committal. "I really don't want to go into that," he said with a chuckle. "It's like picking between my children."

The story begins with Davis, who came over from AA Chapman after the 1989 season. An Orlando native who remembers going to high school games at the Citrus Bowl, he came to the Carolinas as a quarterback at Gardner-Webb in the early 1970s, where he sat for two years behind Greer's Rex Hannon and then started for two. He started coaching in the Gaffney system and then came to Spartanburg in 1980 when Ellis Johnson took over as head coach. He then went to Chapman in 1985, and after a 0-10 start, he led the Panthers to a combined 25-2 in 1988 and 1989, when the call came from Spartanburg. He said it was the only school in the state he would have chosen because of his ties there already.

He inherited a promising young team led by a speedy, powerful running back who shared his surname. Steve Davis (as the future Washington Redskin and Carolina Panther was then known, even though he said he was always Stephen) quickly became one of the best players in the nation and made a run for the coveted position of being hailed as the best player in state history by some sportswriters. However, it was almost derailed during his new coach's first season. Davis's mother, Queenie, was diagnosed with breast cancer. He offered to quit football in order to take care of her, but she ordered him to finish what he had started. It was a wise move.

In the final game of his Viking career, the AAAA title game in 1991, *The State* described him as "a man among boys, the biggest thing going in a game with enough college prospects to fill many a college coach's Christmas stocking." He ran for 230 yards and two touchdowns (41 and 48 yards) on a grinding thirty carries. All of this came after spending the morning taking his SATs. After the game, he made a nod to the past Vikings teams that had come so close to winning the title but failed. He grew up dreaming of being a Viking while playing line at C.C. Woodson Recreation Park because of his size, and the state title was for all of them, he said.

The outburst gave him 2,449 yards on the season, which set a new AAAA rushing record while drawing comparisons to Herschel Walker and Tony Dorsett in terms of ability. He later added *USA Today*'s national offensive player of the year award and the Shrine Bowl MVP to his mantel before heading to Auburn and ultimately the NFL.

The Vikings won a region title in 1992 and went 10-3 the next year before really getting rolling in 1994. The 1994 team went undefeated with five shutouts, including two in the playoffs using a four-linebacker defense. The championship was capped in front of about twenty-two thousand fans in Clemson's Memorial Stadium for the title game against Dorman. Future Clemson and Seattle Seahawk star Anthony Simmons made nineteen tackles in the 24–17 victory. That squad finished seventh in the *USA Today* Super 25, according to newspapers at the time. However, the *USA Today* archives do not reflect this ranking anymore.

The 1995 season saw an all-around team effort that came together after a 0–0 preseason game against a rebuilding Woodruff team. Some people wondered if the Vikings could repeat. However, the team remained unbeatable, taking on all comers, including beating Rock Hill 10–0 in a blinding rainstorm for the region title. After beating an undefeated Conway team in the semis, they slipped past Sumter for the title, 24–14. Running back Corey Miller ran for 1,575 yards, and Terrence Sims had 1,070, while

the defense again posted five shutouts led by linebacker Harold Means. After the season, Spartanburg High fans presented Davis with a brand-new Ford Explorer. A stunned Davis jokingly said it was big enough to fit his entire staff and later would put more than 200,000 miles on it.

The third title came in 1996 after a 13-2 record, led by quarterback Ed Fowler and running back J.R. Dogan. Davis said that Dogan may have been the MVP of all three title games. He started at defensive back and receiver in 1994, linebacker in 1995 and as a defensive back and running back in 1996. He picked off a pass on the second play of the second half in the 1996 title game and ran it back for a touchdown. That was the turning point in the game and ultimately led to a 28–6 victory over Rock Hill. Davis said a lot of people didn't expect the 1996 team to contend, but they extended the winning streak to 37 games before finally losing to crosstown rival Dorman. "They just refused to lose that year," Davis said.

The Vikings remained a state power for the next few years and reloaded for a 2001 state title. However, the team took a back seat to Byrnes and Dorman later in the decade, and Davis resigned after a trying 2-9 2007 season.

A RIVALRY GETS BIGGER

The Spartanburg-Dorman rivalry has always been a big one in the Hub City, but it had always favored the Vikings until the late 1990s. Actually, the all-time record was 36-6 in favor of Spartanburg by the end of the decade. Yet even as Spartanburg was rolling over the state in the mid-1990s, the seeds for Dorman's emergence were being planted when the school district hired Dave Gutshall after the 1992 season. Gutshall had won three North Carolina state titles in the previous ten years and was one of the Tarheel State's brightest coaches. However, Dorman nabbed him with the promise of coaching football in a tougher state, which was a big motivator for the coach. The Cavaliers went 6-8 in his first season, including a 42–14 dismantling by Spartanburg. However, Gutshall rallied his team, and they beat the Vikings in the playoffs and made the state semifinals. It has been all uphill since then. The Cavaliers have had sixteen winning seasons in a row, and they are the only Big 16 school in the state to do so; they have won three region titles; been to the state semifinals nine times; made the state finals five times and won twice, in 2000 and 2009.

Gutshall has led them with a blistering array of coaching styles. Unlike a lot of coaches who build an offense and stick to it, Gutshall changes almost season to season based on his personnel. They have been pass happy, run-oriented and balanced between the two. And as of 2009, he had raised the all-time series record to 39-15.

THE RUNNING MAN

Derek Watson's best game as a high school player may have been his last—the 1998 Shrine Bowl. On a cold December day in Charlotte, Watson slashed through the North Carolina defense for a record 275 yards on an also record thirty-three carries. It was a one-man show that, for Watson, proved he belonged as one of the best runners in the nation, let alone South Carolina. Despite setting then state records for career yards (6,766) and touchdowns scored (eighty-eight) during his senior year at Palmetto High and also being deemed the state's Mr. Football recipient, there was a feeling that Watson was not as good as he seemed because he played for a small school against small-school competition. The feeling was that Watson would get crushed against consistent AAAA challengers. Even Watson seemed to have something to prove when he told *The State* minutes after the Shrine Bowl that he really wanted to show he could compete against Nick Maddox, a star on that year's Tarheel team. "Maddox is one of the best backs in the nation," Watson said. "I just wanted to prove I'm one of them, also."

The recruiting world would soon know a lot about Watson, but let's step backward for a second. Watson barely knew his father, and his mother died of cancer when he was eleven, so he went to live with his grandmother, Mabel Wright, a retired textile worker who said her greatest joy and anguish came in watching Watson run. She loved his spins, cuts and touchdowns but winced every time opponents piled on him and hit him hard. However, one of her daughters returned home with two toddlers just as Watson started high school, so he spent the next four years shuffling between there and his aunt and uncle's place next door.

At six feet, one inch and 205 pounds, Watson was like no player Palmetto had seen in years and was the team's offensive cog by the end of his sophomore year under head coach Tommy Davis. He started his junior year off with a 181-yard, two-touchdown effort against Wren and soon

Palmetto's Derek Watson dominated in the late 1990s on the ground, but his college career was derailed by off-the-field problems. *Courtesy of Palmetto High School.*

was rolling out big games every week as he rushed for more than 2,000 yards that season. In his senior year, he led the Mustangs to their first region championship since the 1970 team won a state title. The offense was basically pitch the ball to Watson and let him go. He used a slashing style that made use of pivots, spins and leaps made in split-second decisions as opponents swarmed in from all directions. Along the way, he broke the career touchdown record held by Berkeley's Mike Dingle while also breaking Wesley McFadden's state rushing yard record in the final game of the season against Emerald. However, that was a heartbreaking 24–20 loss. He also ran for a school single-season record of 2,571 yards, and his forty-four touchdowns were the state's best since Jimmy Fleming of East Clarendon crossed the goal line forty-eight times in 1984. The next few weeks brought accolades, including All-State and All-Southern selections, but some doubts remained. Heading into the Shrine Bowl, head coach Jack King of Wren tried to play a little bit of trickery on opponents by lining up Watson at fullback and tight end during practices. Even Watson wondered what was going on, but after the game (a 38–20 loss), King said he had no doubts about the runner. "The first practice, I knew he was special," he said. "He's as good as any in the nation."

Soon the recruiting battles erupted as Watson became the main focal point in a tug of war between Tennessee's Phil Fulmer and South Carolina's Lou Holtz. And that is when things turned ugly quickly. On January 9, 1999, Watson verbally committed to the Gamecocks, who were coming off a 1-10 season in Columbia. But three days later, he was on a private plane to Knoxville along with Westside's Shaun Ellis, and Carolina fans were in shock. Watson was receiving more than fifty phone calls a night, including one at 11:45 p.m. that stirred him from his bed. Some

nights he turned the ringer off and wouldn't go to the front door. One of his uncles began answering anytime someone knocked. Fed up, Watson asked his high school coach, Davis, to call Tennessee on January 22 and tell Fulmer the tailback was going to join the Volunteers. On January 29, he said his commitment to Tennessee was firm but added that a decision was not set in stone. He was spotted at a USC basketball game the next day with Holtz at his side. In the middle of it all, word leaked that Watson's SAT and ACT scores were not up to NCAA snuff.

Opposing fans chanted "S-A-T, S-A-T" at basketball games, which, according to the February 3 *Anderson Independent Mail*, led to "an ugly atmosphere surrounding some of the Mustangs' games, including scuffles on the court."

"It bothers me a lot," Watson admitted. "If it was them, they wouldn't want anybody to know. I think and I know in my heart that I'm going to pass it. It's just a matter of me going and taking the test and having the determination to do it and just concentrating on the test."

The night that story in the Anderson paper ran, Watson donned a USC baseball cap at his high school and announced the Gamecocks were his choice. South Carolina fans were ecstatic, thinking that Watson was going to be the school's best runner since George Rogers took home the Heisman Trophy in 1980. It didn't quite work out that way. Watson flashed brilliant play at times, including rushing for 1,066 yards and twelve touchdowns in 2000, but his off-the-field antics left many scratching their heads. He was suspended from the 2000 Outback Bowl for wrecking a teammate's car. In 2001, he had an altercation with a referee at an intramural basketball game and later punched a female student, though the charges were dropped. In 2002, he was arrested for possession of marijuana outside a Greenville nightclub the day after he opted not to apply for early admission to the draft. That led to him being dismissed from the South Carolina team, but he landed down the road at South Carolina State. But gridiron glory was outshined by him being suspended for three games following an arrest on a driving with a suspended license charge. Watson entered the NFL draft in 2003, was not picked, went to training camp with the New England Patriots, was cut and later played briefly with the Tampa Bay Buccaneers before heading to Canada. It also made people remember Holtz's prophesy about Watson that the talented runner would either fill NFL stadiums or sweep them.

The Return of Jimmy Satterfield

To borrow a phrase from the Yogi Berra lexicon, it was déjà vu all over again in 1996.

That is when Jimmy Satterfield stepped onto the high school turf for the first time in twenty-three years. Satterfield had spent twenty-one of those years coaching colleges, including eight as the head coach at Furman University, where his Paladins won the 1998 NCAA Division I-AA national championship. He retired in 1994 and figured he was done.

But somehow there he was at Lexington High, which had struggled so much in recent seasons that two other coaches had lost their jobs in the previous five years. Satterfield had cut his coaching teeth in the Midlands, going 49-9-1 between 1968 and 1972 at Eau Claire and Irmo before going to the colleges. He told *The State* in August 1996 that even he didn't expect to be coaching at the high school level again. He had figured his career was done, even though he missed football.

However, things got in motion based on a hunch by Allan Whitacre, Lexington's principal. He called Satterfield's mentor and friend, Art Baker, to see if Satterfield was interested in leading the Wildcats. Satterfield was intrigued because he felt the school gave him the opportunity to be productive. "They seemed to have the kind of things it takes to win. It was just a matter of making it happen," Satterfield said at the time.

Players also were curious. More than sixty new players showed up at spring practices that year, according to *The State*. They wanted to see what all the fuss was about. At the time, Lexington was a Big 16 school that had finished above .500 only twice in the previous twenty years. Many people wondered if the college coach could relate to high schoolers, let alone get them to understand his complex Furman offense.

To borrow another cliché, they wondered if an old dog could learn new tricks. Satterfield's record speaks for itself. In eight seasons at Lexington, the Wildcats went 73-31, never had a losing season, won five region titles and made the state AAAA-I finals in 2000. He closed the books on his career for good in 2004 when, at age sixty-four, he said he was only going to do what his grandkids told him from then on.

The Rebirth of Swansea

Swansea had been a state power for decades under head coach Doug Bennett. There had been a state championship in 1960 and a string of dominance in the 1970s when the Tigers won back-to-back state titles in 1974–75 and three region titles, while being a contender almost every year. But the program faded after a 1981 region championship, and the decade culminated with three straight losing seasons and Bennett stepping down after 1989 with 268 career wins over thirty-seven years.

To replace him, the school board hired Robert Maddox, who quickly turned the Tigers into the king of the jungle again. Swansea put together a twenty-eight-game winning streak between 1992 and 1994 that included three consecutive state titles.

Maddox was an alum—an undersized guard who started as a junior and senior and drew a look to play at Presbyterian. Realizing he was too small to play college ball, he transferred to USC after two years and graduated with a degree in biology education. Teaching and coaching became an intertwined path as he worked his way through the state as an assistant at Strom Thurmond and Aiken. Bennett predicted that Maddox was the person to lead the Tigers into a new era. His words proved prophetic. They made the playoffs in 1990, the state finals in 1991 and then won it all in 1992. That set the stage for an undefeated season in 1993 and recognition as one of the best units in state history by going 15-0. The Tigers' defense, led by the likes of Ian Smith and Derrick Jeffcoat, blanked eight opponents and never gave up more than 12 in a game. The offense, led by North-South quarterback Stanley Myers, scored more than 40 points on six occasions. They outscored opponents 485–71, and their lowest margin of victory was 14 points.

The winning streak ended in early 1994 when Macedonia beat the Tigers 20–7 at home. The team lost the next week as well but then went on an 11-game winning streak and won the final title. Maddox added two more region titles in 1997 and 1998, but resigned after a 2-8 season in 1999 to be with his young family.

They Call Him Mr. Football

In hindsight, it was an honor that was long overdue. When the South Carolina Athletic Coaches Association ended its forty-eighth annual clinic

in the summer of 1995, they called the press to the Adam's Mark Hotel in downtown Columbia

They were starting something called the Mr. Football Award, which was being created to honor the best senior in the state. The coaches dubbed it their equivalent of the Heisman Trophy and explained that coaches from across the state could nominate players at the end of the season. A committee of former coaches would then meet to name five finalists, with the winner being announced during the North-South All-Star Banquet.

Berea's Jermale Kelly won the first award that fall after catching 68 passes for 1,154 yards and 10 touchdowns while helping his team to an 11-2 record, which remains the best in school history. At the time, his career 187 catches were second best in state history. He later starred for the University of South Carolina when the program rebounded from a 0-21 streak to win the Outback Bowl in 2000.

SOME THINGS NEVER CHANGE

Conway's Chuck Jordan is one of the most celebrated and successful coaches in state history because he learned early that the game is about adapting to the changing styles but realizing the game itself never really changes. Sound a little Zen-like? Let Jordan explain it in his own words.

> *The game simply reinvents itself. I've seen it all. We have coaches coming along now who think they invented the forward pass. I can tell you teams were throwing before I started coaching. But that is how it goes. We get a lot of ideas from the college game. More so than the pro teams because we are closer to them. The offense usually finds an advantage first and it takes time for defenses to catch up. Once they do, the offenses start tinkering again. It's the way the game is played.*

Jordan knows about reinventing. His team has consistently won region titles and contended for the state title in three different decades. "That is the reality of where we are," he said.

NOTES FROM THE SHRINE BOWL

The 1990s were once again a dominant decade for the Sandlappers, as they took six of ten from the Tarheels. Part of the reason was a bevy of stars, including future pros such as Riverside's Brandon Bennett and Camden's Bobby Engram in 1990; Wando's Dexter Coakley, Edisto's Terry Guess and Spartanburg's Davis in 1991; Airport's Dexter Staley and Spring Valley's Peter Boulware in 1992; Macedonia's Joe Hamilton and Spartanburg's Anthony Simmons in 1994; Orangeburg-Wilkinson's Woodrow Danztler, Lower Richland's Richard Seymour and Gaffney's Dominique Stevenson in 1996; Hartsville's Albert Haynesworth, Rock Hill's Chris Hope, Chester's Maurice Morris, Dorman's Ryan Sims and Northwestern's Derek Ross in 1997; Stratford's Jonathon Alston, Orangeburg-Wilkinson's Alex Barron, Lakewood's Shannon Davis, Belton Honea-Path's Jeremiah Garrison, Battery Creek's Greg Jones, Marlboro's Cam Newton, Cross's Rod Wilson and Spring Valley's Michael Boulware in 1999. For those counting at home, the eight players to play in the pros from the 1999 team is the highest total in game history for South Carolina. The Sandlappers won the 1999 game 24–3.

With that much talent, coaches often looked for ways to get as many top athletes as possible into the game. For example, Eastside's John Carlisle put Westside's Greg Addis on his team as a punter in 1992. Of course, it helped that Addis was a star receiver and defensive back. Eastside's Nathan Broome was the kicker but also played quarterback, punter and defensive back. Airport's Staley was listed at quarterback but played receiver and tailback in the game.

The 1999 Shrine Bowl saw a familiar name in center Ben Farr of Dorman. Farr's grandfather, Quay II, played in the 1948 game for Greenwood, and his father, Quay III, played in the 1974 game for Cowpens. Quay Farr III was also a coach for many years.

OVER AT THE NORTH-SOUTH GAME

The 1990s were dominated by the North team, which took 7 of 10 from its South counterparts as the game returned to somewhat normal scoring standards. The South edged ahead in the all-time series 21-20-2 with a 29–28 victory in 1990, but it was all North after that. The 1991 game was

a 34–9 affair as the North used ten different runners to win. In 1992, the rosters were expanded from thirty-five to forty, and Westside's Quartzes Mattison threw two touchdown passes to lead the North to a 15–10 victory. It was 31–8 in 1993 and 19–16 in 1994 before the South saved face with a 28–16 victory in 1995. Many expected the South to win the 1996 game because twenty-five of the thirty-five players on the Shrine Bowl team were from the Upstate, and therefore the North would be depleted for the Myrtle Beach game. Wrong. The North won 27–7.

The 1997 game was a special one because it was the fiftieth anniversary and almost one hundred former players attended a ceremony, including North Carolina State coach Mike O'Cain, who had been the MVP of the 1972 game. In addition, the South team's line kept up a strange tradition, according to the *Myrtle Beach Sun*. The staff at the hotel they stayed at asked that no more than ten linemen get in an elevator at a time because of a 2,500-pound weight limit. Sure enough, ten linemen got on, and the hotel elevator got stuck between floors.

The North routed the South in the 1998 game, 41–12, behind Northwestern's Nick Haughey's 213 yards and three touchdowns passing. It was the worst defeat for the South in the game's history. The North ended the decade with a 31–24 victory in 1999 that came after falling behind 17–7 at the half.

STATS, STORIES AND STARS

Irmo kicker Reed Morton tied a state record with fifteen field goals in 1992. That included hitting his final ten of the season with kicks from fifty-six, forty-eight, forty-seven and thirty-eight yards out in his last two games. Walterboro's Will Caison would break the record with nineteen three years later.

Robert Porcher became the first player from South Carolina State ever taken in the first round of the NFL draft in 1992 after a stellar career with the Bulldogs, but his high school career was not as fantastic. His parents wouldn't let him play his sophomore and junior years at Wando because of grades and a poor attitude. He ended up at tiny Cainhoy High School—which closed a few years after he graduated but was where his family lived and his father starred years earlier—for his senior season and played well enough to get a scholarship to Tennessee State, but he

later transferred to South Carolina State. He eventually became a star defensive end in the NFL.

Richland Northeast won the 1993 state AAAA Division II championship one year after finishing 1-10 the year before. Joe Wingard's team had one of the biggest—if not the biggest—turnarounds in state history.

Silver Bluff's Corey Chavous was determined to make it to the next level. Despite being selected for the North-South All-Star Game as a senior in 1993, he didn't receive a lot of attention from major colleges. So he created a slick marketing package that highlighted his skills and his SAT score and soon got the attention of some bigger schools. He chose Vanderbilt and became a starter immediately. He later was drafted by the Phoenix Cardinals and spent more than a decade in the NFL as a cornerback/safety.

The Baptist Hill Bobcats got off to a 5-0 start in 1994, which was the best in school history and got them as high as seventh in the state AA poll. Their coach was Charlie Brown, who starred at John's Island in the 1970s before going to South Carolina State and ultimately being a Pro Bowl wide receiver and a member of the Washington Redskins' "Fun Bunch."

Dillon's Stan Manning ran for a new state record 2,902 yards in 1995, breaking the old record of 2,609 set by East Clarendon's Jimmy Fleming in 1984. The five-foot, nine-inch, 205-pound senior used a 202-yard night against South Aiken to eclipse Fleming's mark. He was on pace for 3,000 yards but was held to only 146 in the final game against Buford.

Lower Richland players picked up the slack in a 1995 playoff game against Hillcrest. Playing without leading rusher Travis McFadden, the Diamonds ran for 446 yards on the ground, led by Shawn Adams with 124 yards, Kippy Bannister with 116 yards and J.R. Broomefield with 114.

Macedonia's Courtney Brown registered 124 tackles in 1995, including eight for losses, and recovered two fumbles and intercepted one pass. On offense, he caught 19 passes for 293 yards and one touchdown as a tight end. Brown had 442 tackles, with 21 tackles for losses and five interceptions during his three-year career at Macedonia. He later played at Penn State and, in 1999, became the first South Carolina native ever taken number one overall in the NFL draft.

Gaffney's Kentrell Jones heaved a then record forty-one touchdowns to lead the Indians to the 1997 AAAA-I title. He also completed 186 passes, which was third best in state history at the time.

The 1997 Fairfield Central team went undefeated while putting up 710 points and 5,914 yards. Quincy Wicker led the way with a school single-

season rushing record 2,063 yards and a career rushing record of 5,042. The team ended up ranked fourteenth in the nation, according to *USA Today*.

Hartsville's Albert Haynesworth tackled seventeen runners and assisted on twenty-three others during his senior season in 1998. That doesn't sound like much, considering the massive defensive tackle was deemed the state's best college recruit. The but, though, is that Haynesworth was double and triple teamed almost all season, and opponents generally ran away from his massive three-hundred-pound frame. A decade and one year later, he signed a $115 million contract with the Washington Redskins.

Rock Hill's Chris Hope started fifty-five career games during his career and ran for 3,750 yards, scored 51 touchdowns, made 474 tackles and had 10 interceptions. He culminated that by winning the Mr. Football Award in 1997. He later won a Super Bowl as a member of the Pittsburgh Steelers.

The 1998 Summerville team was led by the twin rushing attack of Bernard Rambert—200 carries for 1,800 yards with 17 catches for 301 yards and 17 touchdowns—and Jonathan Smalls, who ran 157 times for 1,205 yards and 17 touchdowns. The team finished twenty-first in the *USA Today* poll.

Dutch Fork's Erik Kimrey was a one-man offensive show in the mid-1990s. The Silver Foxes changed their traditional run-first offense to a spread because of his arm, and he responded with more than 3,500 yards and forty touchdowns as a senior in 1997. He was a Mr. Football finalist and played in the North-South All-Star Game. After his playing career, he coached Hammond to three straight state SCISA titles in the late 2000s.

THE 2000s

Football Goes High Tech

The first decade of the new century was a quantum leap in terms of technology. Coaches went from watching film on VHS tapes that took two hours to review to burning games to DVDs in a few minutes. Instead of spending the off-season drawing up plays on chalkboards and white boards, they could now download their playbooks into a video game and teach their players the intricacies of the sport that way. The number of coaches increased, too, as larger high schools began adding staff members whose sole jobs were to work on the computer part of the game. And many of the coaches kept in touch more and more by text messaging one another back and forth as well as using such devices to keep their players in check. Mickey Wilson, who oversaw Myrtle Beach's pyrotechnic offense first as coordinator and then as head coach, said technology such as video game playbooks is the wave of the future. "Pretty soon we all will be doing it," he said.

The computer age also changed the way fans followed the game. While recruiting news has been popular for decades, the process of following it went to whole new levels. Fans could track every aspect of a player's potential collegiate choice with just a few clicks every day as websites popped up offering videos, "exclusive" interviews and measurements. Message boards allowed fans to share memories while also trash-talking their foes using comical, but anonymous, avatars to protect themselves from real harm. It also allowed fans to follow their favorite teams by creating specialized websites that tracked every movement of their favorite teams.

The Reservation at Gaffney underwent a $9 million "renovation" in the first part of the decade. *Author's collection.*

Stadiums also got bigger and better. Byrnes's Nixon Field added a $320,000 Jumbotron and personalized season tickets. Not to be outdone, Gaffney completely rebuilt its famed Reservation in Cherokee County for $9 million to include press boxes, outdoor patio areas, booster boxes, on-field band seating, a team meeting room and a $500,000 Jumbotron. The school's mascot came to the first game at the new field in a helicopter. Exposure grew for the state. In 2009, former Spartanburg High and Super Bowl hero Stephen Davis coached the East team in the national prep Offense–Defense All-American Bowl at Coastal Carolina. The game was growing. Wilson said it was an overflow from the college and pro games. High school coaches were taking the offensive schemes and training methods from the pros. It used to be that football was a fall sport, but now teams practice passing all year round. At Myrtle Beach, they start working with seventh and eighth graders when looking for the next quarterback to take over the reins for the Seahawks. "You can't just show up on August first and start throwing anymore," he said.

Television, which first began showing high school games in the 1950s, also expanded its influence on high school football in the 2000s. Many local stations started showing games in their regions on Thursday nights, which was important enough that many teams often redid their schedules just to fit in a prestigious game under the lights. ESPN also became a major factor, often airing games of many of the state's top programs. In 2007, John McKissick remarked about the nature of television before his Summerville team was making its first-ever appearance on ESPN (the World Wide Leader missed his first 543 wins). "We have been on educational TV and that kind of stuff, but never on national TV. I've got mixed emotions about it, but the town is excited. The kids are excited. I just hope they don't get too excited," McKissick told the *Charleston Post and Courier*. From 1998 through 2004, the state finals were shown on South Carolina ETV each year. While people loved the games, ETV had trouble getting sponsors to underwrite the costs ($2,000 per game for the rights and at least $30,000 to air) of showing the "Weekend of Champions," according to the December 2, 2005 *State*.

But in reality, the game stayed very much the same. Shell Dula retired after forty years on the sidelines in 2008 and took over as the head of the South Carolina Athletic Coaches Association. He said athletics need to be

The South Carolina History Museum created a display honoring football in the state. One exhibit was on the history of the game. *Courtesy of Shonda Boyanoski.*

kept in the right perspective, and that was happening at the high school level. The kids are learning life lessons and how to be good citizens. That is a benefit that transcends the game beyond just winning. He talked about the coaches who influenced him, including Cally Gault at Presbyterian and Willie Varner at Woodruff. Coaches still have that influence. "The state of high school football is very good," he said. Keith Richardson, his predecessor with SCACA, said it really comes down to believing in a system. A coach who believes in what he is doing will do better than a coach trying to teach something he doesn't quite understand. "Good coaching is the key to being successful," Richardson said. "Look at Byrnes. It's not the kids really, but the coaches. If they were to switch to the Wishbone they would be lost. You have to have a system you believe in."

And in maybe the ultimate honor for the game and its permeation in the life of the average South Carolinian, the state History Museum unveiled a massive exhibit honoring the sport in 2008. The exhibit covered all aspects of football, from high school to the pros, but the general flavor of the showcase was to re-create a Friday night in South Carolina, complete with cyclone fences separating pieces.

Rebel Rebellion

Bud Wilson has as much to do with the rise of the Byrnes football program in the 2000s as the coaches and players who won the games. It was the sports-mad Wilson who started taking his next-door neighbor's young son to Rebels games in the 1970s along with his own kids. Seeing the pageantry and color of Friday nights hooked the youngster, and by the end of third grade, young Bobby Bentley decided there was no greater professional goal in life than to one day lead the Byrnes Rebels from the sidelines.

One of the burning questions of the 2000s was whether the Byrnes dynasty could have happened without Bobby Bentley or whether Bentley could have replicated that prep success in another part of the state. Bentley's offensive schemes stretched defenses, and his shrewd judgment in picking assistants bordered on the prescient at times, but could he have gotten such leeway and faith from the administration if he had not led the Rebels to a state title game as a quarterback a decade before he took over the coaching reins? It's hard to believe that the Rebel Nation, which was accustomed to winning teams, would have

accepted an outsider who proposed aligning all of the district's middle school teams under the jurisdiction of the high school boss if he wasn't a native. Likewise, it is hard—but not impossible—to fathom that Bentley could have implemented such changes if he were an outsider in another district. Bentley can't give an answer. He really can't even explain his love for his home team. Aside from being generally regarded as the man who single-handedly created the Byrnes dynasty (he credits the school administration, players and assistant coaches), he could be the number-one fan. He relates history and anecdotes about Byrnes's storied football history. The Rebels won state titles in 1976, 1982 and 1986 and made the state title game in 1985 (with Bentley at the helm as quarterback). There also were region titles in 1975, 1983 and 1993. Nixon Field already was a tough place to play when Bentley took over as coach in 1995, but by then it was more for the famed marching band—the Rebel Regiment—than the on-field Rebels.

Bentley's first two seasons ended with a 3-20 record, but the seeds were being planted. Bentley admits that he realized he needed to be more than a coach on the field. He started taking an interest in the players' lives off the field. He started morning meetings where the players could come in and talk to one another and share their concerns about life. He reinstated things such as the Strike Force Defense and the High-Powered Offense flags that the team carried onto the field to start games. In the next few years, the players would march arm in arm from the goal line together in a show of blue and silver solidarity. When the national wins started piling up, Bentley had reminders of those victories painted on a wall leading into Nixon Field. The players touch each one of those reminders before heading onto the field. The 1997 season brought a winning record and the first playoff win since 1986. The team got better in the next three seasons, but playing in a region with superpowers such as Dorman and Spartanburg didn't translate into many more wins. That changed in 2002.

Starting that year, the Rebels would go 57-2 in the next four seasons and take home 4 straight titles. One of those losses came against a team from Louisiana, while the other was a 2004 12–10 setback to perennial power Gaffney in Gaffney. The 2006 season was a "rebuilding year," with an 11-2 record. Bentley stepped down at the end of the season to take over as head coach at Presbyterian College. Under former defensive coordinator Chris Miller, the Rebels won 23 straight games, a fifth state title in 2007 and were ranked number one in the nation before losing

to archrival Dorman in a 2008 game at Roebuck that drew close to fifteen thousand people and essentially shut down cell service because so many people were reporting to friends about the upset. Byrnes, though, grabbed the last laugh in the playoffs by dismantling the Cavaliers 24–13 and then beating Sumter for the state title. The team started the 2009 season as number two in the nation and played a much-hyped game that was televised on ESPN against number-one St. Thomas Aquinas in Florida. The Rebels lost a back-and-forth classic 42–34 and ultimately ended the season on a losing note in the state title game to Dorman. At the end of the decade, it was hard to believe, but true, that Byrnes had not lost a home game since 2001. Byrnes also put together a 29-game winning streak, which is the fourth longest in state history.

The off-the-field numbers are almost equally impressive. Two *Parade* All-Americans. Three U.S. Army All-American Bowl participants. Three Mr. Footballs. Starting the 2008 season ranked number one in the *USA Today* poll. They were number two in the 2009 poll. The Rebels finished in the top twenty-five in 2005, 2007 and 2008. Two of its quarterbacks sit atop the all-time single-season touchdown list—Will Korn with fifty-three and Chas Dodd with fifty-two. The school's booster club also set a new standard for fan bases. They travel in carloads to away games in places such as Georgia and Florida to turn them into practical home games. The Rebel Touchdown Club has raised more than $1 million in the decade to help pay for things such as meals for players.

Some Other Great Teams

Byrnes wasn't the only school to win a lot of games in the 2000s. Gaffney, along with Dorman, was one of the few schools to cause real trouble for the Rebels. Coach Phil Strickland's team won three state titles in the decade, including 2003, led by Sydney Rice, who snared seventy-seven passes for 1,414 yards and fourteen touchdowns and later became Brett Favre's go-to playmaker with the Minnesota Vikings.

Tiny Silver Bluff, though, outdid Byrnes in one aspect. The Bulldogs won thirty straight games in 2000 and 2001 while claiming back-to-back state AA titles under head coach Al Lown. Stars included Troy Williamson, who later played in the NFL; linebacker Marcus Lawrence, who played at USC; and DeAngelo Bryant, who played at Wake Forest. While Williamson was named

to the Shrine Bowl in 2001, he was only the team's third leading rusher with 1,160 yards. That fell behind halfback Joe Wilson (1,324) and fullback Eddie Bryant (1,196). They put up those numbers behind a starting line that averaged 260 pounds. Offense was the name of the game at Silver Bluff, as the team scored more than thirty points twenty-three times during the streak, including eleven straight times to start the 2001 season. The Bulldogs won seven region titles during the decade as well.

Lamar won three straight Class A titles in the early part of the decade. J.R. Boyd's Silver Foxes went 43-2 in winning titles in 2002, 2003 and 2004. The 2004 team gave up 31 points while going 15-0. The offense was nearly as dangerous, averaging 36.9 a game behind a wishbone-style offense.

However, it was tough to find a team that could contain the Chesterfield Golden Rams in the latter part of the decade. Led by the former flamboyant Gamecock quarterback Steve Taneyhill, Chesterfield went 38-4 while winning Class A state titles from 2007 to 2009. The last of those teams went a perfect 14-0 while registering eight shutouts and averaging forty-nine points a game, including twice going over seventy.

TURMOIL AT THE SHRINE BOWL

The sport's most famous All-Star game underwent major changes in the 2000s. The problems started in a February 22, 2001 meeting among members of the six Shriners temples that run the game. The dispute stemmed from the fact that the group couldn't decide on who to elect as new game officials and quickly degenerated into questions of whether the game would be cancelled. Immediately, Charlotte's Oasis Shrine Temple pulled out of the process (over "how the game should be managed," according to the *Spartanburg Herald-Journal*). That did not stop the questions from coming, but it did give a glimmer of hope. But just a glimmer. Charles Walker, who served on the Shrine Bowl Board of Governors as the general chairman the two previous years, told *The State* in April that "to a small degree, the game is in jeopardy," but added that steps were being taken to resolve the Shriners' issues.

While the 2000 game had raised $65,000 for Shriners Hospitals, fewer than 6,000 people had attended the game, making the 20,000-seat Memorial Stadium seem practically cavernous. Game officials suggested that the game could be moved and had contacted the University of South Carolina's Williams-Brice Stadium, which drew a combined 30,448 people to five state

championship games the year before. However, when the Shriners national governing body said the other temples could not hold a fundraising event in Charlotte without Oasis, it seemed to mark the end of an era. The next few months brought more debate before it was decided that the game would move to Rock Hill—a thirty-minute drive from Charlotte but into South Carolina for the first time. The decision actually started when the head of the Rock Hill tourism board approached Shrine Bowl officials about potentially holding a practice in their city. Instead, Rock Hill was chosen because it was a central point—like Charlotte—to the two states. That was important for the teams, as well as many of the volunteers, who made the game a success by doing everything from dressing up as clowns to working the concession stands. Walker said at the time that the move saved a tradition that was in danger of dying. "It's put life back into the game," he said. "It's sort of reminiscent of when I was a young man and all of the people in Charlotte were enthused about the game. It's like Rip Van Winkle. How long did he sleep? Twenty-nine years? This time we slept for forty years."

Rock Hill initially had a two-year deal, and organizers spoke optimistically about getting the game permanently. Local organizers bent over backward to make the game a success, even getting a local middle-school class to paint the logos on the field—a job that normally would cost about $5,000 for the Shriners—for free. Practices were split between fields at Rock Hill, Northwestern and Lancaster Highs. The game was held at the 10,500-seat District Three Stadium on December 15, and according to *The State* newspaper, it was "bursting at the seams" as fans, including South Carolina Governor Jim Hodges, overflowed the stands. South Carolina won 17–0 on the legs and arm of Pelion's Josh Stepp, who completed 5 of 9 for 86 yards to win offensive player of the game honors. More importantly, $1.4 million was raised for Shriner hospitals.

The game stayed in Rock Hill for 2002, and the Shriners extended it for 2003, but it was decided to open up the bid to other temples afterward. This time, only South Carolina cities—Rock Hill, Greenville and Spartanburg—bid, according to the *Spartanburg Herald-Journal* on August 16, 2003, the day of a secret ballot vote to move the game again. Spartanburg's bid offered Wofford's Gibbs Stadium as the game site and practices at nearby Dorman High School. They also offered medical attention for the week, vehicles to transport players, office space to run the game from, drinks for the entire week and the stadium—all at no cost to the Shriners. Spartanburg got the deal. More than eleven thousand people attended the 2004 game, but game organizers added things such as a Christmas parade as part of the

event week the next year to create more of a festival atmosphere. In 2006, the game's stay in Spartanburg was extended until 2011—just in time for the seventy-fifth anniversary—beating out rival bids from Myrtle Beach, Rock Hill and Raleigh, North Carolina.

In addition, the Oasis Shriners started their own all-star game again in 2005. Dubbed the Oasis Shrine Bowl, it is a showcase for players from the independent school associations in both Carolinas.

NOT TO BE DENIED

They were just two football buddies driving down the road when tragedy intervened. One of their mothers was driving, and they talked about the upcoming season—starting in just six days—when the front tire blew out. Ronald Sampson, Lake View's starting quarterback, was ejected from the car. Quandon Christian rushed from the wreckage to find his friend. Sampson was critically injured and would not live much longer.

A promising season appeared to be marred by tragedy. Lake View head coach Jewell McLaurin—heading into a year where he was to coach the Shrine Bowl—let his players take the week off as needed. Practices, so needed when facing perennial power Dillon, all of a sudden didn't seem so necessary.

"We told the players, 'If you want to come, come. If you don't, that's fine.' All of them showed up, even the one in the wreck. They practiced hard and they always had [Sampson] on their minds," McLaurin told the *Spartanburg Herald-Journal* in December 2006, just a few months after the accident.

McLaurin said he never talked about winning it all for Sampson, who was a team leader and tossed fourteen touchdowns the season before. The players did it themselves. They wanted a state title for Sampson. Even as the quarterback position was filled (by senior Desmond Owens), the players kept his spot in the workout lines vacant. His name and memory were everywhere as they headed through the season.

They lost the opener 27–0 to Dillon and then won five straight before losing to Carvers Bay. From there, it was lights out as the Wild Gators won eight straight and shut out opponents four times. A close scare in the state semifinals to Blackville-Hilda (Lake View won 21–20) set the stage for the finals against Ridge-Spring-Monetta. It was no contest, as the Wild Gators won 40–6 to earn a title for themselves and their lost

teammate. It was McLaurin's fourth state title at Lake View and likely the most memorable. The *Florence Morning News* summed it up best in November 2006: "All across the town of Lake View and Dillon County, Wild Gators fans are celebrating. And somewhere, Ronald Sampson is smiling."

BREAKING THE STREAK

Things weren't really happening when August broke on the 2005 football season at Carolina High in Greenville. The Trojans hadn't experienced a winning season since 1990 and hadn't made the playoffs since 1998. They had snapped a 30-game losing streak midway through 2004, and in the previous four seasons, the record for this west Greenville school had been 1-9, 0-10, 0-9 and 1-9. Their defense gave up more than fifty points nine times, forty points fifteen times and thirty points twenty-three times during that 2-37 malaise. Doug Shaw Jr. took over the program in 2003. The son of the legendary Doug Shaw at Myrtle Beach, this was the younger coach's first head coaching job. He came up from the coast after his cousin, Lee Taylor at Southside, told him about the opening. "My dad always told me that it never hurts to talk to anyone," he said.

Shaw remembered thinking that there was no way he would duplicate the 0-10 from the previous year but realized things were much worse than they seemed with the program. Most of the school's athletes had little interest in conforming to the rigors of high school football. As the season dragged along to a 0-9 finish, he admits he began questioning his abilities but realized he wasn't going to quit. He changed up his offense the next year to suit his players' skills, and things started to click. The games were close, and when the Trojans beat Southside 19–12 in the fourth week of the 2004 season, euphoria swept the campus. "It was like we won the Super Bowl," Shaw said about the reaction from students and parents.

That led to 2005, when the Trojans started 3-3 before going on a 3-game streak with wins over Chesnee, Chapman and Woodruff. It was the longest winning streak since 2000 and ensured the first winning season since 1990. The losing ways were over.

THE RISE AND FALL OF DEMETRIS SUMMERS

Demetris Summers's name seemed to perplex people just as much as his running style. The Lexington running back carved up opposing defenses in the first few years of the decades like few players before or since—a remarkable feat, considering Derek Watson had shattered most records just a few years earlier. However, it may have helped if people could spell his first name. It was often misspelled as "Demitrius" or "Demitris," including once by the University North Carolina when it was trying to recruit him. Summers had an almost magical ride through the Palmetto State gridiron as he shattered state and national records, and many people predicted that his ride would end with a stellar college career followed by a lengthy NFL one. But cracks in the good ship Summers started to appear before his high school career was over, and it never really recovered. He went from the best player in state history in 2002 to being labeled by *Sports Illustrated* as one of the biggest busts in recruiting history by 2006.

Summers's story, like many of the best ones, starts with a coach who believed in him. Summers was a struggling eighth grader believing the school system

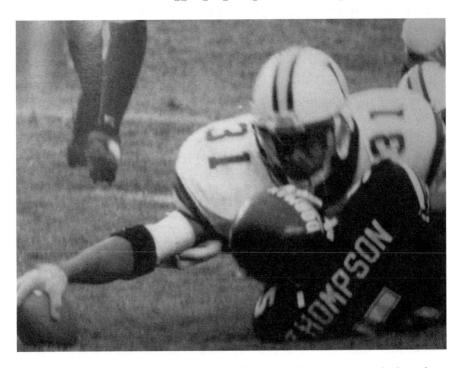

Lexington's Demetris Summers set the standard for rushing for years to come in the early part of the decade. *Courtesy of Lexington High School.*

didn't work when Lexington head football coach Jimmy Satterfield stepped into the picture. The former Furman head coach had surprised people in 1996 when he returned to the high school ranks, but Satterfield said he still wanted to coach. In the young Summers, he saw potential where others had seen a troublemaker. He invited him out to varsity practice that spring. As Satterfield later told *The State* on October 15, 2002, "He basically came out and ran flat over our best player." Satterfield got the teen into summer school and watched over him to make sure Summers became eligible the next season. He garnered All-State accolades as a freshman and followed that up with a monster sophomore season that saw him run for more than two thousand yards. His name shot up the national recruiting charts, and the letters from the major colleges began rolling in every day. His mother, Jacqueline Ludley, really didn't put much stock in it at first but eventually would fill four scrapbooks with letters.

On October 11, 2001, the junior Summers broke Watson's all-time rushing total when he broke a 40-yard run against Airport High with one minute and forty-eight seconds gone in the game. Less than a month later, he took part in the state's biggest ground battle since the Battle of Cowpens when he and North Augusta senior Reggie Merriweather combined for an air-like 707 yards rushing and 10 touchdowns. Merriweather had 406 and six scores in the 49–42 North Augusta victory that saw both men go over 2,000 yards for the season. While Merriweather graduated (and went on to a good career at Clemson), Summers had one more season, and he made it a memorable one. By the time the 2002 season was over, he had scored 127 career touchdowns, ran for 9,076 yards and a national record 46 100-yard games. He was All-State every year and AAAA player of the year as a senior and was a *Parade* (among many others) All-American. He was the top running back in the nation on most scouting lists, but a crack had formed.

Shrine Bowl coach Jim Ringer didn't select the superstar for the South Carolina roster. Ringer said Summers didn't do enough besides run the ball. He didn't see film of blocking or receiving or doing the little things to win games, Ringer said. The coach wanted an all-around player. Summers downplayed the snub by saying that he was ready to move on and not worry about it. He added that not playing in the game allowed him time to prepare for the SATs. Then, Clemson coach Tommy Bowden sent a handwritten note to Summers expressing his regrets. Others flailed on Ringer, including *The State* on November 6, 2002: "Keeping Summers off the Shrine Bowl team because he's not a great blocker is akin to saying the NFL's all-time

leading rusher, Emmitt Smith, isn't a Pro Bowler because he's taken out on passing downs."

However, rumors circulated of Summers being a "problem" off the field, which Satterfield denied and said that Ringer and his staff never asked about it. The controversy went to the back seat when Summers signed to play at South Carolina that winter. It came after a lengthy courtship from the nation's elite football programs. More than fifty sent queries, including Georgetown and Santa Clara offering basketball. Some addressed him as "Meat," which was his nickname. Some, as mentioned, butchered his name. Some sent letters from every coach on staff. Some offered athletic advice, such as stay away from soft drinks. Some wrote him in as an All-American. Some offered details of places to eat near their campuses. Some quoted a smorgasbord of historical figures, including Ronald Reagan, George Patton, John Wooden and Bear Bryant.

He was hailed to be the next great thing at USC. After playing sparingly for three games, he was unleashed. He ran for back-to-back 150 yards, including against nationally ranked Tennessee. And then things came crashing down. At some point, Summers began smoking marijuana and "partied" away his career. He was dismissed from the team in March 2005 after the leading the Gamecocks twice in rushing. After some failed tryouts in the NFL, he landed in the CFL.

THE LAND OF A THOUSAND DEFENSIVE BACKS

Rick Sanford is a trailblazer of sorts—not just because he was the first player from the University of South Carolina to be drafted in the first round of the NFL draft but also because he started what can best be described as a defensive back dynasty out of Rock Hill High, Northwestern High and now South Pointe High. Eight natives of this York County city have played in the NFL, and seven have been defensive backs. And not just any defensive backs. All seven were selected in the first three rounds, including Sanford, who went to Northwestern High, in the first round of 1974; Rock Hill's Robert Massey in the second round in 1989; Northwestern's Jeff Burris in the 1994 first round; Rock Hill's Chris Hope and Northwestern's Derek Ross, both in the 2002 third round; and Northwestern's Johnathan Joseph in the first round of 2006 and Rock Hill's Ko Simpson in the third round of that same class.

They've all had distinguished careers. Sanford picked off sixteen passes, including returning one ninety-nine yards for a touchdown in 1982. Massey intercepted fourteen passes and made the Pro Bowl in 1992 after returning three picks for touchdowns. Burris was considered one of the NFL's top defensive backs for the Bills and Colts in the 1990s. Hope made a Pro Bowl and starred in the Steelers' Super Bowl victory in 2005. Ross picked off five interceptions as a rookie in Dallas. Simpson was an immediate starter in Buffalo. Joseph has grown into a top cornerback for the Bengals. In addition, Sanford, Hope, Ross and Simpson all played in the Shrine Bowl in high school. The only reason Burris, who was an All-American, did not was because Hurricane Hugo pushed back the South Carolina playoffs, said Jimmy Wallace, his head coach at Northwestern.

Aside from those seven, Jamie Robinson, Miquel Graham and Jonathan Hefney were all Rock Hill athletes who played defensive back in the Shrine Bowl in the late 2000s before going on to play at top colleges. Robinson, who intercepted twenty-seven passes for Wallace at Northwestern, has a shot to play in the NFL as of 2010 after a stellar career at Florida State. Add in South Pointe's Stephon Gilmore, who won the Mr. Football Award in 2008 as a quarterback but is playing in the secondary at USC, and the Rock Hill dynasty looks to keep growing.

Wallace joked that there must be something in the gene pool but said that a lot of it is success building on success. The players know about the tradition of the area and strive to be just as good. So who is the NFL's nondefensive back from Rock Hill? It is former Jets punter Chuck Ramsey. Thinking Ben Watson, who was All-State at Northwestern and later starred for the Patriots Super Bowl team in the 2000s? He is actually a Virginia native.

NOTES FROM THE SHRINE BOWL

The first game of the decade saw South Carolina erupt for a record 66 points while holding North Carolina to 14. The two teams combined for 80 points, which also is a game record, as well as the Sandlappers' margin of victory—52 points. In 2001, the North Carolina coaching staff wanted to put some juice into the rivalry. So they ordered T-shirts with the words "It's on" printed on them. The Tarheels revealed their tees to the South Carolina team at a dinner Wednesday. On Thursday, the Sandlappers had an answer, donning T-shirts with the words "You bet, it's on" printed on

them. They proved it by winning 17–0. In 2004, Timmonsville's Bill Tate became the game's first black head coach, twelve years after he became the first black assistant. "It's like waking up Christmas morning and every toy you wanted is under the tree," he said at the time. It was like Christmas as the Sandlappers won 35–21.

Some stars of the decade include Richland Northeast's Airese Currie, who played in the NFL for the Bears, from the 2000 team; Orangeburg-Wilkinson's Tim Jennings, who played for the Colts, and Silver Bluff's Troy Williamson, who later was drafted in the first round by the Vikings, from the 2001 team; Wilson's Justin Durant, who played for the Jaguars, Keenan's Anthony McDaniel, who also played for the Jaguars, Conway's Allen Patrick, who played for the Ravens, and Rock Hill's Ko Simpson, who was an All-American at USC and then played with the Bills, from the 2002 team; Gaffney's Sydney Rice, who now stars for the Vikings, Spartanburg's Landon Cohen, who played for the Lions, and Wilson's Lawrence Timmons, who is now with the Pittsburgh Steelers, from the 2003 team. There have been no players to make the jump to the pros since then, but many possible stars are still in college. The Tarheels and the Sandlappers split the decade series 5-5.

MEANWHILE, OVER AT THE NORTH-SOUTH GAME

The South's defense accounted for six sacks, an interception and a fumble recovery while holding the North to a paltry seventy yards in an 18–7 victory in the 2000 game. Spring Valley's Travis Williams led the way and was named the defensive MVP for the South. The North rallied for a 39–38 victory in the 2001 game on the arm of Union's Josh Harris, who tossed two touchdowns on twenty-two completions but, most importantly, a lob pass for a two-point conversion with forty-eight seconds left to clinch victory.

It looked like the South was heading to the first shutout victory since 1989 in the 2005 game, when the North scored 11 points in the final seven minutes to pull off an 11–10 victory. The scoring came on a forty-four-yard pass from Westside's Thomas Griffin to Byrnes's Jamar Anderson and a blocked punt for a safety by Union's Troy Epps. Spencer Lanning of York earned the North team's offensive Most Valuable Player award for kicking a go-ahead, forty-two-yard field goal with just more than two minutes remaining.

It was the start of a three-year romp by the North in the annual game, which included a 24–10 victory in 2006 and 26–10 in 2007. The South

finally got back on top in 2008, when Goose Creek's Jerry Brown coached them to a 24–14 victory. Lexington's Anthony Carden ran for 106 yards and a touchdown. The game was dedicated to Clinton's Keith Richardson and his wife, Tallulah. The two were stepping down as the executive director and office manager of the South Carolina Athletic Coaches Association at the end of the year. Shell Dula became the new executive director. The North won the decade's series 7-3.

Stats, Stories and Stars

Union scored sixty-one points in the 2002 AAA state title game, which was the most points in a final since Blackville-Hilda scored sixty-three in the 1983 Class A game.

Lake View's Vernell Jones ran for 1,830 yards and twenty-eight touchdowns as a junior in 2002 and then followed it up with 1,944 yards and thirty-two touchdowns as a senior. Nicknamed Tooty Boot, his younger brother came right after him and ran for 1,738 yards and twenty-three touchdowns in 2006. Dayton Jones was nicknamed Scooty Boot.

Riverside's Richard Jackson kicked a sixty-four-yard field goal in 2005 to set a new state record. However, it was apparently well within his range, as he had booted the pigskin as far as seventy yards at camps for recruiters. He later played for Clemson.

Clinton's Kenny Cook was diagnosed with Hodgkin's disease in 2007, which was his sophomore season in high school. He underwent months of radiation treatment, and the cancer went into remission. He came back with a new attitude and would pick off seventeen passes during his junior and senior seasons. The six-foot, five-inch defensive back was named to the 2009 North-South Game.

Strom Thurmond's CoCo Hillary passed for 174 yards and one touchdown and ran for 63 yards and two scores in leading the Rebels to a victory in the 2005 AAA state title game. He accumulated 3,131 yards of offense and thirty-seven touchdowns that season.

North Augusta's Andre Young set then school records with seventy-two receptions for 1,311 yards and twelve touchdowns in 2003. Those numbers included a then state record of 322 receiving yards in a single game.

Marlboro County quarterback Syvelle Newton ran for 1,029 yards and fifteen touchdowns, while throwing for 933 yards and five touchdowns as

Greenwood's Kelcy Quarles was one of five South Carolinians named to the U.S. Army All-American Bowl. *Courtesy of Greenwood High's Gene Cathcart.*

a senior in 2002. He was the Gatorade Player of the Year and an All-American. Yet he was not named to the Shrine Bowl. The future USC star played in the North-South All-Star game instead.

A.J. Green was one of the most hyped freshmen in state history when he started his career at Summerville in 2004. Four years later, he would finish his career with several accolades, including being a four-time All-State selection, being named the top sophomore in the nation, earning first-team All-American honors from *USA Today* as a junior and senior and earning *Parade* All-American honors as a senior. He finished his career with 279 catches for 5,373 yards and sixty-two touchdowns. He had more than 1,000 receiving yards in each season and ended up signing to play collegiately at the University of Georgia.

It's tough to tell which Northwestern player had more fun and more importance in rewriting the state passing record books in 2009—Robert Joseph or Justin Worley. Joseph hauled in an amazing 150 passes (the old state record was 103). That broke the national record as well but did not set it, as a receiver in Illinois hauled in 165. He also caught 22 passes in one game to break the record of 20 set by Lamar's Derrick Higgins in 2000. Those passes were coming from Worley, who completed 392, which broke his own record of 309 set in 2008. Worley set a single-game record of 37 as well. His 42 touchdowns, though, were "down" in 2009, despite being the sixth-best in the state. He threw 50 in 2008, which is third best.

Former Carvers Bay star Clifton Geathers capped the decade by getting selected in the sixth round of the 2010 NFL draft. It is somewhat of a family tradition. His dad, Robert, was taken in the third round in 1981; his brother,

Robert Jr., was a fourth rounder in 2004; and his uncle, James (aka Jumpy), went in the second round of the 1984 draft. All four played high school ball in the Georgetown area.

Five South Carolina athletes were named to the 2010 U.S. Army All-American Bowl, which set a new state record. The "East" team included Marcus Lattimore and Brandon Willis of Byrnes, Victor Hampton of Darlington, Kelcy Quarles of Greenwood and Martavis Bryant of T.L. Hanna.

THE FINAL RECORD

*Results and Milestones from Almost
One Hundred Years of Football*

MR. FOOTBALL

While there had been numerous awards given over the years for various top players in the state, it wasn't until 1995 that the South Carolina Athletic Coaches Association decided to begin offering the Mr. Football Award. The trophy is a gold football located on a base and is given to the senior who exemplifies on and off the field abilities and leadership. The first winner was Berea's Jermale Kelley, who later starred for the University of South Carolina. The second winner was Daniel's Kyle Young, who went on to become an Academic All-American at Clemson. He is the only offensive lineman to win the award to date. With three winners, Byrnes High School has the most recipients of any school in the state.

2009	Marcus Lattimore, Byrnes, RB
2008	Stephon Gilmore, South Pointe, QB
2007	Richard Mounce, Blythewood, QB
2006	Malcolm Long, Gaffney, WR
2005	Prince Miller, Byrnes, DB
2004	J.D. Melton, Myrtle Beach, QB

2003	Trey Elder, Byrnes, QB
2002	Eric McCollom, Camden, QB
2001	Moe Thompson, Stratford, DE
2000	Roscoe Crosby, Union, WR
1999	Mark Logan, Greenwood, QB
1998	Derek Watson, Palmetto, RB
1997	Chris Hope, Rock Hill, DB
1996	Kyle Young, Daniel, OL
1995	Jermale Kelly, Berea, WR

THE ALL-AMERICANS

All-State teams have been around almost since the start of organized football in the 1910s, and All-Southern teams started in the 1920s. However, it is a little tougher tracking down All-American players. There were many different groups that gave such honors over the years (Marion Campbell of Chester may have been the first in the state to grab such an honor when he was selected to play in the All-American Prep Bowl in 1948), but if there is anything close to an "official" All-American list it is the *Parade* magazine team. Here are the South Carolina players on that list:

1972	Mickey Sims, Lockhart, DT
1975	Brooks Williamson, Mayo, RB
1977	Derek Hughes, Bishop England, RB
1981	Perry Cuda, Summerville, QB
1984	Raymond Roundtree, South Aiken, QB
	Rodney Williams, Irmo, QB
	Richard McCullough, Loris, OL
	Raymond Chavous, Silver Bluff, OL
1985	Keith Jennings, Summerville, WR
1986	Tony Rice, Woodruff, QB

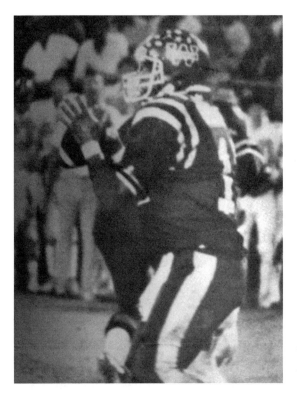

Woodruff's Tony Rice was a
Parade All-American in 1986.
Courtesy of Woodruff High School.

1988	Preston Jones, T.L. Hanna, QB
1990	Jeff Burris, Northwestern, RB
	Marty Simpson, Spring Valley, K
1991	Bobby Engram, Camden, WR
1992	Wally Richardson, Sumter, QB
	Steve Davis, Spartanburg, RB
1993	Charles Peterson, Laurens, QB
	Kevin Long, Summerville, OL
1994	Zola Davis, Burke, WR
1995	Rodney Brown, Burke, LB
1996	Courtney Brown, Macedonia, OL
1997	Jamal Reynolds, Aiken, LB
1998	Chris Hope, Northwestern, DB

1999	Durrell Robinson, Byrnes, WR
	Kevin Breedlove, Daniel, OL
2001	Roscoe Crosby, Union, WR
2002	Ricardo Hurley, Greenwood, LB
2003	Demetris Summers, Lexington, RB
	Eric Young, Union, OL
2004	Leon Hart, Spring Valley, OL
	Lawrence Timmons, Wilson, LB
2005	Eric Huggins, Conway, WR
2006	Clifton Geathers, Carvers Bay, DE
	Richard Jackson, Riverside, K
2007	Will Korn, Byrnes, QB
	Carlos Dunlap Jr., Fort Dorchester, DL
2008	A.J. Green, Summerville, WR
	DaQuan Bowers, Bamberg-Ehrhardt, DE
2009	Malliciah Goodman, West Florence, RB
	Stephon Gilmore, South Pointe, Rock Hill, QB
2010	Marcus Lattimore, Byrnes, RB

In the 2000s, the U.S. Army All-American Bowl became the preeminent showcase for high school talent nationwide, as cameras filmed players announcing where they planned to play football in college while scrolling screens updated how colleges were faring in landing the top players in the land. Here are the South Carolina players in the game:

2001	Tymere Zimmerman, Marlboro, DL
	Jeff Littlejohn, Gaffney, DE
2003	Demetris Summer, Lexington, RB
2003	James Thompson, Sumter, OT
2004	Leon Hart, Spring Valley, OT
2005	Eric Huggins, Conway, WR

2006 Ricky Sapp, Bamberg-Ehrhardt, DE

Clifton Geathers, Carvers Bay, OT

2007 Will Korn, Byrnes, QB

Gary Gray, Richland Northeast, DB

2008 Robert Quinn, Fort Dorchester, DE

2009 Roderick McDowell, Sumter, RB

Malliciah Goodman, West Florence, RB

Chris Bonds, Richland Northeast, DT

2010 Brandon Willis, Byrnes, DE

Marcus Lattimore, Byrnes, RB

Kelcy Quarles, Greenwood, DE

Victor Hampton, Darlington, DB

Martavis Bryant, T.L. Hanna, WR

A BRIEF HISTORY OF THE NORTH-SOUTH ALL-STAR GAME

There were numerous attempts at All-Star games in the 1940s and 1950s. Various incarnations included a game in the Pee Dee region, a Greenville-Spartanburg game, Richland County All-Stars against the rest of the state, a Pickens County game and many others, including an Upstate versus Lower State contest. However, the South Carolina Athletic Coaches Association started its own game, to be played during the group's annual August clinic in 1948. The first few games, the teams were dubbed Upcountry and Lowcountry (or Upper State and Lower State) before becoming the traditional North and South teams by the late 1950s. A game MVP award was started in 1950. In 1962, a most valuable back and lineman honors were awarded. The back is listed first. There was no 1970 lineman honored, and in 1994, the coaches decided to honor an offensive and defensive player from each squad after the game. The game was also associated with the Shriners during the 1950s, but that moniker was eventually dropped. In 1977, the game was moved from August to December, following the end of the regular season. Woodruff's Willie Varner and Summerville's John McKissick are the only men to twice serve as head coach, including 1992, when Varner's

North team beat McKissick's South team 31–8. Spartanburg—with Charlie Cummins, Alf McGuinnis, Bob Bell and Bill Carr—and Conway—with Lindsay Pierce, Buddy Sasser, Julius Derrick and Chuck Jordan—have had the most coaches in the game.

YEAR	SCORE	MVP(s)
1948	South 7 North 6	None
1949	North 7 South 6	None
1950	South 46 North 6	Johnny Grambling, Orangeburg
1951	South 20 North 0	Bobby Delinger, Berkeley
1952	North 32 South 7	Don King, Anderson
1953	North 12 South 6	Budgie Broome, Greenwood
1954	North 7 South 6	David Quattlebaum, Bishopville
1955	North 6 South 2	Jim Bowman, Clover
1956	South 13 North 7	Pug Ravenel, Bishop England
1957	South 14 North 6	Reggie Logan, Orangeburg
1958	North 19 South 0	Ben Fleming, Berkeley
1959	South 6 North 0	Leroy Brinson, St. John's
1960	Tie 14–14	Jerry Taylor, Winnsboro
1961	South 7 North 0	Delano Heath, Langley-Bath-Clearwater
1962	South 13 North 6	Gene Williams, North Augusta; Ricky Gilstrap, St. Andrew's
1963	North 14, South 0	Bob Cole, Eau Claire; Bob Warren, Allendale
1964	South 6 North 3	Ray Hesse, Saluda; Ken Ackis, Daniel
1965	North 12 South 6	Ted Phelps, Spartanburg; Steve Greer, Greer
1966	South 21 North 14	Ricky Medlin, Palmetto; James Lyle, Edmunds
1967	South 20 North 7	Allen McNeil, Lower Richland; Gil Royal, Aiken
1968	South 22 North 14	George Tyson, McClenaghan; Jimmy Trembley, Edmunds

The Final Record

Year	Score	MVP(s)
1969	South 16 North 14	Steve Muirhead, Myrtle Beach; Ken Pettus, Greenville
1970	North 13 South 10	Marty Woolbright, Chapin
1971	South 32, North 3	Freddy Solomon, Sumter; Garry Talbert, Irmo
1972	South 15 North 9	Mike O'Cain, Orangeburg-Wilkinson; Henry Marshall, Hillcrest
1973	North 14 South 9	Leonard Duncan, Lancaster; J.T. Williams, Lancaster
1974	North 24 South 23	Kenny Brown, Brookland-Cayce; Steve Bailey, St. John's
1975	North 14 South 12	Harold Goggins, Clinton; Ronald Dunlap, Conway
1976	South 7 North 6	Kevin Steele, Dillon; L.T. Singleton, Fort Johnson
1977	North 7 South 0	Bruce Reeves, Irmo; Joey Johnson, Greenwood
1978	North 10 South 6	Steve Marshall, Abbeville; Jim Robinson, St. John's
1979	North 3 North 0	James Glenn, Byrnes; John Sprinkle, Hillcrest
1980	South 14 North 3	Craig Doctor, Conway; Jessie Prioleau, Battery Creek
1981	Tie 7–7	Rodney Payne, Hartsville; William Jackson, Abbeville
1982	North 10 South 7	B. Hackett, Broome; James Carmichael, Lake View
1983	North 10 South 6	Barry Armstrong, Blackville-Hilda; Shawn Simpson, Irmo
1984	North 6 South 0	S. Pulley, Richland Northeast; Rodney Mack, Berkeley
1985	North 9 South 7	Ronald Darby, Orangeburg-Wilkinson; Jerome Rice, Spartanburg

YEAR	SCORE	MVP(s)
1986	North 28 South 14	Ed McDaniel, Batesburg-Leesville; Russell Johnson, Batesburg-Leesville
1987	North 42 South 7	Anthony Williams, Greer; Dexter Davis, Sumter
1988	South 18, North 14	Bru Pender, Barnwell; Hazel Richardson, Sumter
1989	South 3 North 0	Wade Lewis, North Myrtle Beach; Steve Mellon, Northwestern
1990	South 29, North 28	Rusty Wright, Silver Bluff; Andy McCrorey, Rock Hill
1991	North 34 South 9	David Sarn, Northwestern; Rufus Glenn, Byrnes; Cordell Kelly, Loris; John Burton, Columbia
1992	North 15 South 10	Perez Mattison, Westside; Jason Lawson, Union; Nakia Addison, Stall; Al Young, Silver Bluff
1993	North 31 South 8	Abdul Davis, Byrnes; Terrance Miller, Northwestern
1994	North 19 South 16	Mike Young, Clinton; Matt Padgett, Lexington; Adrian Dingle, Holly Hill; Robert Hayes, Williston-Elko
1995	South 26 North 18	Mickey Gist, Dorman; Sammy Roach, Aiken; John Singleton, Jasper; Damon White, Spring Valley
1996	North 27 South 7	Jermaine Petty, Chapman; Travis Cunningham, Laurens; Ish Hall, Berkeley; Sherman Scott, Batesburg-Leesville
1997	South 30 North 24	Devin Scott, Spartanburg; Marshall Rickenbacker, Rock Hill; Erik Kimrey, Dutch Fork; Brad Moultrie, Stratford
1998	North 41 South 12	Nick Haughey, Northwestern; Keito Whetstone, Orangeburg-Wilkinson; Phillip Krauel, Conway; Robert Spearman, Summerville

The Final Record

Year	Score	MVP(s)
1999	North 31 South 24	Chris Gaines, Daniel; Dexter Smalls, Northwestern; Derrick Hamilton, Dillon; Greg Fountain, Camden
2000	South 18 North 7	Mazzie Drummond, Greer; Eric Fuller, Clinton; Eddie Conover, Fort Dorchester; Travis Williams, Spring Valley
2001	North 39 South 38	Josh Harris, Union; Roberto Smith, Union; Shawn Harris, Silver Bluff; Carlos Ross, Lancaster
2002	North 34 South 24	Marcus Howard, Hanahan; Syvelle Newton, Marlboro; Ronnie McGill, Clover; Chris Pope, Ninety Six
2003	North 17 South 14	Tony White, Seneca; Andre Young, North Augusta; Mark Wojoski, Irmo; Duran Lawson, Conway
2004	South 21 North 12	Bobby Wallace, Conway; Richard Delesto, Fort Dorchester; Eric Goode, Chesnee; Andre Clark, Rock Hill
2005	North 11 South 10	David Erby, Rock Hill; Spencer Lanning, York; Andre Roberts, Spring Valley; E.J. Brown, Stratford
2006	North 24 South 10	Malcolm Long, Gaffney; Chad Diehl, Byrnes; Carlos Dunlop, Fort Dorchester; Rashad Counts, Dutch Fork
2007	North 26 South 10	C.J. Missick, Stratford; Eddie Jones, Myrtle Beach/Michael Coats, Greenwood; Montez Hatton, Westside
2008	South 24 North 14	Anthony Carde, Lexington; Kenyatta Gary, Cheraw; Cedric Proctor, Chesnee; Hakeem Adams, Northwestern
2009	North 21 South 17	R.J. Robinson, Berkeley; Malik Brown, Edisto; Brandon Willis, Byrnes; Okoye Houston, Woodmont

Shrine Bowl Scores

The Shrine Bowl is South Carolina's preeminent all-star event. Started in 1937 as a fundraiser for the Shriners Hospital, the game has grown into the highest honor for coaches and players. Initially, juniors were allowed to play in the game, but save for a few special exceptions during World War II, it has been an all-senior affair. In addition, coaches also face strict criteria. A South Carolina coach must serve as an assistant in the game before getting the opportunity to serve as a head coach who, besides calling the shots on the field, also picks the players. That second part is a pressure his annual North Carolina counterpart does not have to worry about. Rosters have grown over the years from twenty-two to thirty-three to thirty-five to forty-four today. As of 2009, the South Carolina team leads the series 40-28-4. The last draw came in 1948. Aside from ties, the Sandlappers have seven shutouts over the Tarheels, while being blanked four times. South Carolina's longest winning streak is seven (1981–87), and its longest losing streak is three (1949–51), though because of ties in 1947 and 1948 the Sandlappers went five years without winning. South Carolina scored a record sixty-six points in the 2000 game, and the fifty-two-point margin of victory in that game is the largest in the game's history. Between 1981 and 1995, North Carolina scored more than twenty points only once (1984). During that same time frame, South Carolina hit that mark six times.

1937 Tie 0–0
1938 North Carolina 19 South Carolina 0
1939 South Carolina 12 North Carolina 0
1940 North Carolina 19 South Carolina 12
1941 Tie 0–0
1942 North Carolina 33 South Carolina 9
1943 North Carolina 20 South Carolina 7
1944 South Carolina 6 North Carolina 0
1945 North Carolina 8 South Carolina 0
1946 South Carolina 19 North Carolina 13
1947 Tie 7–7
1948 Tie 7–7
1949 North Carolina 20 South Carolina 7
1950 North Carolina 47 South Carolina 7
1951 North Carolina 13 South Carolina 6
1952 South Carolina 23 North Carolina 19

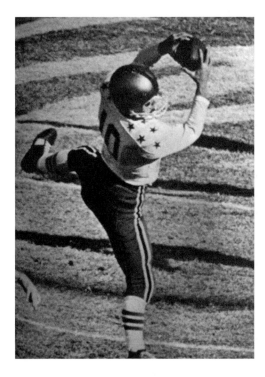

Gaffney's Johnny Sarratt picks off a pass in the 1965 Shrine Bowl. *Courtesy of Gaffney High School.*

1953 North Carolina 13 South Carolina 12
1954 South Carolina 27 North Carolina 7
1955 North Carolina 19 South Carolina 13
1956 North Carolina 20 South Carolina 13
1957 South Carolina 12 North Carolina 6
1958 North Carolina 26 South Carolina 20
1959 South Carolina 20 North Carolina 14
1960 South Carolina 19 North Carolina 3
1961 South Carolina 20 North Carolina 0
1962 North Carolina 14 South Carolina 7
1963 South Carolina 23 North Carolina 13
1964 South Carolina 20 North Carolina 6
1965 South Carolina 31 North Carolina 27
1966 North Carolina 34 South Carolina 14
1967 South Carolina 27 North Carolina 21
1968 South Carolina 21 North Carolina 7
1969 North Carolina 21 South Carolina 20
1970 South Carolina 35 North Carolina 21
1971 South Carolina 3 North Carolina 0

1972 South Carolina 17 North Carolina 14
1973 North Carolina 17 South Carolina 6
1974 North Carolina 38 South Carolina 12
1975 South Carolina 39 North Carolina 27
1976 South Carolina 9 North Carolina 0
1977 North Carolina 37 South Carolina 6
1978 South Carolina 27 North Carolina 12
1979 South Carolina 37 North Carolina 21
1980 North Carolina 35 South Carolina 33
1981 South Carolina 7 North Carolina 6
1982 South Carolina 14 North Carolina 10
1983 South Carolina 45 North Carolina 7
1984 South Carolina 34 North Carolina 28
1985 South Carolina 47 North Carolina 14
1986 South Carolina 10 North Carolina 7
1987 South Carolina 24 North Carolina 13
1988 North Carolina 14 South Carolina 7
1989 South Carolina 12 North Carolina 0
1990 North Carolina 10 South Carolina 7
1991 South Carolina 13 North Carolina 10
1992 South Carolina 36 North Carolina 7
1993 North Carolina 9 South Carolina 0
1994 South Carolina 14 North Carolina 10
1995 South Carolina 30 North Carolina 10
1996 North Carolina 21 South Carolina 14
1997 South Carolina 21 North Carolina 20
1998 North Carolina 38 South Carolina 20
1999 South Carolina 24 North Carolina 3
2000 South Carolina 66 North Carolina 14
2001 South Carolina 17 North Carolina 0
2002 North Carolina 28 South Carolina 0
2003 North Carolina 21 South Carolina 12
2004 South Carolina 35 North Carolina 21
2005 North Carolina 28 South Carolina 24
2006 North Carolina 23 South Carolina 16
2007 South Carolina 31 North Carolina 24
2008 South Carolina 24 North Carolina 16
2009 North Carolina 24 South Carolina 14

HIGH SCHOOL LEAGUE STATE TITLES

There was one title winner from 1916 through 1925; Classes A and B from 1926 through 1931; and A, B and C titles from 1932 through 1956. However, the writers in the state began awarding a title in 1930 for the state's largest schools, which were deemed too large to take part in the regular playoffs. From 1930 through 1944, that was the Class A title. Meanwhile, World War II saw many of the Class B and C titles dropped because of manpower and transportation issues. In 1945, there was a Class A playoff, while the AA champion was awarded by the writers. The A title went back to the writers in 1946, but in 1947, the writers would again award AA, while A, B and C were won through a playoff system. In 1957, the system was shuffled again for the formation of AA, A, B and C classes that took part in a playoff system, and an AAA class whose champion was selected by writers. Starting in 1968, the SCHSL created a AAAA class for the largest schools that finally included a playoff system. The rest of the schools were then split into AAA, AA and A classes. In 1981, AAAA was split into two classes—one for the largest sixteen schools and the second for the rest of AAAA. The AA class split for two years in the early 1990s but returned to crowning one champ since. Class A went to dual champions in 2006. In years listed below where there is no runner-up, that means that either there was no title game played or a champion was declared.

YEAR	CHAMPION	RUNNER-UP
1916	Florence	Chester
1917	Florence	Winnsboro
1918	Florence	
1919	Florence	
1920	Charleston	
1921	Charleston	Chester
1922	Charleston	Gaffney
1923	Thornwell	Columbia
1924	Columbia	Gaffney
1925	Columbia	Gaffney

Summerville's Harvey Kirkland won two state titles at Summerville in the late 1940s. *Courtesy of Summerville High School.*

YEAR	CHAMPION	RUNNER-UP
1926	Columbia	Gaffney (A)
	Thornwell	Mullins (B)
1927	Gaffney	Columbia (A)
	Batesburg-Leesville	Lancaster (B)
1928	Gaffney	Columbia (A)
	Batesburg-Leesville	Chester (B)
1929	Gaffney	Columbia (A)
	Chester	Camden (B)
1930	Columbia	(A)
	Chester	Marion (B)
1931	Gaffney / Orangeburg	(A)
	Camden	Chester (B)
1932	Spartanburg	(A)
	Chester	Camden (B)
	Ninety Six	Sardis (C)

Year	Champion	Runner-up
1933	Columbia	(A)
	Johnston	Camden (B)
1934	Gaffney	(A)
	Great Falls	Camden (B)
	Epworth	Summerville (C)
1935	Chester	Gaffney (A)
	Beaufort	Great Falls (B)
	Epworth	Olanta (C)
1936	Chester	(A)
	Camden	Honea Path (B)
	St. Paul's	Epworth (C)
1937	Easley	(A)
	Honea Path	North Charleston (B)
	Epworth	Greeleyville (C)
1938	Columbia	(A)
	Lake View	Clinton (B)
	Epworth	Hillcrest (C)
1939	Columbia/Parker	(A)
	Clinton	Lake View (B)
	Epworth	Clio (C)
1940	Greenville/Anderson	(A)
	Kingstree	Olympia (B)
	Hillcrest	Thornwell (C)
1941	Lancaster	(A)
	Saluda	Marion (B)
	Thornwell	Pinewood (C)
1942	Anderson	(A)
1943	Greenville/Columbia	(A)
	Olympia	Allendale (B)

YEAR	CHAMPION	RUNNER-UP
1944	Camden	(A)
	Mullins	Olympia (B)
	St. Paul's	Gable (C)
1945	Rock Hill	(AA)
	Honea Path	Aiken (A)
	Beaufort	Clover (B)
	Monetta	Clio (C)
1946	Rock Hill	(A)
	Mullins	Olympia (B)
	St. Stephen	McCormick (C)
1947	North Charleston	(AA)
	Dillon	Walhalla (A)
	Liberty	Summerville (B)
	Blackville	Dentsville (C)
1948	Greenwood	(AA)
	Lexington	Dillon (A)
	Summerville	Olympia (B)
	McCormick	Gable (C)
1949	Greenwood	(AA)
	Lexington	(A)
	Summerville	Olympia (B)
	Central	Olar (C)
1950	Florence/Anderson	(AA)
	Lexington	Aynor (A)
	Moultrie	North Augusta (B)
	Heath Springs	Macedonia (C)

J.W. Ingram diagrams some of the plays that helped lead Lexington to three straight state titles in the late 1940s. *Courtesy of Lexington High School.*

Year	Champion	Runner-up
1951	Dreher	(AA)
	Aynor	(A)
	Kershaw	Mullins (B)
	Central	North (C)
1952	North Charleston	(AA)
	Pickens	Lake City (A)
	St. Andrew's	Olympia (B)
	Central	St. John's (C)
1953	Rock Hill	(AA)
	Mullins	Pickens (A)
	Olympia	Berkeley (Moncks Corner) (B)
	St. John's	Heath Springs (C)
1954	Dreher	(AA)
	Mullins	Pickens (A)
	Barnwell	Langley-Bath-Clearwater (B)
	Norway	Thornwell (C)

YEAR	CHAMPION	RUNNER-UP
1955	Florence	(AA)
	St. Andrew's	Olympia (A)
	Summerville	Saluda (B)
	St. John's	Thornwell (C)
1956	Dreher	(AA)
	Woodruff	St. Andrew's (A)
	Summerville	Saluda (B)
	Elloree	Heath Springs (C)
1957	Dreher	(AAA)
	Camden	Lancaster (AA)
	Woodruff	Langley-Bath-Clearwater (A)
	Johnston	Ridgeland (B)
	Springfield	Heath Springs (C)
1958	Anderson	(AAA)
	North Augusta	Lancaster (AA)
	Winnsboro (Mt. Zion)	Batesburg-Leesville (A)
	St. Matthew's	Ninety Six (B)
	St. John's	Jackson (C)
1959	Dreher	(AAA)
	Lancaster	Georgetown (AA)
	Winnsboro (Mt. Zion)	Berkeley (A)
	Johnston	St. Matthew's (B)
	Furman	Thornwell (C)
1960	Gaffney	(AAA)
	Orangeburg	Easley (AA)
	Berkeley	York (A)
	Swansea	St. Matthew's (B)
	Elloree	Bethune Clifton (C)

The Final Record

Year	Champion	Runner-up
1961	Greenwood	(AAA)
	North Augusta	Clinton (AA)
	Lake View	Honea Path (A)
	East Clarendon	Swansea (B)
	Cameron	St. Stephen (C)
1962	Greenville	(AAA)
	Easley	Garrett (AA)
	Saluda	Woodruff (A)
	Ninety Six	East Clarendon (B)
	St. Stephen	Norway (C)
1963	Gaffney	(AAA)
	Chester	Eau Claire (AA)
	York	Saluda (A)
	Bamberg	Dixie (B)
	Norway	Jefferson (C)
1964	Gaffney	(AAA)
	Camden	Easley (AA)
	Ware Shoals	Lexington (A)
	Kershaw	Bamberg (B)
	Norway	St. Stephen (C)
1965	Gaffney	(AAA)
	Woodruff	Berkeley (AA)
	Lower Richland	Ware Shoals (A)
	East Clarendon	Kershaw (B)
	Elloree	Heath Springs (C)

YEAR	CHAMPION	RUNNER-UP
1966	Brookland-Cayce	(AAA)
	Daniel	Berkeley (AA)
	Pendleton	Batesburg-Leesville (A)
	Kershaw	Lamar (B)
	Elloree	Heath Springs (C)
1967	Eau Claire	(AAA)
	Easley	St. Andrews (AA)
	Lower Richland	Winnsboro (A)
	Allendale-Fairfax	Kershaw (B)
	Heath Springs	St. Stephen (C)
1968	Greenwood	Hartsville (AAAA)
	James Island	Woodruff (AAA)
	Strom Thurmond	Laurens (AA)
	St. John's	Heath Springs (A)
1969	Edmunds	Gaffney (AAAA)
	Summerville	Easley (AAA)
	Winnsboro	Strom Thurmond (AA)
	Williston-Elko	St. John's (A)
1970	Lower Richland	Eau Claire (AAAA)
	Palmetto	South Florence (AAA)
	Lake View	Graniteville (AA)
	Blackville	Swansea (A)
1971	Orangeburg-Wilkinson	Union (AAAA)
	Abbeville	Central (AAA)
	Lake View	St. Angela (AA)
	Lockhart	Blackville (A)
1972	Easley	Lower Richland (AAAA)
	Clinton	Hanahan (AAA)
	Bishopville	Woodruff (AA)
	North	Whitmire (A)

The Final Record

Year	Champion	Runner-up
1973	Spring Valley	Spartanburg (AAAA)
	Fort Johnson	Clinton (AAA)
	Chapin	Bamberg-Ehrhardt (AA)
	McColl	Jonesville (A)
1974	Spring Valley	T.L. Hanna (AAAA)
	James Island	Clinton (AAA)
	Chapin	Bamberg-Ehrhardt (AA)
	Swansea	Jackson (A)
1975	Spring Valley	Irmo (AAAA)
	Clinton	Myrtle Beach (AAA)
	Woodruff	Bamberg-Ehrhardt (AA)
	Swansea	Calhoun Falls (A)
1976	Greenwood	Summerville (AAAA)
	Byrnes	Bishop England (AAA)
	Woodruff	Lake View (AA)
	Blacksburg	H.E. McCracken (A)
1977	Eastside	Spring Valley (AAAA)
	Clinton	James Island (AAA)
	Woodruff	Mayo (AA)
	Christ Church	H.E. McCracken (A)
1978	Summerville	Irmo (AAAA)
	Clinton	James Island (AAA)
	Woodruff	Andrews (AA)
	Whitmire	Williston-Elko (A)
1979	Summerville	Irmo (AAAA)
	Cheraw	Strom Thurmond (AAA)
	Batesburg-Leesville	Woodruff (AA)
	Williston-Elko	Jonesville (A)

YEAR	CHAMPION	RUNNER-UP
1980	Irmo	Summerville (AAAA)
	Myrtle Beach	Strom Thurmond (AAA)
	Woodruff	Swansea (AA)
	Williston-Elko	Whitmire (A)
1981	Berkeley	Gaffney (AAAA-1)
	Hartsville	Airport (AAAA-2)
	Myrtle Beach	Broome (AAA)
	Abbeville	Hampton (AA)
	Lake View	Whitmire (A)
1982	Summerville	Spartanburg (AAAA-1)
	Middleton	Northwestern (AAAA-2)
	Byrnes	Myrtle Beach (AAA)
	Ninety Six	Barnwell (AA)
	Ware Shoals	Blackville-Hilda (A)
1983	Summerville	Gaffney (AAAA-1)
	Laurens	Walterboro (AAAA-2)
	Myrtle Beach	Clinton (AAA)
	Woodruff	St. John's (AA)
	Blackville-Hilda	Ware Shoals (A)
1984	Summerville	Spartanburg (AAAA-1)
	Laurens	Hartsville (AAAA-2)
	Myrtle Beach	J.L. Mann (AAA)
	Woodruff	Saint John's (AA)
	Blackville-Hilda	Lewisville (A)
1985	Gaffney	Sumter (AAAA-1)
	Hillcrest Dalzell	Byrnes (AAAA-2)
	Clinton	Middleton (AAA)
	Mid Carolina	Barnwell (AA)
	East Clarendon	Timmonsville (A)

The Final Record

Year	Champion	Runner-up
1986	Summerville	Gaffney (AAAA-1)
	Byrnes	Berkeley (AAAA-2)
	York	Strom Thurmond (AAA)
	Silver Bluff	Batesburg Leesville (AA)
	Lewisville	Timmonsville (A)
1987	Sumter	Spartanburg (AAAA-1)
	Hartsville	Westside (AAAA-2)
	Clinton	Marion (AAA)
	Barnwell	Pageland Central (AA)
	Lewisville	Aynor (A)
1988	Spring Valley	Gaffney (AAAA-1)
	Hartsville	North Augusta (AAAA-2)
	Manning	Daniel (AAA)
	Barnwell	Pageland Central (AA)
	Blackville-Hilda	Aynor (A)
1989	Northwestern	Lancaster (AAAA-1)
	North Augusta	Lower Richland (AAAA-2)
	Greer	Aiken (AAA)
	Pageland Central	Bamberg-Ehrhardt (AA)
	Lake View	Lewisville (A)
1990	Sumter	Rock Hill (AAAA-1)
	Union	Lancaster (AAAA-2)
	Camden	Hilton Head (AAA)
	Silver Bluff	Pageland Central (AA-1)
	Bamberg-Ehrhardt	Andrew Jackson (AA-2)
	Jonesville	Lake View (A)

YEAR	CHAMPION	RUNNER-UP
1991	Spartanburg	Sumter (AAAA-1)
	Laurens	Lower Richland (AAAA-2)
	Daniel	Stall (AAA)
	Silver Bluff	Pageland Central (AA-1)
	Abbeville	Swansea (AA-2)
	Great Falls	Timmonsville (A-1)
	Lake View	Lewisville (A-2)
1992	Gaffney	Sumter (AAAA-1)
	Aiken	Hartsville (AAAA-2)
	Daniel	Wren (AAA)
	Swansea	Batesburg-Leesville (AA)
	Timmonsville	Lake View (A)
1993	Northwestern	Gaffney (AAAA-1)
	Richland Northeast	Hartsville (AAAA-2)
	Cheraw	Clinton (AAA)
	Swansea	Woodruff (AA)
	Johnsonville	Buford (A)
1994	Spartanburg	Dorman (AAAA-1)
	Berkeley	Dillon (AAAA-2)
	Greer	Manning (AAA)
	Swansea	Pageland Central (AA)
	Choppee	Timmonsville (A)
1995	Spartanburg	Sumter (AAAA-1)
	Union	Walterboro (AAAA-2)
	Daniel	Strom Thurmond (AAA)
	Batesburg-Leesville	Barnwell (AA)
	Blackville-Hilda	Timmonsville (A)

The Final Record

Year	Champion	Runner-up
1996	Spartanburg	Rock Hill (AAAA-1)
	Berkeley	Darlington (AAAA-2)
	Fairfield Central	Seneca (AAA)
	Abbeville	Allendale-Fairfax (AA)
	Lewisville	Johnsonville (A)
1997	Gaffney	Northwestern (AAAA-1)
	Walterboro	Hartsville (AAAA-2)
	Fairfield Central	Daniel (AAA)
	Pageland Central	Barnwell (AA)
	Lake View	McCormick (A)
1998	Summerville	Gaffney (AAAA-1)
	Marlboro	Ridge View (AAAA-2)
	Daniel	Manning (AAA)
	Emerald	Batesburg-Leesville (AA)
	Lewisville	Johnsonville (A)
1999	Stratford	Dorman (AAAA-1)
	Greenwood	Aiken (AAAA-2)
	Union	Dillon (AAA)
	Batesburg-Leesville	Ninety Six (AA)
	Timmonsville	Williston-Elko (A)
2000	Dorman	Lexington (AAAA-1)
	Greenwood	Aiken (AAAA-2)
	Union	Manning (AAA)
	Silver Bluff	Abbeville (AA)
	Ninety Six	Lamar (A)
2001	Spartanburg	Northwestern (AAAA-1)
	Marlboro	Conway (AAAA-2)
	Camden	Union (AAA)
	Silver Bluff	Batesburg-Leesville (AA)
	Ninety Six	Timmonsville (A)

Year	Champion	Runner-up
2002	Rock Hill	Irmo (AAAA-1)
	Byrnes	Conway (AAAA-2)
	Union	Camden (AAA)
	Carvers Bay	Abbeville (AA)
	Lamar	Lake View (A)
2003	Gaffney	Sumter (AAAA-1)
	Byrnes	Conway (AAAA-2)
	Greer	West Florence (AAA)
	Pageland Central	Batesburg-Leesville (AA)
	Lamar	Lake View (A)
2004	Rock Hill	Stratford (AAAA-1)
	Byrnes	Irmo (AAAA-2)
	Belton-Honea Path	Dillon (AAA)
	Broome	Cheraw (AA)
	Lamar	Calhoun Falls (A)
2005	Gaffney	Summerville (AAAA-1)
	Byrnes	Richland Northeast (AAAA-2)
	Strom Thurmond	Clinton (AAA)
	Batesburg-Leesville	Cheraw (AA)
	Blackville-Hilda	Calhoun County (A)
2006	Gaffney	Irmo (AAAA-1)
	Greenwood	Conway (AAAA-2)
	Blythewood	Timberland (AAA)
	Cheraw	Newberry (AA)
	Carvers Bay	Chesterfield (A-1)
	Lake View	Ridge-Spring-Monetta (A-2)

The Final Record

Year	Champion	Runner-up
2007	Byrnes	Summerville (AAAA-1)
	Clover	Beaufort (AAAA-2)
	Wilson	Chester (AAA)
	Cheraw	Chapman (AA)
	Chesterfield	Carvers Bay (A-1)
	Blackville-Hilda	Great Falls (A-2)
2008	Byrnes	Sumter (AAAA-1)
	South Pointe	Northwestern (AAAA-2)
	Myrtle Beach	Chester (AAA)
	Dillon	Pageland Central (AA)
	Chesterfield	Carvers Bay (A-1)
	Scott's Branch	Williston-Elko (A-2)
2009	Dorman	Byrnes (AAAA-1)
	Berkeley	Northwestern (AAAA-2)
	Clinton	Myrtle Beach (AAA)
	Dillon	Pageland Central (AA)
	Chesterfield	Lamar (A-1)
	Williston Elko	Scott's Branch (A-2)

SOUTH CAROLINA INDEPENDENT SCHOOLS ASSOCIATION

SCISA started a football league in 1973 to serve as an organization for the state's small, independent schools. The early years featured two title games, but the league's growth expanded it to three classes in 1978. It dropped to two divisions in 1981 for two years, and there was a temporary effort at five divisions in the mid-1980s as well as eight-man football in 1990. Since 2006, eight-man football has again held a title game. With seven titles, Orangeburg Prep has the most championships of any SCISA school. The school made nine title game appearances between 1986 and 1995. Wardlaw has made the most appearances with twelve (five wins, seven losses). Laurence Manning

and Jefferson Davis have six state titles each. Thomas Heyward, Wade Hampton, Thornwell and Hammond have all won five titles. The biggest margin of victory was Jefferson Davis's 44–0 rout of Roy Hudgens in the 1979 AA game. The most points scored in an eleven-man final was 114 in 1996, when Andrew Jackson beat Carolina 64–50. However, Wardlaw beat Patrick Henry 78–54 in the 2009 eight-man final.

YEAR	CHAMPION	RUNNER-UP
1973	Thomas Heyward	Wade Hampton (AA)
	Thornwell	Country Day (A)
1974	Wade Hampton	Hammond (AA)
	Thornwell	Country Day (A)
1975	Wilson Hall	Wade Hampton (AA)
	Catawba	Allendale (A)
1976	Roy Hudgens	Robert E. Lee (AA)
	Mims	Wyman King (A)
1977	Hammond	Thomas Heyward (AAA–AA)
	Catawba	Mims (A)
1978	Thomas Heyward	Wilson Hall (AAA)
	Calhoun	May River (AA)
	Andrew Jackson	Catawba (A)
1979	Thomas Heyward	Wilson Hall (AAA)
	Jefferson Davis	Roy Hudgens (AA)
	Carolina	Thomas Hart (A)
1980	Thomas Heyward	Hammond (AAA)
	Jefferson Davis	May River (AA)
	Mims	St. Stephen's (A)
1981	Thomas Heyward	Hammond (AAA)
	May River	Jefferson Davis (AA)
	St. Stephen's	Holly Hill (A)

The Final Record

Year	Champion	Runner-up
1982	Wade Hampton	Hammond (AAA)
	Thornwell	May River (AA)
1983	Wade Hampton	Wilson Hall (AAA)
	Thornwell	May River (AA)
1984	Wade Hampton	Hammond (AAA)
	Laurence Manning	Country (AA)
	Dorchester	Mims (A)
1985	Wade Hampton	Williamsburg (AAA)
	Laurence Manning	Hilton Head Prep (AA)
	Jefferson Davis	Dorchester (A)
1986	Orangeburg Prep	Clarendon Hall (AAA-1)
	Catawba	Roy Hudgens (AAA-2)
	Laurence Manning	Richard Winn (AAA-3)
	East Cooper	Allendale(AA)
	St. Stephen's	Country Day (A)
1987	Orangeburg Prep	Williamsburg (AAA)
	Clarendon Hall	Dorchester (AA)
	Mims	Wyman King (A)
1988	Orangeburg Prep	Thomas Heyward (AAA)
	Clarendon Hall	Dorchester (AA)
	St. Stephen's	Wardlaw (A)
1989	Laurence Manning	Thomas Heyward (AAA)
	Clarendon Hall	Wyman King (AA)
	Lord Berkeley	Wardlaw (A)
1990	Orangeburg Prep	Thomas Heyward (AAA)
	Patrick Henry	Richard Winn (AA)
	Victory Christian	Wardlaw (A)
	Long Cane	Pee Dee (eight-man)

YEAR	CHAMPION	RUNNER-UP
1991	Laurence Manning	Orangeburg Prep (AAA)
	Dorchester	Wardlaw (AA)
	Pee Dee	Carolina (A)
1992	Orangeburg Prep	Thornwell (AAA)
	Patrick Henry	Clarendon Hall (AA)
	Carolina	Bowman (A)
1993	Orangeburg Prep	Thomas Heyward (AAA)
	Jefferson Davis	Wardlaw (AA)
	Carolina	Pee Dee (A)
1994	Orangeburg Prep	Laurence Manning (AAA)
	Patrick Henry	Wardlaw (AA)
	Bowman	Byrnes Schools (A)
1995	Thornwell	Orangeburg Prep (AAA)
	Richard Winn	St. Andrew's (AA)
	Pee Dee	Andrew Jackson (A)
1996	Porter-Gaud	Thornwell (AAA)
	Richard Winn	St. Andrew's (AA)
	Andrew Jackson	Carolina (A)
1997	Laurence Manning	Porter-Gaud (AAA)
	Hilton Head Prep	St. Andrew's (AA)
	Andrew Jackson	Newberry (A)
1998	Porter-Gaud	Ben Lippen (AAA)
	St. Andrew's	Calhoun (AA)
	Andrew Jackson	Bowman (A)
1999	Dorchester	Heathwood Hall (AAA)
	Richard Winn	Calhoun (AA)
	Wardlaw	Carolina (A)

The Final Record

Year	Champion	Runner-up
2000	Porter-Gaud	Wilson Hall (AAA)
	Byrnes Schools	Williamsburg (AA)
	Cambridge	Wardlaw (A)
2001	Heathwood Hall	Wilson Hall (AAA)
	Dorchester	Colleton Prep (AA)
	Cambridge	Holly Hill (A)
2002	Porter-Gaud	Wilson Hall (AAA)
	Colleton Prep	St. Andrew's (AA)
	Wardlaw	Cambridge (A)
2003	Wilson Hall	Heathwood Hall (AAA)
	Colleton Prep	Robert E. Lee (AA)
	Wardlaw	Bowman (A)
2004	Heathwood Hall	Wilson Hall (AAA)
	Calhoun	Dorchester (AA)
	Jefferson Davis	St. John's Christian (A)
2005	Augusta Christian	Porter-Gaud (AAA)
	Hilton Head Prep	Colleton (AA)
	Jefferson Davis	St. John's Christian (A)
2006	Hammond	Augusta Christian (AAA)
	Hilton Head Christian	Northwood (AA)
	Dorchester	Dillon Christian (A)
	Laurens	Holly Hill (eight-man)
2007	Hammond	Augusta Christian (AAA)
	Hilton Head Prep	Hilton Head Christian (AA)
	Charleston Collegiate	Colleton Prep (A)
	Holly Hill	Laurens (eight-man)
2008	Hammond	Wilson Hall (AAA)
	Northwood	Thomas Sumter (AA)
	Dillon Christian	Bible Baptist (A)
	Wardlaw	Andrew Jackson (eight-man)

YEAR	CHAMPION	RUNNER-UP
2009	Hammond	Heathwood Hall (AAA)
	Hilton Head Christian	Northwood (AA)
	Dillon Christian	Palmetto Christian (A)
	Wardlaw	Patrick Henry (eight-man)

NATIONAL RANKINGS

Love it or hate it, *USA Today* was a major driver in the ways that Americans viewed newspapers in the last quarter century. One of its biggest innovations has been its Super 25 rankings of the top high school teams in the nation. Many South Carolina teams have made appearances on the list, even reaching as high as number one, but none have won the mythical national crown to date. Below are the teams that finished their season ranked.

YEAR	SCHOOL	RECORD	RANK
1984	Summerville	(14-0)	8
1994	Berkeley	(15-0)	16
1995	Spartanburg	(15-0)	15
1997	Fairfield Central	(15-0)	14
1998	Summerville	(15-0)	21
1999	Stratford	(15-0)	22
2005	Byrnes	(15-0)	7
2006	Gaffney	(15-0)	11
2007	Byrnes	(15-0)	13
2008	Byrnes	(14-1)	9
2009	Dorman	(14-1)	16

BIBLIOGRAPHY

BOOKS

Dutton, Monte. *Pride of Clinton*. Auburn, NY: Jacobs Press, 1986.

Hamer, Fritz A., and John Daye. *Glory on the Gridiron: A History of College Football in South Carolina*. Charleston, SC: The History Press, 2009.

Klein, Walter J. *Bowl Full of Miracles*. Shrine Bowl of the Carolinas, 1986.

Miller, Jeff. *Going Long: The Wild 10-Year Saga of the Renegade American Football League in the Words of Those Who Lived It*. New York, NY: McGraw-Hill, 2004.

O'Toole, Andrew. *Paul Brown: The Rise and Fall and Rise Again of Football's Most Innovative Coach*. Cincinnati, Ohio: Clerisy, 2009.

Trubiano, Ernie. *South Carolina Sports Legends*. Charleston, SC: Arcadia Publishing, 2009.

Yarborough, Cale, and William Neely. *Cale*. New York, NY: Crown, 1986.

YEARBOOKS

Aiken High School
Berkeley High School
Chapin High School

Chester High School (courtesy of the Chester County Library)
Easley High School
Florence High School (courtesy of the Florence County Library)
Gaffney High School
Greenville High School
Greenwood High School
Lexington High School
Lower Richland High School
McClenaghan High School (courtesy of the Florence County Library)
Rock Hill High School
Spartanburg High School
Spring Valley High School
Summerville High School
Woodruff High School

WEBSITES

Coach Babb Reunion, http://www.coachbabbreunion.com.
Easley Hall of Fame, http://www.cityofeasley.net/recreation.
Gaffney Athletics, http://www.gaffneyathletics.com.
Greer Sports Hall of Fame, http://www.yellowjacketsports.net.
North-South All-Star Football, http://www.northsouthallstarfootball.com.
Shrine Bowl, http://www.shrine-bowl.com.
South Carolina Athletic Coaches Association, http://www.scaca.org.
South Carolina High School History Road Show, http://www.scfootballhistory.com.
South Carolina High School League, http://www.schsl.org.
U.S. Army All-American Bowl, http://www.usarmyallamericanbowl.com.
USA Today, http://www.usatoday.com/sports/preps/rankingsindex.htm.

KEY INTERVIEWS (ALL DONE BY AUTHOR)

Bill Ammons, player and coach at Camden
Bobby Bentley, player, coach and administrator at Byrnes
Johnny Mack Brown, player at Greenville

Harry Carson, player at Wilson and McClenaghan

Doc Davis, coach at Gaffney, Chapman, Spartanburg and Ashley Ridge

Carl Dubose, player at Dreher

Shell Dula, player at Laurens, coach at Woodruff, Ninety Six, Union and Greenwood and administrator with the South Carolina Athletic Coaches Association

Mike Fanning, athletic director South Carolina Independent Schools Association

Fritz Hamer, curator of the South Carolina State Museum

Mike Hawkins, player at Parker and coach at Wade Hampton, Eastside, Riverside, Union and Laurens

Keith Jennings, player at Summerville

Chuck Jordan, player and coach at Conway

Keith Richardson, player at Chester, coach at Woodruff and Clinton and administrator with the South Carolina Athletic Coaches Association

Doug Shaw, player at Myrtle Beach, coach at Myrtle Beach, North Myrtle Beach, Carolina and Mauldin

Dick Sheridan, player at North Augusta, coach at Eau Claire, Orangeburg, Orangeburg-Wilkinson and Airport

Wayne Sloan, player at Woodruff

James Talley, player at Carver, coach at Carver and Spartanburg

Jimmy Wallace, coach at Northwestern

Mickey Wilson, player at Conway, coach at Conway and Myrtle Beach

Marty Woolbright, player at Chapin, coach at Lower Richland, Clover and Gilbert

Rex Woolbright, player at Chapin

Chris Wright, historian of Epworth Children's Home

NEWSPAPERS AND MAGAZINES

Aiken Standard

Aiken Standard and Review

Anderson Independent Mail

Beaufort Gazette

Charleston News and Courier

Charleston Post and Courier

Charlotte Observer

Columbia Star
Easley Progress
Florence Morning News
Gaffney Ledger
Greenville News
Greenville Piedmont
Greer Citizen
Horry Messenger
Myrtle Beach Sun
Orangeburg Times and Democrat
Pickens Courier
Raleigh News and Observer
Rock Hill Evening Herald
Rock Hill Herald
Seneca Daily Messenger
Spartanburg Herald
Spartanburg Herald-Journal
Sports Illustrated
The State
Sumter Item
Time

INDEX

ABOUT THE AUTHOR

John Boyanoski is an award-winning journalist based out of the Upstate. He has written for the *Greenville News*, *Spartanburg Herald-Journal*, *Greenville Journal*, *Sports Business Journal*, the Associated Press, *GolfLink*, the *Tulsa World* and many more. His work has been cited numerous times by the Suburban Newspapers of America and the South Carolina Press Association. Contact him at palmettopigskin@yahoo.com.

Visit us at
www.historypress.net